CLEVE GRAY

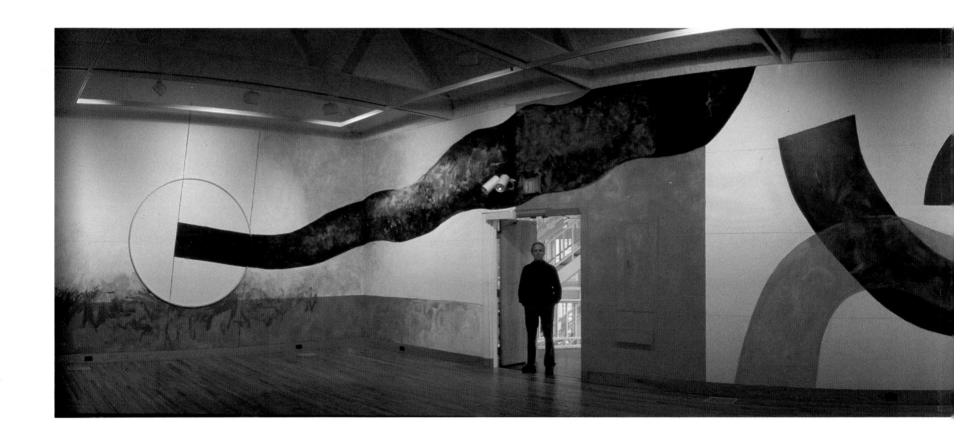

CLEVE GRAY

Nicholas Fox Weber

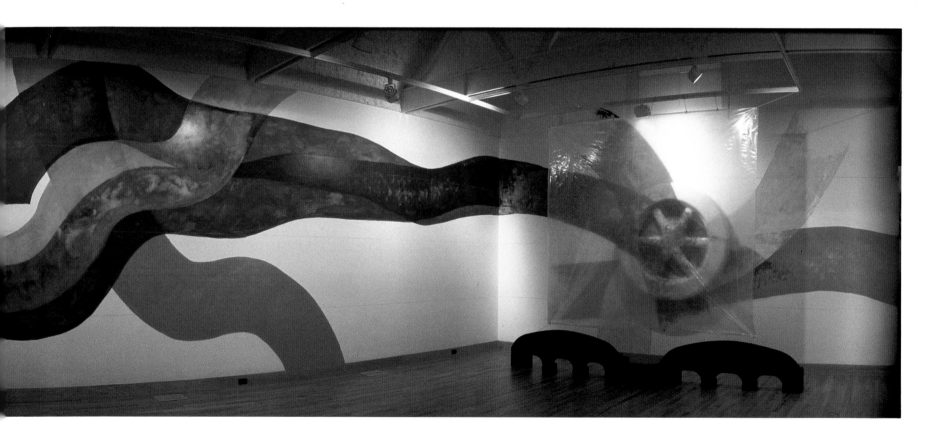

HARRY N. ABRAMS, INC., PUBLISHERS

DEDICATION

For Nancy—like Cleve, a perpetual explorer and celebrator

NFW

For Joanna and Daniel Rose with deep gratitude and devotion

CG

EDITOR: ROBERT MORTON
ASSISTANT EDITOR: NOLA BUTLER
DESIGNER: RAYMOND P. HOOPER

Library of Congress Cataloging-in-Publication Data

Weber, Nicholas Fox, 1947–
Cleve Gray / Nicholas Fox Weber.
p. cm.
Includes bibliographical references and index.
ISBN 0–8109–4138–4 (hardcover)
1. Gray, Cleve—Criticism and interpretation. I. Gray, Cleve.
II. Title.
ND237.G6165W43 1998
759.13—dc21 98–12076

Printed and bound in Japan

Harry N. Abrams, Inc.
100 Fifth Avenue
New York, N.Y. 10011
www.abramsbooks.com

Pages 2–3: *Enter, Entrance, Exit.* 1989. 16899 high by 218 by 558.
Acrylic on plaster. Temporary installation at the Aldrich Museum of Contemporary Art, Ridgefield, Connecticut

CONTENTS

Dawn was revealing colors, one by one. First the red of the wild arum berries, the reddish slashes on the pine trees. Then green, the hundred, the thousand greens of the fields, bushes, woods, which a short time before had been uniform: now, instead, a new green appeared every moment, distinct from the others. Then the blue: the loud blue of the sea which deafened everything and made the sky seem wan and timid. Corsica vanished, engulfed by the light, but the border between sea and sky did not become firm; it remained that ambiguous, confused zone, frightening to look at because it does not exist.

All of a sudden houses, roofs, streets were born at the foot of the hills, along the sea. Every morning the city was born like this from the realm of shadows, all at once, tawny with tiles, sparkling with glass, lime-white with stucco. The light every morning described it in the smallest details, narrowed its every doorway, enumerated all its houses. Then the light moved up along the hills, revealing more and more particulars: new terraces, new houses. It arrived at Colla Bella, yellow and barren and deserted; and it discovered a house up there as well, isolated, the highest house before the woods.

Italo Calvino,
Man in the Wasteland[1]

I

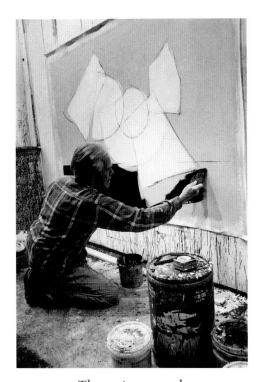

The artist at work
in his Connecticut studio, 1997.
Photograph by Inge Morath

"What do I want my work to do?" Cleve Gray asks. It is he who poses the question; I would not have dared make so general an inquiry. But with the lucid and circumspect vision that prompts him to take various approaches to a single issue, he often keeps up both sides of the dialogue, and is at once questioner and answerer. "I want it to celebrate life. I've been so fortunate, and the only way I can repay my good fortune is to celebrate what I see and know."

The remark might sound too good to be true from someone of less penetrating intelligence or erudition. But coming from this complex painter, whose first major work dwelt on themes of the Holocaust and of bombed-out ruins in London, whose abstractions refer to Greek tragedies and the Vietnam War as well as to Zen harmonies, it has a courageous simplicity and refreshing clarity.

We are standing in Cleve's studio, a vast barnlike space, as a full-force blizzard, quite unexpected in northwestern Connecticut at the end of April, rages outside. Cleve and I face *Elements IV*, an enormous wall-sized painting comprising four canvases adjacent to one another, soon to be sent to Dallas to be installed in the lobby of a new apartment building for which it has been commissioned (pages 8–9). I marvel at the balance of the brushy abstract forms against their vibrant orange and yellow backgrounds; for all their apparent spontaneity and disorder, they bespeak precise intentions and a knowing hand.

I hazard the remark—a bit of a risk, since I am speaking to an abstract painter—that they remind me of an Annunciation. The "figure," or flurry of paint, on the left has the active nature, the look of hasty arrival, traditionally accorded to the angel Gabriel; the free-formed massing on the right is, by contrast, restful and passive, like the Virgin receiving the news of the miraculous conception.

Cleve's surprising response to my mention of this popular Renaissance theme is a resounding "Absolutely!" He takes the idea further, saying, "I have always been attracted to

Elements IV. 1997. 8 × 24′
(Quadriptych). Acrylic on canvas. The
Plaza at Turtle Creek, Dallas, Texas

9

the Chinese sense of yin yang—opposites converging to make a harmony. Male, female, black, white: all coming together."

He meets me with his gaze—powder blue eyes under bushy, blond gray brows. His smile is animated as ever. At age seventy-eight, Cleve is remarkable for his lean and youthful body, and the strong gait he has retained in spite of a range of recent health problems. His face recalls that of a little boy who has the wisdom of an old man, rather than the other way around.

"I don't believe in God, or heaven, or an afterlife. Francine"—the reference is to his wife, the writer Francine du Plessix Gray—"is a lapsed Catholic, but underneath it all she remains Catholic. But my ideas about spirituality are fuzzy. What I believe in is this world; there's an underlying rhythm in this world."

Not that Cleve denies sadness or tragedy, or is unrealistic about cruelty and loss. But with knowledge, and with time to fight for his beliefs, he has found a personal solution in the world of painting. He has made and written about art with virtually ceaseless gusto since his teenage years. "One knows that the miseries outnumber the joys. I expected the problems I've had. I've lived my life; whatever happens is great. I don't wallow in misery." In painting, sculpting, and writing, Cleve has embraced hope.

When he was a student at Princeton before World War II, Lyonel Feininger and John Marin were among the first twentieth-century artists he admired. In their technical proficiency and the more ethereal aspects of their work, he gleaned some vital possibilities. "I think they're both rather transcendental artists. And to me transcendental means a sense of some power in nature and in man—not necessarily a specified deity."

Quickly he amends his own comments, with the instinct for self-correction that has led him to destroy paintings by the score, but also with the healthy amount of self-esteem and the prevailing sense of hope and belief that have allowed him to enjoy his own best work. "I don't like the word deity, which I just used, but more a force, a power; that's why I became so fascinated with Zen. The Chinese have a saying, 'ch'i-yün shĕng-tung: Life's rhythm and spirit's resonance.'"

Perspective, a mix of optimism and realism, indeed spirituality, are what one finds not just in Cleve Gray's verbal and written expression, but above all in his vibrant, luminous paintings. "I know perfectly well art does not move the world; it doesn't change society. But it can help to elevate the human spirit." The speaker of those words has succeeded in creating a body

of work that does just that.

These four large panels for Dallas, which read as one unified composition, are often the starting point of my conversations with Cleve. It is the spring of 1997, and they dominate his Connecticut studio as they lean against a long wall near the door and await shipment. Cleve and I meet once or twice a week over a time period of several months, and while it is always my intention to have us work our way in an orderly chronological sequence from his earliest work until now, we cannot help jumping all over the place, and I cannot prevent myself perpetually from being intrigued by this most recent work—so uplifting and highly charged, yet at the same time clearheaded and resolved—and asking the artist further questions about it.

On a June morning as bright and summery as the April day was wintry, Cleve tells me that he made this large work—*Elements IV* is eight feet high, twenty-four feet long—between three medical procedures in the past winter. Someone else might sound more upset or apprehensive mentioning illness, but Cleve sees it only in relation to its effect on his ability to work. And clearly the art made in the interval, rather than reflect any of the suffering or discomfort the artist must have experienced, provides an antidote to pain, an immersion in the technicalities of painting as well as the emotional potential of color and pigment.

"When I have the thought to do something, I'm terribly driven by it. I have to do it right away. Dale Bullough—my patron in this work, as it were—came to my dealer, the Berry-Hill Gallery, wanting something for the lobby of a condominium he was building. When asked for some guidelines, he first said, 'It's up to Gray,' but after further questioning, he said 'something with a Mediterranean look,' which I took to mean spacious and with very bright colors. I knew realistically that the work would be seen very quickly and superficially by people walking through the lobby swiftly, so I wasn't aiming for anything too profound. I don't mean to sound condescending, but people in those circumstances want a quick lift.

"The four panels have the same foundation color: a dark red. That provides them with an underlying unification—which for me is like human blood. Then I used four different colors transparently over that same red to make the backgrounds: a brighter red, orange, gold, and yellow orange.

"Next I started with the blue circular form on the left. I then proceeded to green, in undulating movements. But I found that the green was not relating enough to the blue, which is why I added the other linear movements."

This sort of visual thinking, unique to a painter's mind, is essential to the process of Cleve's work, whatever the emotional intention.

Cleve tells me that once I mentioned the Annunciation idea, it made sense to him, and that the concept was further confirmed when he and Francine went to the Tiepolo exhibition at the Metropolitan Museum of Art in New York. "When I looked at the magnificent small Tiepolo *Annunciation*—what a painter he is!—I saw what you meant, with the cloud coming through the window. This, in a very general way, was what was in my mind: I wasn't thinking of the *Annunciation* specifically, but I intended something charged and something receptive.

"But some people see it as sea monsters. The ambivalence that you can get in the response is what fascinates me with abstract painting. But when I work, I'm thinking of planes in space, and movement, and significant line. And then expanding into some unknown. Especially recently, as I've been trying to think of the universe in new ways after reading Timothy Ferris's book *The Whole Shebang*. We have to readjust our whole conception of space.

"This is what I love about abstract art; finally I've gotten to the point where I let the painting take me away." The results of those flights of intuition seem to delight him, however distant they may be from his original intention—so long as the artworks cohere to his own rigorous standards.

Cleve Gray at four years old

Cleve discusses biographical issues comfortably, but he attributes little significance to them. Having opted for a way of life very different from the one into which he was born—rural New England rather than urbane New York; the priority of art and intellect over traditional upper-middle-class values; a marriage based on the concept of equality and the mutual respect of two seriously accomplished people, rather than the husband as the sole provider—he has little fascination with his origins and childhood except in relation to his development as an artist.

Cleve Ginsberg was born on September 22, 1918, in New York City. The arts were important to his mother and her family, but suspect to his father. "My mother's father was the brother of Lew Fields, of the comedy team Weber and Fields," Cleve has written in an informal summary of his life he calls his "Autochronology." "In my childhood my mother wrote lyrics for pop songs, and once she went on stage to accept a prize at the RKO theater. That same night my father called a halt to her career: he was 'the breadwinner' and, besides, 'everyone knows that stage people are all tramps.'"

Yet Cleve respected and liked his father—in spite of their dissimilar interests. "My father

came from a close-knit conventional Jewish family. He could never afford college. He loved the business world and was imaginative and adventurous in it; this sometimes got him in trouble, but generally he did well and kept us comfortably." (Here and throughout the text, these quotations of the artist's voice combine our conversations with the "Autochronology.")

That practical support was something Cleve never underestimated. He told me that it "mystified" his father that he should devote his life to art. "He didn't know why; a trusting, genial man, he never understood my resolution to be an artist." Yet in a vital way both of his parents were always there for him. "Even without approval, my father throughout his life gave me the financial help I needed." The link with both of his parents was sufficiently strong that as a young man Cleve would continue to spend a lot of time with them; they provided his existence with a dependable framework in what might otherwise have been a rather haphazard period of formation. "I didn't have the guts to face it alone," Cleve remarks, as he looks back at it now.

For Jacob Ginsberg, Cleve's father, "artists, prostitutes, and stage people were the same ilk. Yet I could always credit my father for my first aesthetic experience." The pale blue eyes light up and the smile widens. Cleve is looking almost transported. He conjures one of his earliest memories, as essentially visual and rich in color as some of the canvases leaning against the far wall of the studio. The moment occurred in the "two-floor apartment with huge rooms on West End Avenue at 90th Street," where Cleve's family lived in his early childhood. "Having been very successful in banking, my father had then bought for his brothers a textile company, A. Rosenthal & Company. Eventually they went bust, and he lost his money, but initially he had set them up manufacturing silk. He would return home from work with rolls of silk ribbons, all different widths and different colors, on white spools. I would always be so thrilled seeing these. I came to my father's knees and would excitedly reach up to grasp the colors. The bands of palpable beauty were intensified by the white paper spools on which the ribbons were rolled. To me that was like entering heaven. This was the first time I was aware of the magic of color."

It was that same magic that Cleve would explore more systematically, but no less viscerally, twenty years later as a GI in André Lhote's Paris studio, where the emphasis was on the contemporary School of Paris approach to values and light intensity in contrast to the American technique with its inclusion of black. And the realm of heaven that Cleve first felt at his father's knees is memorialized as powerfully as ever in the recent paintings that sur-

round us now, where the power of pure acrylic color is intensified by the unpainted canvas at its edges, much as those paper spools offset the glories of their silk ribbons.

Cleve's love for visual experience and for the processes of art was present virtually from the start. His wish to paint was "absolutely instinctive. There was no question about it. I knew since I was four that I wanted to be a painter. I remember pleading, at age five or six, for oil paints. I had no idea how to use paint or canvas, but I put the canvas on the floor and started in. My first painting was of a house at night with light coming through one window. I showed it to my parents when they were having dinner. My mother said, 'Oh, that's beautiful, Cleve.'

"But my father asked, 'What is it?' I replied, 'Can't you see? It's a house at night.' Then he said he liked it. My next painting was of an oversized dog's head."

In 1924, at age six, Cleve entered the Ethical Culture School in New York. In second grade there, he won a prize for a watercolor of his mother at the piano. The school encouraged his artistic interest and provided him with visual nurturing from which he would enjoy lifelong benefits. But sometimes as a child he took his interest to extremes unusual even in an environment that encouraged artistic exploration. He stole a ceramic tile made by a classmate because "her tile was better than mine and I didn't want it around." At another time, "during one lunch period I climbed to the top floor of school, where the studio was located; I found the poster colors and smeared them over my abdomen—a highly sensual experience, I was in love with paint. Nothing seemed as beautiful as an open box of watercolors: the white porcelainized interior surrounding the small chips of pure color which ranged alongside each other was a celestial sight. I still gasp when I see a child's open paint box, and I try to capture in my work the directness and purity of that vision."

The bold forms and highly charged colors of *Elements IV,* in front of us throughout this discussion, are testimony to the success with which Cleve has evoked that primal pleasure in the power of paint. All of his recent work, in fact, despite its intellectual sophistication, has something unequivocal about it—the brazen embrace of artistic creation, the child's instinct to immerse himself in colorful shapes, the innate wish to explore his visual universe.

When he was about twelve years old, Cleve was startled and perplexed by an exhibition of Matisse at the recently formed Museum of Modern Art, still in its initial location in the Hecksher Building at the corner of Fifth Avenue and 57th Street. The show "made me terribly nervous, and I started laughing. I laughed out of nervousness, and I did not like it." It is a

judgment he would eventually reverse: "I now think Matisse is the greatest painter of our recent past, along with Cézanne—much more so than Picasso." The same year as the Matisse exhibition, when he was in the eighth grade, he fell for a girl in his class at Ethical Culture— "Shirley Stollof, a redhead, who I thought was just magnificent." Cleve cites his admiration for Shirley as his reason for persuading his parents to let him go to art school once a week; his inamorata was studying with a teacher named Antonia Nell, and he followed suit.

In Cleve's recollections, Toni Nell was "strongly affected by her teacher George Bellows; she painted little Bellowses. She opened my eyes to the idea of using color; she told me shadows weren't black, which I thought they were up to that period. I then saw the blues and purples in them." He became imbued with what he terms a "romantic realism."

Cleve in those early years had the usual artistic goal of a twelve-year-old. "I was trying to reproduce what I saw. I thought my mother playing the piano was beautiful, so I painted the painting that won the prize." Similarly, he wanted to achieve a reality of appearances in Toni Nell's class. Discussing this, we walk into a storage room adjacent to his studio to look at a very impressive still life Cleve had produced under the guidance of that first teacher. I remark on the level of skill unusual in one so young. But the artist himself remains less satisfied, just as he was as a child. "Actually I was very distressed because that's supposed to be a bottle and I didn't know how to make it look like glass."

Fortunately, some grown-ups recognized the boy's talent even if he did not. Antonia Nell said Cleve "was going to be a very important artist," even if Jack (as everyone called him) Ginsberg "thought the idea was ridiculous." The still life was shown at the National Academy of Design. And Toni Nell "told my parents I was very very gifted. So they let me go back for more classes. I remember it was four dollars a session, which was difficult for them because they had recently lost a lot of money." In any event, the boy made the most of his opportunity, and often worked late after everyone else had left. He produced an even more accomplished painting—of fish—although the task was arduous owing to the decaying subject. "My art teacher laughed when she saw me holding my nose while I was painting those fish. I used one hand to squeeze my nostrils together, and the other to hold the brush."

The artworks would eventually stand on their own: visually enticing, a universe unto themselves, worked out with the resolve of a born painter. But at the same time they often referred significantly to a subject of vital importance to their maker, just as those first still lifes reflected

First Still Life. 1930. 16 × 30". Oil on canvas board. Collection the artist

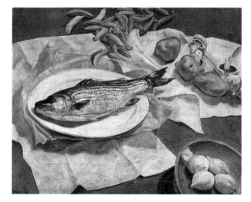

Fish and Vegetables. 1934. 24 × 30". Oil on canvas board. Berry-Hill Gallery

15

the reality before the young artist's eyes.

Consider Cleve's best-known paintings: the 1972–73 mural series *Threnody* (pages 18 and 19). These fourteen large panels, each roughly twenty feet square, commissioned for the Neuberger Museum at the State University of New York at Purchase (SUNY)—where they fill, floor to ceiling, a 60-by-100-foot room—are one of the artist's quintessential achievements. His admirers cite it frequently, and Cleve and I continually refer back to it in our conversations.

Cleve initially discusses *Threnody* with me in our first lengthy interview, during that blizzard when we began with *Elements IV*. He had segued from his comments on the ability of abstract painting to take him intuitively into unexpected areas. "As for the vertical movement repeated in each panel of *Threnody:* it was a goddess, it was a tree—which comes right out of Greek myth, right?—but I also thought of them as pillars in a cathedral, which hold up the vault and give it its presence. But it was also and especially a dance of death, a theme that had fascinated me ever since I saw the Dürer woodcuts when I was fifteen.

"There may be many meanings. It's some kind of a statement about death and the human spirit. That came across to people. The greatest thrill I had was three or four days after it went up, when a group of women students were in there and they said, 'Oh, wow'—and then, one by one, they took off in a dance around the room. That was everything I could hope for."

In a brief text about the creation of *Threnody*, Cleve quoted the monk and poet Thomas Merton: "The deepest level of communication is not communication but communion." When one stands in the hallowed space in which these paintings simultaneously loom and recede, there is, indeed, that level of communion: a lowering of barriers. Acrylic on canvas becomes veil-like. The hues that Cleve mixed in toy plastic swimming pools and painted with janitors' pushbrooms have a spirituality and profundity that defy explanation. The subject—emotional balance, uplift in the face of tragedy; the possibilities of the act of painting—is incredibly present.

A threnody is a dirge, a song of lamentation. This lament, specifically, was for the dead in Vietnam. "I felt that tragedy had been manifested more intensely during those years and in the preceding decade than at any other time in American history," Cleve says. "Iniquity, futile death, and destruction surrounded us." His task was to voice the loss and at the same time to mourn it appropriately.

Cleve found the visual analogue to "the inseparability of life from death, the reconcilia-

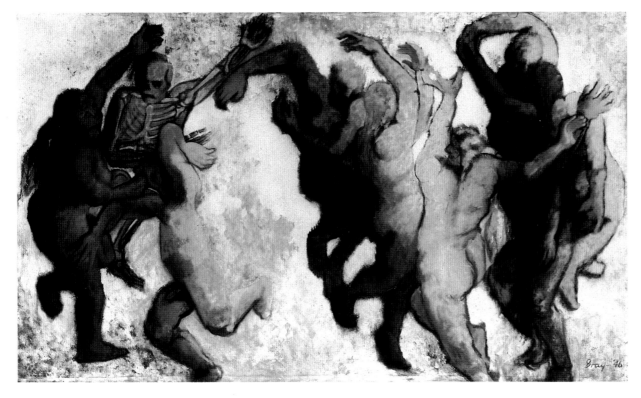

tion of opposites" that he wanted to evoke—the same issues that, on a far simpler level, he had been grappling with in those stinking but beautiful fish, and that we are still discussing in 1997 apropos his most recent work. Double meanings, and the reconciliation of opposites, have long obsessed him. The imagery of *Threnody* was both male and female; beyond that, "this dualism took on still other aspects: the form became more interlocked with the void, the dark flowed into the light, line into pattern, soft shape into hard." *Threnody* was "a dance of death and life."

With his consistent ability to go beyond himself, to fasten onto the realities of others, Cleve very much had in mind the effect of that dance on its particular audience. The Neuberger, after all, was on a university campus. He "hoped that the students at Purchase, whose minds (like those of all students) are crammed with imposed knowledge, could enter this room and possess themselves of *their own* thoughts, would react to the paintings as an environment for meditation, where there could be both influx and afflux." Those generous intentions, and the otherworldliness of their expression, truly characterize the artist. "I thought of the room as a cathedral—a source of light and hope."

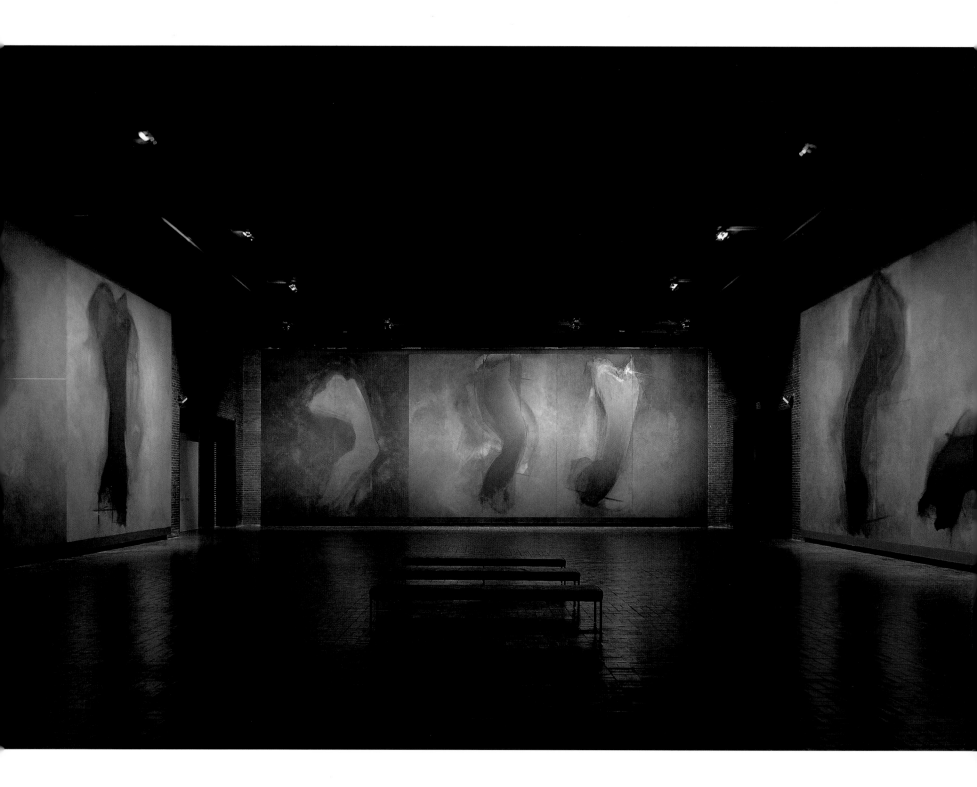

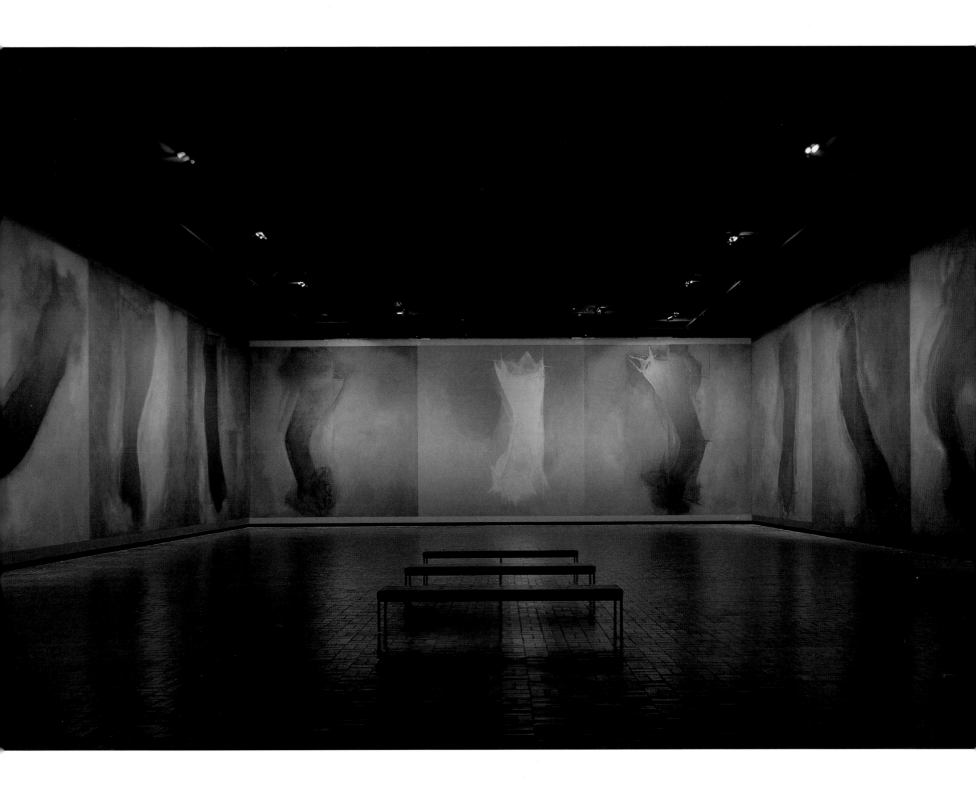

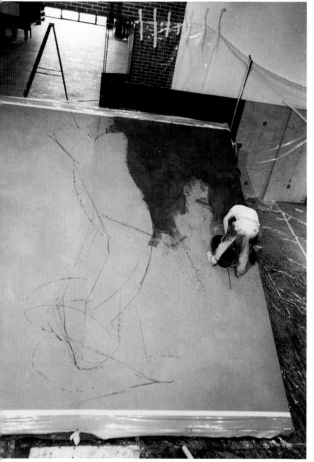

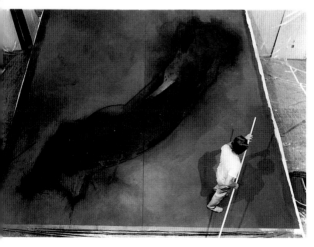

Within a cathedral, there is, of course, an apse. Because "the depiction of tragedy often requires an element of hope, I chose—after many trials, including white and black—a positive red for the central figure of the 'apse' wall. Unexpectedly but inevitably this figure became the climactic point of the room. In the midst of death it had to offer the hope of life, just as blood is both the palpitating fluid of life and a fleeting evidence of death."

The only way to know the success of these intentions for *Threnody* is to visit the space itself. For there the viewer not only enters a nonverbal universe—one that defies explanation as does a mountaintop at sunrise, or, perhaps more aptly, one where sunrise and sunset exist simultaneously—but he or she can observe other viewers (really participants) transported with like intensity but for very different, personal reasons. Yet for all the variables, one can safely say *Threnody* is about life as well as death, the physical act of painting and the ethereality of feeling.

"Why do I paint?" Cleve asks in his "Autochronology" entry for 1974, the year after *Threnody* went on view. "I paint to see what I will paint. But then what is the source of that urge? To deny death? Our children are our immortality, our books, our music, our painting. I fool myself, I know, but it is the only way I can live at peace with death. What a feeble defense against death painting is, the most evanescent of the arts. I am aging and I hate it. At fifty-five I begin to feel I don't have much time left, and I haven't accomplished much." But what Cleve encountered in reaction to *Threnody* typifies, in extreme form, the mixed responses to his work he has known from early childhood to the present day. He paid a hefty emotional price.

That melancholy of 1974 was brought on by the recent death of his brother and was exacerbated all the more by the reception of *Threnody*. "I never thought my work would become controversial, but *Threnody* became controversial. Some critics equated it with the Rothko Chapel, a few said even better, others all but laughed at it." And when the mockery came—exacerbated by a single newspaper article—he was let down completely by the administration at SUNY/Purchase, where the Neuberger Museum had just been built, with *Threnody* unveiled as part of its opening festivities.

Cleve tells me the story as we sit in his living room in the company of two standard poodles. Paintings by Robert Motherwell, Helen Frankenthaler, Paul Feeley, and other friends, as well as one of Cleve's own recent works, are all in view. Work by the Grays' younger son, Luke—whose recent exhibitions in New York and Germany have scored considerable success—is just around the corner. There are piles of books. The piano is covered with family pho-

tographs, including several of their older son, Thaddeus, his wife, Allison, and their growing family. The space is richly packed with the mementos of two lives devoted both to family and the joys of daily living, a world in which art and literature reign supreme, but where politics and the pleasures of daily existence are ever present. In 1997, the problems that followed the presentation of *Threnody* are as fresh in his mind as when he was reeling from the aftermath of the unpleasantness in 1974.

"I've always been out of style," the artist remarks, more matter-of-fact than bitter. What happened with *Threnody* was a case in point. He gives a history of the commission. He had met Bryan Robertson, the Neuberger Museum's founding director, at Robert Motherwell's house. "Bryan was putting together the whole museum, and did the most marvelous job of it. He came up here to visit my studio. He looked at my paintings and loved them. He said, 'Cleve, how would you like to do a room at this museum? I have a hangarlike space, designed by Philip Johnson.' Initially Robertson anticipated working with five artists. He intended to have each artist make works for the room, and planned to exhibit each one for a period of time. I said, 'I'll be down there tomorrow morning.' I was down there the next day, and I was overwhelmed with excitement. When I get a commission, my mind goes sixty miles per hour, and I want to begin immediately."

Among the other artists whom Robertson had intended to ask to paint murals for the vast space were Motherwell and Clyfford Still. But funding difficulties ensued, so that Cleve ended up being the solitary participant—in part because of his willingness to forsake any payments beyond reimbursement for the cost of materials.

The timing from Cleve's point of view could not have been better. In his Sheba series, which preceded *Threnody*, Cleve had already begun his practice, still in effect, of doing his abstractions in closely related groups, working a theme as far as he could in multiple variations and then moving on. It was the Shebas, each of which was a vertical configuration on a nine-foot-square background, that Bryan Robertson had seen in Cleve's studio the day he asked the artist to consider the commission for the Neuberger. "If Bryan had asked me to undertake this enterprise a year earlier, I would not have been ready; a year later my vertical form would probably have been played out, past its crest of interest for me; I would have been unable to sustain my conviction of its rightness. At the moment of his asking, the form I had developed up to the Sheba paintings had reached the perfect point of ripeness and lent itself ideally to the kind of heroic abstraction and tragic content I had in mind for the wall paint-

The artist at work on the *Threnody* series in the Neuberger Museum of Art, State University of New York at Purchase

21

ings. In spite of Francine's and my deep involvement with the antiwar movement, I had been frustrated by my inability to express my thoughts and emotions in my work."

To fund the commission, the Friends of the Neuberger Museum covered Cleve's expenses, once he agreed to donate his labor. Cleve had a model built of the room at a one-inch-to-one-foot scale, and feverishly set about working. By the time he proceeded from studies to work on the actual canvases in situ, he was sometimes painting twelve hours a day for seven days of the week.

Cleve faced whatever obstacles there were with his usual humor. "Absolutely everything had clicked for me. At one time a strike was threatened because I was not a member of the painters' union; it would have halted all work on the campus, which was still under construction. Three workmen came in to see me at work and to examine the situation; after considerable discussion, none of which I was aware of, they decided I wasn't actually a painter after all: no real painter works with pushbrooms. I was a janitor!"

Accolades poured in. Virtually every viewer who saw what Cleve considered to be his consummate achievement to date heaped praise. Everything went spectacularly until Hilton Kramer, then the chief art critic for the *New York Times*, wrote an article on the occasion of the opening of the Neuberger. "He put down *Threnody* completely. He wrote that it was going to be a laughingstock. The Monday after Kramer's article appeared, people who were hugging me the day before and telling me *Threnody* was a masterpiece now walked by, without even saying hello, averting their eyes.

"Bryan Robertson was crushed by the tirade. The chief officials of the university were totally antipathetic."

Fortunately, however, Cleve Gray's supporters were not so timid. Their venues were a bit less influential than the *New York Times*, but their admiration for the paintings was even more ardent than Kramer's censure. In the May 18, 1974, *New York Post*, the critic Emily Genauer declared that these fourteen murals "constitute the most moving and beautiful mural project in the country.

"In quality, in spiritual strength, in imaginative power, in technical brilliance, with these 280 feet of running wall painting," Genauer declared, Cleve Gray had exceeded the achievement of the Rothko Chapel in Houston.

About a year later, Thomas B. Hess, one of the sages of modern art, made a similar com-

parison in the pages of *New York* magazine by declaring the *Threnody* paintings "extraordinarily successful (in their own, more outgoing way, as moving as the famous murals Mark Rothko painted for his chapel in Houston)."

Hess evoked the particular glories of Cleve's work in a rich visual description of the fourteen twenty-by-twenty-foot canvases which, he pointed out, composed "the largest suite of abstract paintings designed for a public, architectural role ever created." The critic enables us both to see their colors and forms and to feel their effects:

> They glow on the walls of the darkened room in suffusions of greens and violets, and black and red. The square paintings are divided into two panels which, together or separately, present a non-objective motif, or figuration, that in gesture and proportion reminds you of a dancer. . . .
>
> The backgrounds of the images have most of the colors; painted in acrylics, they have dried to mat, rusty brightness. Shifts from tone to tone bear evidence of Gray's methods of application through smearing, sweeping, scrubbing, wiping. The central figurations are darker; they glisten like mica or graphite; sometimes they reflect like sheets of white. . . . Gray's "dancers" have something of the swivel-hipped austerity of Martha Graham or Isadora Duncan. Still, the shapes are never animate or humanoid. They don't Mickey Mouse. They stick to the wall—dignified, aloof, vaguely tragic in their flickering from colored sheen to deepest black. They share a pathos of lost grandeurs, of memories of a time when artists engaged in vast undertakings at the instance of some enlightened prince or fanatic saint. And Gray's "dancers" mirror and rhyme each other across Philip Johnson's eloquent space in a saraband for a lost, betrayed American empire.[2]

Hess's splendid homage evokes methods and emotions, a relationship of technique and appearance and—the word with which we began—spirituality. The critic tremendously admired the mix of discipline and freedom, the skill as well as the warmth, that made *Threnody* such a success, that placed "Gray firmly in the tradition of Kline and Motherwell," that had transformed the teenage boy who stayed later than anyone else in Toni Nell's class into one of the country's most sophisticated and accomplished painters.

"The very size of his project—the giantism of *Threnody*—forced him to calculate every spontaneity, to plan in advance each area for later improvisation, to work at keeping a bit off

balance," Hess wrote. "He was like an engineer constructing the ultimate bobsled run, designing ice walls and snow-packed gullies down which, out of control at 120 miles per hour, will rattle a team of harebrained athletes. . . . Only an artist of Gray's Janus-faced capabilities could have brought it off. . . . It's to Gray's singular credit that he was the right artist at the right place with the nerve, capability, ambition, and special training to attempt to recapture, in an out-of-the-way local university, something of the vision Jacopo Tintoretto planned for Venice—a huge, noble, vigorous, sustained, awesome elegy."

A couple of weeks after Cleve tells me about Hilton Kramer's comments, I realize that I would do well to see the actual article—both because Kramer is a critic of substantial intellect whose integrity and seriousness of purpose I greatly respect even when our tastes do not concur, and also because I know that people often remember stings as being sharper than they actually were. I hesitate, however, to ask Cleve to provide a copy; the object of what he has described as fairly wounding derision would probably sooner avoid it. Yet knowing that Cleve keeps rather complete archives, I imagine that he may have what I am looking for.

Finally, in the course of a telephone call, I steel my nerve to ask Cleve, first with an apology for raising what may be an unpleasant subject, if he still has Kramer's piece. The reply is a loud chortle. "Yes, indeed, I do: many, many copies. I read it whenever I'm starting to feel too good about myself."

We agree that I can pick it up the next time I see him, but a couple of hours later Kramer's May 21, 1977, column arrives by fax. The critic's actual words are, in fact, a hair milder than Cleve has made them out to be, although the artist's rendition of them was accurate. Kramer did, indeed, start with the statement, "But no one—least of all a harried museum director—is infallible." And after declaring that Cleve had done *Threnody* "without fee, it should be noted," Kramer called the murals "little more than a decorative parody of the abstract expressionist style. . . . With its cabaret lighting and morbid pretentiousness, it is certain to be the subject of a good deal of humor on campus for the duration of its exhibition."

One could see why it was a blow to Cleve. But someone less self-effacing might have pointed out that Hilton Kramer's displeasure extended almost equally to Philip Johnson's architecture for the Neuberger and to the rest of Roy Neuberger's collection as to Cleve Gray's murals. Kramer termed the place where *Threnody* was installed as "the most unwieldy of the exhibition spaces Mr. Johnson has saddled the new museum with." Bryan Robertson, whom

Kramer admired for his previous work at the Whitechapel Gallery in London, faced "two for-midable obstacles" in Purchase: "the pictures themselves," and "the problem of the space Mr. Johnson provided for the collection." Kramer's taste was highly independent and at a distance from the mainstream of critical thought. While the vast number of visitors would have val-ued Roy Neuberger's collection of paintings by Milton Avery, Edward Hopper, Marsden Hartley, and other such names from the pantheon of American art, the *Times*'s critic declared it "dominated by small-scale works of secondary importance." Another of Johnson's galleries is likened to "one of those charmless, anonymous spaces one associates with apartment house lobbies." Kramer's critique should be viewed in the context of his response to the new museum in general. They represented the seriously thought-out stance of a knowledgeable viewer, but the disdain went in many directions.

Threnody now gets regularly reinstalled at the Neuberger every two to three years; Cleve tells me that "the reaction has been more and more wonderful." Most commentators have been effusive. Robert Buck, then director of the Albright-Knox Art Gallery in Buffalo, began his foreword to a catalogue of a 1977 exhibition of Gray's work by writing of *Threnody*, "Rarely has a group of paintings moved me to the same degree. . . . In a dark, cavernous space, the immense and glowing images came forth with a rich, chromatic radiance creating a spec-tral ambiance without parallel in American painting of the '70s." Buck, too, made the com-parison to the Rothko Chapel. Then, in the very pages where Kramer deplored the work—the Sunday *New York Times*—David Shirey, in 1979, followed Tom Hess by comparing *Threnody* to Tintoretto's Scuola di San Rocco murals as well as to Michelangelo's Sistine Ceiling, declar-ing the paintings at the Neuburger "heroic in conception, in execution and in feeling." In the November 1979 *Art International*, Daniel Robbins called the murals "among the most suc-cessful large-scale paintings of postwar American art."

There have also been more private, but equally significant, songs of praise. In April of 1975, less than a year after the Neuberger opened and *Threnody* premiered with it, Columbia University's Jacques Barzun, one of the most esteemed cultural commentators of the postwar years, wrote Philip Johnson on the subject. Barzun declared to the architect, "I have been bowled over by your museum at Purchase and particularly by the great room decorated by Cleve Gray. The two making one whole is a monument of contemporary art whose equal is not to be found in this country."

Professor Barzun, however, was not satisfied with the response to this splendid collabora-

tion. "But it is scarcely known," he continued. "People I talk to have only vaguely heard of the new university there. The very name Purchase sounds supposititious and in any case anaphrodisiac. All this being so, it occurred to me that a book should be put together about that room, fully illustrated and commented on."[3]

Whatever the influence of the name Purchase (indeed, one wonders if Barzun wasn't quite correct about its unfortunate effect), the professor again took up the cudgel about a month later, when there was reason to hope a book on Philip Johnson's museum designs might be published. This time Barzun addressed himself to the new director of the Neuberger. "If a book is published," Barzun conjectured, "I hope the Gray murals will be given a large place, in color, too. For a mere sample of one or two will not convey the magnitude of the achievement, which has unaccountably been under-noticed—as if a performance of that sort happened every other day."[4]

Yet in my conversations with Cleve, he seemed more aware of the negative response, of his relegation to the role of outsider in the art world, than of this level of praise.

Fortunately, however, the artist had developed his fortitude early, the sense of self that would enable him to deal with adversities such as the *Threnody* debate. His father in the early 1930s was beginning to recoup his money, most of which he had lost in the late twenties. Suddenly, Cleve's sister was expelled from Fieldston—the high school of the Ethical Culture Society, where Cleve had had one year—for smoking in the lavatory. His parents reacted to the short-sighted institution with rage and loyalty to their daughter. "They were so angry that they took me out of the Ethical-Fieldston system, deciding to send me to Phillips Academy, Andover." This move was easy enough to make because of Cleve's straight-A report card, a few early examples of which Francine has saved to this day.

"I went from glory to anguish. I had thrived at Ethical; I was always president of my class. But the time at Andover was the unhappiest of my life." The fourteen-year-old from New York felt himself a complete outsider. "I was a spoiled, fat boy, not at all ready for New England austerity and the WASP ethos. At home I had been a mama's boy, adored by this beautiful woman. But at Andover the other students were very nasty, and I was miserable. I became introverted and retiring, the opposite of the compulsive and masterful child I had been. Part of my introversion was certainly due to my unusual consciousness of Hitler's growing threat to the world. American boys of fourteen or fifteen were interested in athletics, not in the future of humanity. Of course, none of my acquaintances at Andover had my Jewish back-

ground to give them a sense of terror about the future. Unless there was a secret Jew some-where, I was the only one in my class."

It was in the misery of boarding school that Cleve learned "to close my mind to bad things." In fact, that is a simplification; it would be more accurate to say that the artist developed an instinct to cope. Rather than close his mind, he learned how to compartmentalize. "I hated Andover. The attitude of most of the guys there was brutal. I was forced to play football, which wrecked my knees forever. Yet I'm grateful to Andover; I learned how to overcome and face psychological problems and adversity." Just a moment before saying this Cleve has pointed out the glories of the sun pouring into the living room, the marvel of the light outside bouncing off the blanket of fresh snow that covers the large lawn. These are the comments of someone who has dealt with problems by celebrating the alternatives, not by bitterness.

"I had made myself a crystal radio set hoping to hear rebroadcasts of Hitler's speeches to the Germans; I couldn't understand what he was saying, but the dramatic tones and guttural shrieking were clear enough to anger and terrify me." That memory from boarding school life an hour north of Boston has elements that have pertained to Cleve Gray ever since.

But there was a solace. "In those seemingly endless, bleak, and sad years at Andover, my only respite was in the museum and in Bartlett Hayes's newly formed art program." Cleve's resolve to paint was stronger than ever. Hayes set up a studio in the basement of the Addison Gallery, where Cleve and a few other students were permitted to engage in the innovative practice of taking an art course for credit. "Hayes never taught me how to paint, only how to experiment"—which some would say was the best thing a teacher could do. "He exposed me to Impressionism. I remember asking him why my landscape didn't recede in space. I had tried putting a wash over the entire thing, and it didn't work. He brought out a book of the Impressionists to give me ideas." This was progress from the heavier palette encouraged by Toni Nell.

Senior year at Andover, Cleve and his fellow students painted a large mural for the biology lab, for which he made the overall design. This led to further endorsement of his skills when he was awarded the Samuel F. B. Morse Prize at graduation, given to the most promising artist—or, as Cleve puts it with a characteristically acerbic aside, "the one who worked hardest." He would, indeed, be fairly relentless with himself in his drive to fulfill that promise.

II

Following Andover, Cleve and his father made a deal about his educational future. Cleve wanted to head straight to Europe to study art. His father had more traditional goals for him. "He pooh-poohed the art thing. He said, 'If you go to Princeton for a year, and you don't like it, I'll send you to Paris.'

"But I liked Princeton; it wasn't suffocating like Andover. For not only was there great art instruction, but the teaching of philosophy and the other humanities, in which I was uneducated, excited me tremendously."

His lifelong priorities were established. The life of the mind, the ability to paint, and the freedom to expand: these were the essentials of existence.

At Andover, where there was a very strict quota system, Cleve had often felt the sting of anti-Semitism. "They took any chance they got to ridicule Jews." Then or now, Cleve has never denied being Jewish, but the strong identification has never suited him. When he was bar mitzvahed at a temple in the New York suburbs, it was very much against his will; he did not believe in the tenets of the ritual. Again, the issue was his quest for spirituality rather than strictures. "I believe in everything: Buddhism, Catholicism, Protestantism are all equally interesting. They're all expressions of our search for meaning."

In 1936, Jack Ginsberg's wife and children—as well as the youngest of his three brothers—persuaded him to change his last name to Gray. "In any event, Ginsberg was not our real name; it was only the one given to my grandparents at Ellis Island."

What Cleve got from his parents was more an attitude than a credo. "Neither one of them really had religion," but they offered other values. On his mother's side were two generations of a prominent stage family founded by Lew Fields. And from his banker father he acquired his optimism and resiliency. "He gave me the wherewithal to keep going—not merely financial support, but optimism, the continuing faith in possibilities even in the face of adversity.

"At Princeton, I began to know who I was. For the first time I was able to pursue the inter-

ests that excited me most." This was where, among other things, he had that initial exposure to Lyonel Feininger and John Marin, as well as to Cubism. "These paintings conveyed to me my own emotions in the face of nature." (See page 31.)

Cleve's new joy and intellectual engagement certainly had nothing to do with enthusiasm for the college's trademark tiger football mascot, its eating clubs, or the other Ivy League traditions that mattered to so many of his classmates. What counted, rather, were the serious studies from which Cleve graduated Phi Beta Kappa and summa cum laude. One brilliant professor, George Rowley, introduced him to Chinese and Japanese art and philosophy, as a result of which he wrote a thesis on Yuan dynasty landscape painting. Cleve tells me with evident pleasure that according to Wen Fong, who had taught at Princeton and is an adviser to the Met on their Oriental collection, it is still used at the college today.

"I did not join a club; I was not asked into one I liked. I ate by myself all the time. I had few close friends. That part of it was not very nice." But he relished the chance to study the history of art and philosophy. And Jim Davis, who headed the studio art department, opened up to him the possibilities of abstract art. Davis emphasized the notion of "lines of force that emanate from all objects."

In little time, Cleve's work began to show the strong influence of Cézanne. "I think I loved everything by him, but I succumbed first via the landscapes." Beyond that, he was profoundly affected by Marin—to whom Jim Davis had introduced him during his sophomore year. Marin "talked as fascinatingly as he wrote," in an Emersonian, transcendental, nineteenth-century manner. And then there was Feininger, whose rendering of landscapes and buildings enchanted Cleve even if he hated the artist's figures. What excited Cleve so much about Cézanne, Marin, and Feininger, for all of their stylistic differences, was that they offered him a clear visual sense of what nature inspired, rather than simple realism. These three artists were the primary influences evident in the solo exhibition the art department gave Cleve in 1940, his senior year; their pertinence is still apparent when he talks about the glories of the sun pouring in through his living room window, or the colored acrylics that sing in his latest abstract canvases.

Cleve painted constantly in those college years. He produced some of his best work of the period in a room at the Hotel Gloria in Rio de Janeiro when he was there in the summer of 1939 on a cruise with his maternal grandmother. Looking at these still fresh and lively canvases with their creator, I find that, unlike so many painters, Cleve is more than willing to

acknowledge the influences. "Cézanne was my ideal. But the idea for the brushwork came out of my interest in Oriental art; I was trying to paint Cézanne in that way. Of course, the white background coming through was a product of my looking at Cézanne too."

It isn't far-fetched to say that this confluence of factors—Cézanne's spareness and the air of his compositions (the watercolors and oils alike); the lyrical, cultured brushwork imperative to Oriental calligraphy and painting; the philosophical approach to experience and decision making—is as vitally present in Cleve Gray's work of the 1980s and '90s as it was when he was a college undergraduate.

And he remains to this day an intellectual explorer. Looking at a lineup of his recent Eumenides canvases against three walls of his studio, he tells me, with a particularly quizzical look on his face, "The question I keep asking myself is, 'What if?' What if I use a different color, or move in a different direction? Painting for me is a dialectic. Everything you do is constantly suggesting its opposite. Sometimes I make decisions in the middle of a painting; sometimes I complete the current painting and make the changes in the next one. Once I've developed a structure, I go from color to black and white and back again, or make changes in the surface, thick and thin." The series that divide his total body of work into subsets, like the chapters in a novel, are based on those carefully derived structures that in turn allow, and invite, endless variation until the painter is satisfied and moves on.

But satisfaction is not the goal as much as experimentation and exploration are. Moving among his own canvases, he turns from them to me and asks, "What if I didn't use line as an outline?" Musing aloud, he then contemplates the other changes—of form, of color, or of dimension. Beginning at Princeton, Cleve began to embrace the efforts and quests that have been his lifeblood ever since: in his art, they are both technical and psychological.

The exposure to Chinese art through Princeton's George Rowley led to a piece Cleve published some fifteen years later in the *College Art Journal*. Entitled "Chinese and Western Composition," it takes the form of an interview with his former professor. It is illustrated by a combination of Cleve's own work and paintings from the Sung and Ch'ing dynasties.

Toward the end of the article, Cleve summarizes the characteristics of Chinese art in a way that illuminates his own work—from the 1940s through *Threnody* to the present day:

In the case of Chinese painting the composition is not thought of as a static whole

Man and the Northern Lights. 1950. 30 × 40″. Oil on canvas. Addison Gallery of American Art, Phillips Academy, Andover, Massachusetts

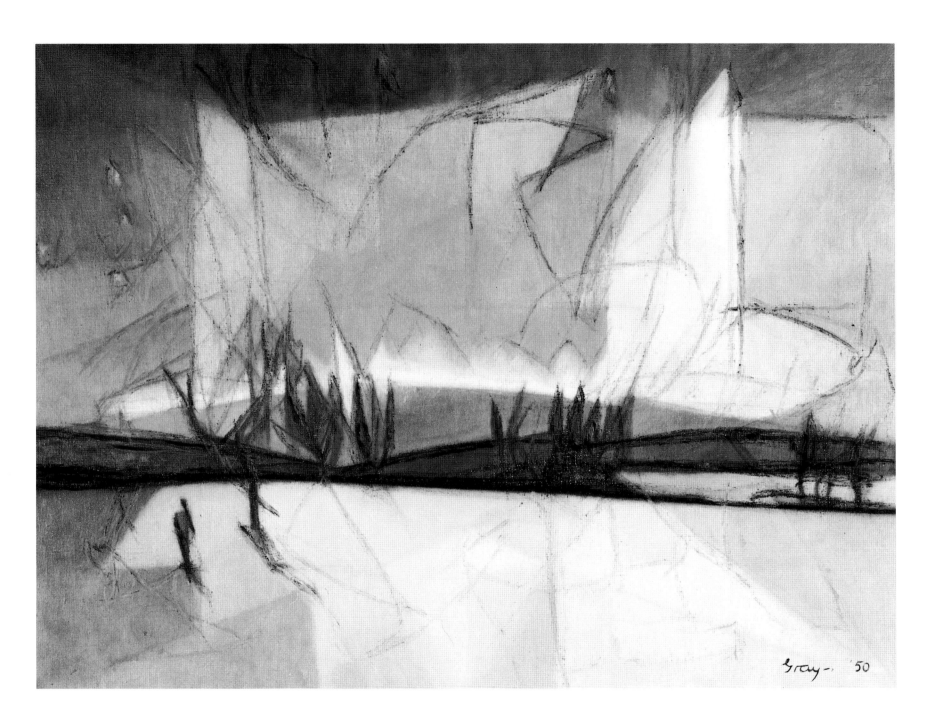

apparent as an immediate unity but as something revealed through a process or act of the spectator which relates lines, areas, or groupings to each other. The result is that Chinese painting cannot be analyzed as an immediate experience but must be regarded as the building up, over a period of time, of sequences and harmonious relations. And you would say that a Chinese painting is well composed if these sequences have coherence and harmony and that the harmony of these sequences is determined by a knowledge of nature's basic principle of growth. . . . Chinese composition is not a static, rationalized organization but one that requires the eye to move in time to assimilate; that, put in other words, is "dynamic" because the eye partakes in the actual experience of movement through the voids to relate the parts; and that, consequently, these parts are forces at work held in equilibrium. You feel that the differences of this kind of equilibrium from that of the West are further intensified and explained by the principles of *yin-yang*—the fusion of opposites; that in the West we don't present this sort of a dualism but rather a rationalized unity. . . . Chinese painting is composed from the start of nature's growth principles and consequently by definition is vital.[5]

Portrait of the Artist's Father.
1938. 26 × 20″. Oil on canvas board.
Berry-Hill Gallery

Portrait of the Artist's Mother.
1938. 24 × 18″. Oil on canvas board.
Berry-Hill Gallery

In these words we are treated not only to Cleve's reverence for being taught and his intense ability to learn, but also to an understanding of the beliefs and goals seminal to his own work, the connection to "nature's growth principles" and "the fusion of opposites" that is essential to the entire body of his art, whatever the variables of subject matter or emotional climate.

Following his graduation from Princeton in 1940, Cleve chose the way of life that has suited him, with a few interruptions, ever since. "I wanted to be out of New York, and to work": the same objectives that determined the life in which we find him at age seventy-eight. The rest of Cleve's college class may have headed for law school or Wall Street or another of the accepted destinations for privileged young men, but the young artist opted for a turkey farm.

This rural retreat in Mendham, New Jersey, belonged to a friend of Cleve's father. "I loved living and working alone in the country. I painted all day on the glassed-in porch, brushing smallish areas of saturated color which I thought were somehow related to Chinese painting. There was a lot of canvas showing. I was progressing." But paradise was quickly shattered. His landlord's chauffeur and butler were sent from the city to harvest turkeys as Thanksgiving presents; Cleve could not tolerate the sounds and sights of the violence. Then, after vacating

the house so that its owner could spend the holiday there with his family, he returned to discover that "they had flipped through all the paintings. Some of their kids had even put mustaches on the faces. I moved out."

But nothing could deter Cleve from painting. Back in New York in January in the middle of that first postgraduate year, he did two fine portraits of his parents, in which the strength of their personalities emerges through the sure-handed drawing and lively impasto. More than fifty years later, Cleve questions the imagery—"My father looks mean there. Yet he wasn't a mean man; he was kind and genial. It wouldn't be fair to think of him like that." His mother seems more in character in her Lily Daché hat. But whatever the artist's own reservations are in hindsight, these canvases effectively evoke the milieu of successful prewar New Yorkers.

In early 1941, Cleve rented a house in the desert near the Catalina Mountains on the outskirts of Tucson, Arizona. He had long been plagued by allergies and severe sinus problems that had failed to respond to the many treatments proffered by various doctors. As an alternative to the proposal of surgery, they suggested he try living in a dry climate. Although the war would soon interfere, this refuge gave him the chance to paint away from his parents with the focus and concentration he craved.

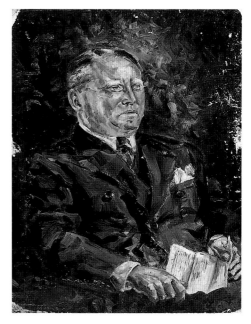

Cleve's life, like the art he produces in series, has aspects of "variations on a theme." What is consistent is that he has chosen to live with cultured and worldly companionship at a geographic remove from urban civilization, and that in the blend of isolation and sophistication offered by these settings he has cultivated an art that fuses the Asian and Western traditions. His method had always paired tradition and discipline with emotionalism and modernity.

In Arizona, the person who was central to the young Princeton graduate's way of life was Louise Grace, "a maiden lady who was a passionate amateur painter," to whom he was "a sort of son figure" and who became "a mother-sister" to him. Cleve had first encountered Miss Grace when he was fourteen: Antonia Nell had taken some of her students to meet the heiress—Louise Grace's father was W. R. Grace, a shipping magnate—at her house in Great Neck, New York. Miss Grace needed someone to prepare the white underpainting for her projected murals in the house she had built in Arizona, and it was the teenage Cleve who got the job. Once he was settled in Arizona in that year after his college graduation, Cleve telephoned Miss Grace so that he could see her again and view the finished murals in Eleven Arches, her

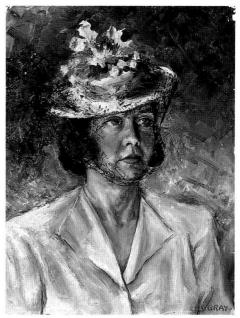

spectacular house in the foothills of the Catalina Mountains.

Louise Grace, Cleve says, "gave me strong intellectual and spiritual guidance of a kind which I had not found in my own family. She was Whartonesque, highly cultured, independent, tolerant, and beautiful: an older lady with the radiance of youth. She taught me tolerance: all the good things. She tried to eliminate the rough edges that a young self-absorbed man would have. I cannot exaggerate her intelligence and kindness."

Cleve was soon living in the summers in Louise Grace's Tucson gatehouse, where his task was to make sure that the generally irresponsible gardener gave the plants the watering their desert climate required. In winters, he moved into a wing of Eleven Arches. He and Miss Grace would play golf in the mornings and paint together later in the day, and she provided his life with a framework of pleasant company and good meals. Cleve's work flourished. The art he produced in Arizona was imbued with a new looseness and articulateness. The influences were apparent, but the paintings were fluid and spirited.

Cleve and I are looking at *The Waterfall*. The artist is very clear about what his objectives were at that early point. "It's based directly on a famous Chinese painting. My attempt was to reproduce with linear brushwork the force of water rushing down a rocky cascade. The style, of course, was influenced by Cézanne and Marin, at least in subject matter. Though the style would change, this early painting relates to my later Rocks and Water period of 1983. In fact, in almost all of my themes over the years, I can find something that recalls my earlier work."

But the world, and Cleve's own conscience, would not permit the young artist an endless future in the desert. He had had early premonitions of war when he was at Andover and sensed the increased threats when he was still at Princeton. "Paris fell the week I took my final exams; I had a hard time keeping my thoughts off the growing catastrophe. Paris to me was the essence of western civilization." Then, one Sunday morning in December 1941, when he and Louise Grace were playing golf, they wondered why there were so many planes flying over the course. When they returned home they heard the first news reports of Pearl Harbor.

In 1942, Cleve tried to enlist in the U.S. Army Air Force in Tucson, but he was turned down because of his health. Cleve, however, later managed to enlist in the U.S. Army Signal Corps. And in spite of his previously severe sinus problems and asthma attacks, for the duration of his three years of military service his health was perfect—possibly a commentary on a new internal resolve.

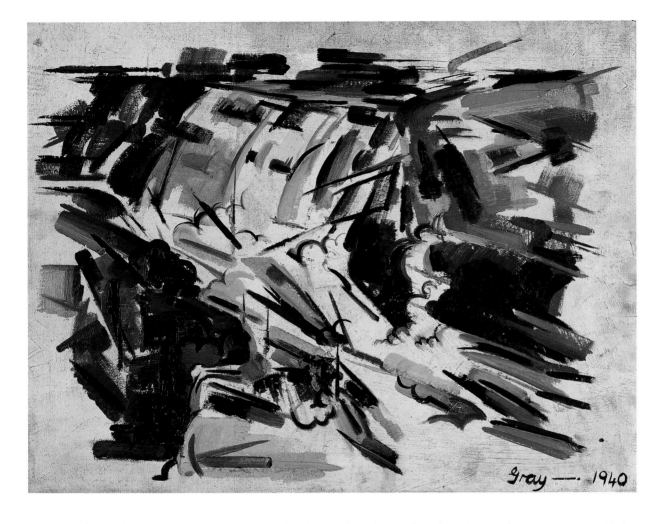

The Waterfall.
1940. 20 × 26″. Oil on canvas board.
Berry-Hill Gallery

"At about the same time, my sister died—suddenly—after five days of pneumonia. All the penicillin, a brand new drug, was going to the army; they didn't allow any for civilians. It was the most traumatic event of my life. The change in my life caused by war and army service was minimal compared to the effect of her death on my whole conception of existence."

Cleve was trained for and placed in an intelligence unit in the army; it took him to Europe. While serving his country, he continued to move forward with his art. Not long after France was liberated, Cleve got to Paris. He relished his first direct exposure to French culture.

Initially, Cleve had been sent to England. Then, in 1944, he arrived in Paris. He was already bilingual; having had a French governess during childhood. "In the euphoria of the Liberation,

the French were intent on being nice to Americans. I went to the Red Cross because they were very kind about helping you do the things you wanted to do. I wanted to meet artists. At the Red Cross center, they came out with a list. A very nice lady at the Red Cross canteen asked me which French painters I wanted to meet. I said, 'Oh yes! Picasso!' "

" Unfortunately, he is not on my list, but Jacques Villon is," the Red Cross worker replied.

"Who's he? I've never heard of him," said a disappointed Cleve. The woman explained that Villon was a good artist as well as being Marcel Duchamp's brother.

With characteristic self-mockery, Cleve recounts what he said next. "Horror of horrors, I responded, 'Oh well, if he's a brother of Marcel Duchamp, I'd like to meet him.' And so with that condescension a friendship of great importance to me began. Villon turned out to be an absolutely marvelous artist and man."

In our many conversations about his work, Cleve makes frequent reference above all to Jacques Villon, and also to André Lhote and other Cubists or disciples of Cubism. They and their work enabled him to take some pivotal artistic steps.

The work of Marin and Feininger and what he had learned at Princeton had taken him far in his effort to lighten and expand his artistic style, to marry Oriental grace with personal emotion and fulfill his goal of juxtaposing certain oppositions, both visual and emotional. Now he would go even further. If one were to draw a genealogical chart of Cleve's artistic development, Cézanne would probably be at the top as the ancestor from whom everyone else descends, giving unity to the family tree. For all the influence of certain American artists, there is no question that the genealogy to which Cleve belongs is the one given to the European side of the family. The formalism and discipline that consistently define all of his art—whether the series refers to Greek myth or Vietnam atrocities, whether the mood be buoyant or grieving—derive essentially from the Cubism of the French School. If placed in an American context, Cleve's erudition and temperance, his traditional code of behavior in preference to bohemian excesses, the intensity of his artistic passion, align him more with an earlier generation of gentlemen artists in the mode of Winslow Homer than with the Cedar Bar style of living preferred by a number of the Abstract Expressionists.

Even when Cleve and I look at paintings that he made a decade after meeting Jacques Villon—the London Ruins series, for example, and subsequent work—he talks about his impulse in those years to incorporate elements of Villon's technique into his own art. And even after that point—when he later became deliberately un-Villonesque—the Frenchman

was significant as the father figure against which Cleve rebelled.

In 1944 and '45, Cleve could walk from his billet in Neuilly up to Villon's house and studio in Puteaux, on the outskirts of Paris. Having discovered that his gracious hosts had spent their month's ration allowance on the single meal they gave him on his first visit there, Cleve brought along whatever he could provide from the army mess on future occasions. Villon and his wife, Gaby, instantly impressed the young soldier even more with their personal qualities than their artistic skills. They were "gentle, highly cultured, humor-loving, totally unaffected, so ingenuous. I saw Villon first as a rare human being; somewhat later I realized he was a master."

Cleve became part of the Villons' life. "I spent every weekend with them. The Villons were wonderful to me. They took me to meet Camille Renault, a 450-pound restaurant owner—of whom Jacques Villon had done several portraits." Later Cleve also made a large portrait at Renault's request, which he swapped for a sizable credit at Renault's restaurant. It was more than a decade later when, as newlyweds, Cleve and Francine finally used up the rest of the credit.

Working for the army at night, writing reports based on information from intelligence officers, Cleve was supposed to sleep in the morning, but he managed to get along on only a few hours of rest and spent his days painting. He and Jacques Villon made portraits of one another. Cleve spent many of the daylight hours two or three days a week in Puteaux. And on other days he studied in André Lhote's studio.

It was Jim Davis, his Princeton teacher, who had urged Cleve to turn to Lhote. The experience was rugged but beneficial. "Lhote would come into his atelier once a week and give you a violent criticism of how horrible your work was. But my palette began to lighten up under his influence. As a student I always became a docile disciple of my teachers, just as I had been a docile son. I just gave them back what they wanted. As a result I matured very very slowly." ("The aggression came out in the painting," interjects Francine, who has been listening to our conversation.)

"Now I feel that in Paris I had a relapse of my abilities. I was too busy trying to take in the whole School of Paris. I lost my own way of working and ate the art of others. It took me a long time to get over the impression these marvelous artists made on me. I was still trying to paint like Villon in the late fifties."

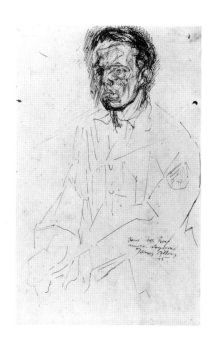

ABOVE:
Jacques Villon.
Portrait of Cleve Gray.
1945. Ink on paper.
Collection the artist

RIGHT:
Portrait of Jacques Villon.
1945–50. 42 × 34″.
Oil on canvas.
Berry-Hill Gallery

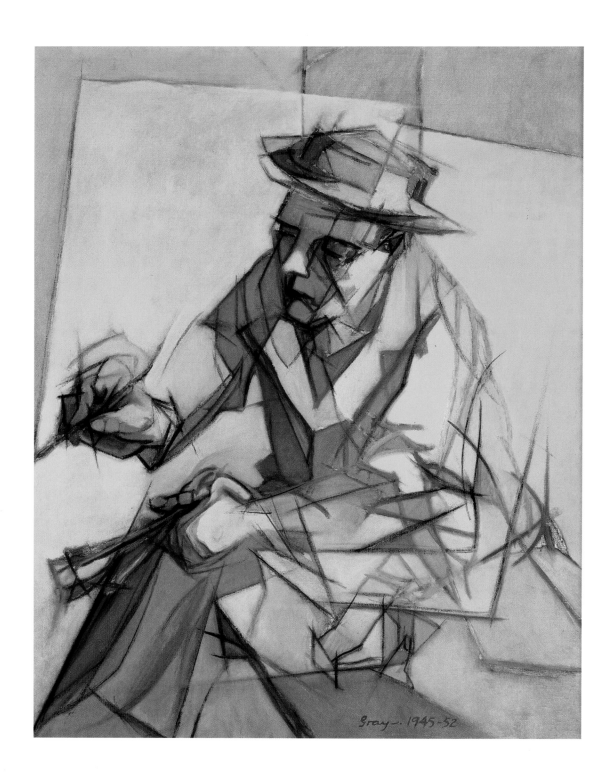

But for all of the self-deprecation implicit in this analysis of his own artistic education, Cleve made considerable strides through this exposure to the classic tenets of the Paris School. "They were the ones who taught me that values and intensities were very different things. . . . [Lhote] usually scraped my whole painting off. I didn't mind this because I was learning something. I love to be well taught. Francine's the same way."

In truth, Cleve was by no means the blind acolyte he makes himself out to have been. His painting of these early years is clearly of a time and place, but it reflects considerable know-how and has a spirit of its own. Lhote steered him in that direction, but the young artist knew what to do with these new possibilities.

"Villon and André Lhote taught me the difference between color *value* and color *intensity*. Values range from white to black. Hues have their own level of value as well as of intensity. Yellow, for example, is very high in value—nearer to white—but is most intense at a lower level of value, that is darker. The blues, the greens, the violets are closest to the middle range of value when they are at their most intense hue. Each hue has its most intense activity at a different level of value. Villon showed me a color wheel made by Rosenstiehl. In later life, he liked to have his hues at their most intense.

"I wanted, perfectly frankly, to get as close to Villon's painting as I possibly could. This meant getting color as intense as possible; I, too, got a Rosenstiehl color wheel for myself in Paris. And simplified the line, as the Cubists did—I don't mean only Braque and Picasso, but also the Section d'Or, people like Metzinger or Gleizes. And it had to be in strong color because Lhote had said to me, 'You paint like all Americans, black and white.' I wanted to get away from this."

That remark of Lhote's had made Cleve smart when the Frenchman initially said it to him. At the time, "Lhote stormed, slashing paint over what I had worked on all week." But the blast had its effect: "In this way I learned about color as the School of Paris understood it."

Villon took over where Lhote left off. "The French school was trying to teach equal values of color; Villon added to that equal intensities of color. I thought values and intensities were the same; I had not, until then, understood the distinctions between them. Villon had me read Rosenstiehl's book on color and study the Beaudeneau color charts; he also had me searching for and finding every possible book on dynamic symmetry."

But the rigorous training Cleve received in Paris had an unexpected result. When, early in

Self-Portrait (in the Army).
1945. 14 × 11".
Oil on gessoed board.
Berry-Hill Gallery

39

1946, the renowned French gallery Durand-Ruel mounted an exhibition of work by selected American artists in Paris, included were about six of Cleve's works. And, above all, he had earned the respect and affection of the Villons. "When I went to say good-bye, Villon handed me a brown paper bag; I thought Gaby Villon had made me a sandwich for the plane trip. When I opened it later for dinner, I found a jewel of a sandwich-sized painting: *Le Piano à Quatre Mains.*" This gem still hangs on the wall of the living room where Cleve and I often meet before going out to the studio.

Cleve did, in fact, manage to meet Picasso in that same time period, just after the liberation of Paris. "I just barged in, as an American soldier. I was the first GI Picasso saw at his flat on the rue des Grands Augustins. Sabartés opened the door. I said I was an artist and Picasso was my hero. Then I stood there and waited for six or seven minutes. Finally, I followed Sabartés up a narrow staircase.

"Picasso had just gotten out of bed; he was still wearing his BVD's. Sabartés put his shirt on him, one arm at a time, first one sleeve and then the other. It was like a Louis XIV *levée.* Picasso was looking at the newspaper *L'Humanité* in his free hand. There was a large photograph of a Russian tank on the front page. He told me how much better the Russian tanks were than the American. He was very aggressive.

"He then withdrew his aggressiveness for a moment and said, 'Oh, those are wonderful shoes you have on,' pointing to my GI boots. I was trembling and couldn't regain my aplomb; I didn't react quickly enough to say, '*Cher maître,* please let me give them to you.' Anyway, we were not permitted to give away government property, and I didn't want to walk across Paris in my socks.

"Then Kahnweiler arrived; he gave me a wicked frown. He was there to see Picasso's new paintings. So I went with them into the next floor studio, too. Most of them were astonishing heads of Dora Maar.

"Picasso terrified me. I didn't like him, and I never returned." Picasso's sensibility bothers him still. Cleve feels that however masterful he was as an artist, Picasso views life in a way that requires him always to deprecate. "What I object to about Picasso is that he was a destroyer. He was a genius; his work is fascinating and exciting; but in the end he built a structure of hatred."

I have discovered by now that this distaste for negativism is fundamental to Cleve Gray's perspective on the world, whether he is discussing military tyrants, Picasso, or the art of Bruce

Naumann. Cleve has unabashed admiration for Picasso's technique and for his brilliance; by his own account he was trying to make little Picassos when he was at Andover because there was no question as to who the genius of the twentieth century was; but he cannot warm up to Picasso as he warms to Matisse or some of his other favorite artists.

"In my early years, before I met Villon, I was certainly dominated by Picasso. But all of art interested me then: Kandinsky, Braque, Bonnard. I loved Duchamp's early work—and El Greco. There are structural qualities in the work of all these artists that are valuable to the process of abstraction."

Whatever his tastes, the young soldier was getting the most he could out of his situation. In the same period when he visited Picasso, Cleve also met Gertrude Stein. "Alice Toklas answered the door when I rang the doorbell. I thought she looked like a mongoose, but within seconds I found her endearing. Then out came Stein, looking like a mountain, just like the Picasso portrait of her hanging right there to her left in the living room.

"They gave me tea. They'd just come up from the South, I was the first GI they'd seen in Paris and they were very excited, they treated me like a long-lost relative."

A short while later, Cleve helped to organize the first talk Stein gave to the GI's, under the auspices of the Red Cross. "In the same circular, cryptic manner in which she wrote, she spoke about what it meant to be an American, and the GI's loved it."

After working in Paris for several months, Cleve got discharged from the Army there and, with the help of his father's friends, got on the first civilian flight home. By the end of 1946 he was happily back in New York.

"I was so glad to get home and out of my army clothes that I got undressed in the elevator on the way up to my parents' apartment. A few days later I telephoned Marcel Duchamp with messages from the Villons."

So began Cleve's new life in 1946. Years later he would end up translating Duchamp's *A l'Infinitif*, but for now he would focus above all on his own painting. In studio space over a grocery on 106th Street he painted his first really personal series of pictures: the London Ruins.

The realities of war inevitably matured Cleve as a man; more surprisingly, they also matured him as an artist. Having been sent to London in 1943, he made drawings (page 44) in the aftermath of the blitz that resulted several years later in his most original paintings to date

(pages 48 and 49). Beyond displaying the relentlessness of his wish to make art—to keep a visual and emotional diary of some of the major sights and experiences of his life—his London Ruins paintings were a breakthrough.

We look at these paintings together one morning in the studio. Although Cleve did these oils from 1946 to 1948, when he was back in New York in that studio space over the grocery, they look to me as if they had been painted while he was standing on London sidewalks staring at the rubble. Between the time Cleve drew the sketches in situ and the time he created these paintings, he had made some giant technical and aesthetic strides. But what matters most about these remarkable oils is the way they bring us face to face with the startling truth of the blitz, while succeeding as works of art.

As we look at these renditions of destroyed buildings, Cleve reminds me that he worked for the army at night. "In the daytime, I would walk around London and draw. There was no possibility of painting, but I bought a pad of paper and some colored pencils, and I went around drawing the ruined buildings." His peregrinations sent him marching along Green Street, and to places like Portman Square at the heart of central, civilized London. "I was always struck by the pathos—the tragedy of the human lives that were lost, the centuries of work destroyed." The misery caused by the recent bombing, as well as the beauty that the violence destroyed, emerge in tandem from this first major series of paintings.

After studying Cleve's images of doorways and rubble, of well-constructed walls and of their adjoining detritus, I comment that he has painted the destruction in upbeat, even enticing, colors—a juxtaposition I find fascinating. This slightly ironic approach was, he explains, very much part of his plan. "I think my reasoning was, if the subject matter is desolate enough, the message of the work is helped by the quirky disparity between the message and the color. Those tones serve as an enticement to look at the painting rather than as a repellent. That's not always a very well received idea, though, because people expect you to use more direct means to deliver the message. But in London you would look into some of the most beautiful interiors stripped of their outside wall. And they really had rich colors."

We consider one of the images in which a staircase seems to link nothing to nothing. "The spiral movement of the staircase has such evidence of lives having been lived," Cleve points out. On the other hand, of course, the essential shell of the dwelling has been shattered irrevocably. "I saw a painful tension between the beautiful and the horrible." That real life dichotomy would remain central to the emotional range encompassed in Cleve's art from then on.

III

It was with the London Ruins paintings that Cleve began to get on the artistic map in America. Alfred H. Barr Jr.—the influential founding director of the Museum of Modern Art—came to see Cleve because of these paintings, and "liked them very much. He asked me to have six sent to the museum. I was under the impression that they would acquire one."

Cleve suddenly grows particularly self-critical, telling me that not only did he mature late emotionally and artistically, but that he was slow in coming to his senses about how to handle an artistic career. His first error, by his account, was that "I showed Barr my paintings in my parents' Fifth Avenue apartment, which was a mistake. I should have shown them in my studio over the grocery store, which was just the atmosphere Barr would have liked. But I matured very late: as a human being, as an artist, and as a careerist.

"The paintings went down to the museum, where they were stacked in the hallway outside Dorothy Miller's office—where people would regularly bump into them. Alfred Barr had said, 'We have a small fund for these,' but I didn't recognize that what he wanted was for me to donate at least one of the paintings. I was too proud. I didn't want to be seen as someone who would pay my way into a museum collection, and eventually those six London Ruins paintings were returned." It was only some fifty years later that Cleve's work actually entered the collection of the Museum of Modern Art, thanks to the generosity of Agnes Gund and Daniel Shapiro, who purchased *Sable-Vested Night* for the museum (page 108).

In 1947, Cleve took a studio on Charles Street in Greenwich Village. There he produced a series of paintings of the Holocaust so effective as to be barely tolerable (pages 45–46). I am aware, on the morning when he has pulled these large and brooding canvases out into his studio, that my instinctive reaction is to look and then to turn away. My involuntary flinching is a tribute to the success of the art.

Cleve, of course, had not actually seen the evidence of the Holocaust as he had seen the

Four drawings of
London Ruins.
1944. Each, 8 × 6½".
Colored pencil on paper.
Berry-Hill Gallery

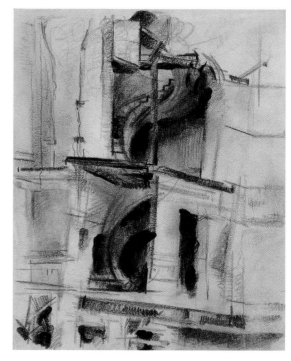

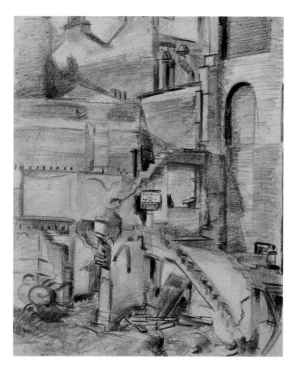

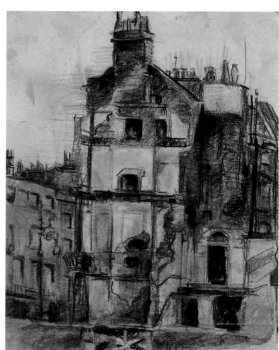

destruction wrought by the blitz. But he had studied newspaper photos and paid close attention to the horrendous reports. The theme of Nazi atrocities was hardly new to him; anti-Semitism, both local and global, had been sharply on his mind ever since his days at Andover. In the paintings, he faced it head on, evoking the Furies as well as the corpses, using glue to add mass to the paint, creating blobs that became hideous vultures swooping down from the tops of the canvases. He grapples here with the atrocity of emaciated bodies and wholesale killing.

Refuse.
1947. 48 × 51″. Oil on canvas.
Berry-Hill Gallery

And while in recent decades more and more artists have taken a similar approach to the Holocaust, in those years immediately following the war most people wanted to avoid the subject. "The general attitude of people at that time was that they didn't want to hear about it, much less see it," Cleve says sadly.

While a few people greeted Cleve's work with keen enthusiasm, others responded with mild indifference. He faced the problem of finding a gallery. Fortunately, Cleve had met the writer Francis Steegmuller at the Villons' after the end of the war; back in New York he and Francis's wife, Beatrice, a fellow painter, shared a model. The Steegmullers thought enough of Cleve's work to introduce him to Pierre Matisse and Kurt Valentin, two of the leading art dealers of the day. Matisse declared the paintings "good, but after all, not that original. There's really nothing new in your work. It's right out of Delaunay." Kurt Valentin, however, recognized the talent. Valentin himself had a policy not to show young American artists—with the exception of Alexander Calder—but he mentioned Cleve's name to Jacques Seligmann, who was opening a new gallery.

In December 1947, Seligmann gave the young artist his first solo show. Sam Hunter, an important critic who was particularly astute about contemporary art and who was then writing for the *New York Times*, labeled the exhibition "an auspicious first." More importantly, Henry McBride, then as now considered one of the great seers of the contemporary American art scene, wrote about them in the *New York Sun* the day after the opening, declaring,

Cleve Gray, now showing in the Jacques Seligmann Galleries, is an impressionist by birth and with such strong leanings toward the abstract that a little encouragement might push him wholly into it. He has been working in London where the ruins are themselves abstract and where all that is necessary is to watch one's colors and compose the shadows. These things Mr. Gray accomplishes with skill and taste, for his impressionist palette serves him well and his sense of picture-making is secure.

Cleve may have blown the chance to have the London Ruins enter the collection of the Museum of Modern Art, but they were very well presented in Seligmann's second Gray exhibition. Each of the twelve canvases bore a general title (*The Spiral Staircase, Reconstruction, Charred Walls, Harlequin Shadows*) and a more specific subtitle as well (*Green Street, Grosvenor Square, Lower Berkeley Street, Great Cumberland Place*). Edward Alden Jewell, the senior critic at the *New York Times*, picked *The Spiral Staircase* for his representation in the Grand Central Art Gallery's "The Critic's Show," which featured it as the catalogue's frontispiece.

Seligmann mounted almost yearly exhibitions of Cleve's work in the autumn time slots considered especially desirable in the New York gallery scene. The knowledge that these shows would occur gave the young painter added support and impetus. Cleve had returned to Tucson and taken up residence again at Eleven Arches with the generous patronage of Louise Grace, but he came east for the shows.

"The main goal of my work at that point was to try to reconcile Western with Oriental art. I'd returned to that earlier preoccupation, which had been dormant during the war years. I did an awful lot of shuttling back and forth. Cubism was always at the forefront. I remember Theodoros Stamos saying to me—although this was not until the late 1950s—'Your problem is to get rid of Cubism.' But gradually I moved toward less constrained brushwork."

In 1948 Louise Grace invited Cleve to accompany her and some friends on a trip to Europe, but she was felled by a stroke shortly before the journey. After she recovered, she insisted that Cleve go anyway, generously funding his travel. Just after he arrived in Paris, she had a second stroke and lapsed into a coma. He returned to the U.S. immediately, but his friend and patron was too ill even to be seen. Cleve went back to Europe and soon ended up on his first trip to Italy, drawing voraciously with his colored pencils as he and his friends—George

Carrion.
1947. 48 × 51".
Oil on canvas with Casco glue.
Berry-Hill Gallery

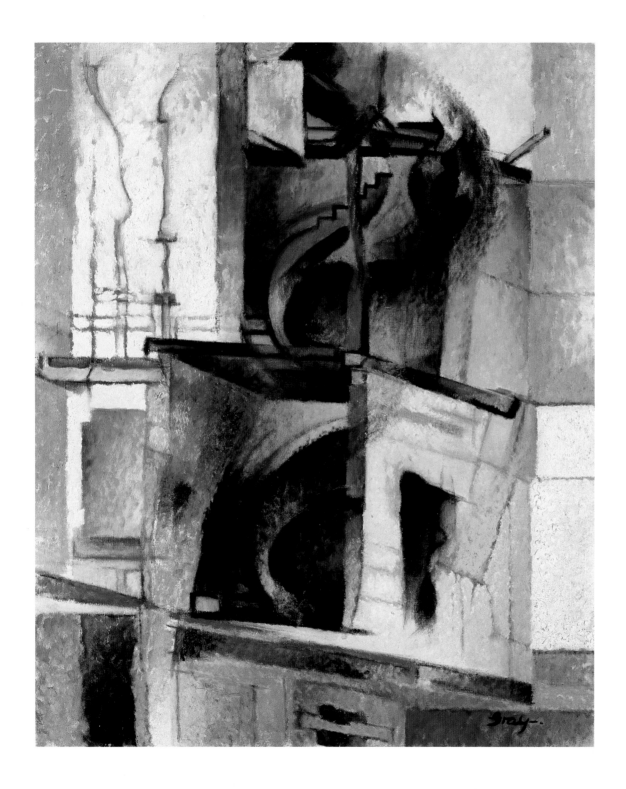

LEFT:
London Ruins #1
(The Spiral Staircase).
1946. 42 × 34″.
Oil on canvas.
The Wadsworth Atheneum,
Hartford, Connecticut.
The Ella Gallup Sumner and
Mary Catlin Sumner
Collection Fund and The
Alexander A. Goldfarb
Contemporary
Art Acquisition Fund

OPPOSITE:
London Ruins
(Charred Walls).
1948. 34 × 42″.
Oil on canvas.
Berry-Hill Gallery

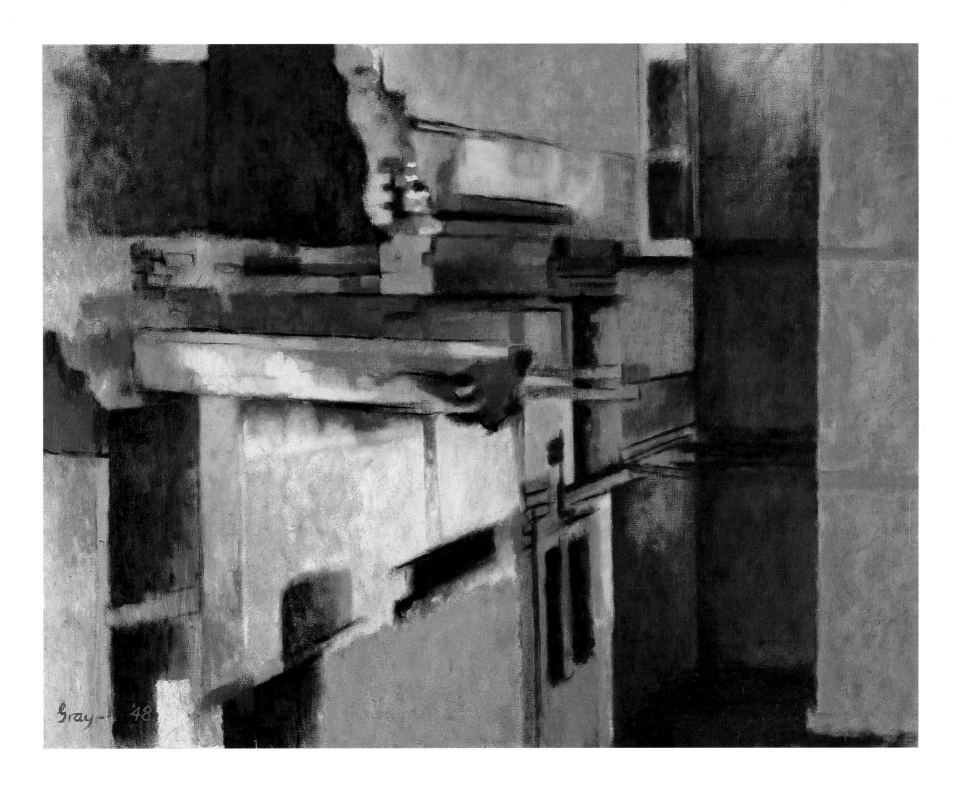

49

Rowley and Rowley's companion, Marion Mackie—sought out Byzantine mosaics and work by Ambrogio Lorenzetti and Piero della Francesca. He was as enraptured as when he gathered those colored silk ribbons into his hands as a small boy. "I ended up in Venice, where I was so captivated that I canceled the remainder of my plans in order to remain in that enchantment. I hired a sandala—a small gondola—and drew and drew." This is the man whom I find in his Connecticut studio surrounded by a sea of cans of acrylic paint, content to apply it to canvas day in and day out, still in that transport afforded by color and light.

When Cleve returned to New York in 1948 following that European journey, he embarked on the way of life he has lived, with variations, ever since. "Returning to New York I could not stand its frenetic activity." He did not, however, want to go back out to Arizona alone. Louise Grace remained in a coma; he was never to see her again. She passed away in her home in Great Neck.

It was then that Cleve came upon the house and farm in Warren, Connecticut, "with which I fell in love passionately" and where he has lived ever since. The core of the charming, rambling house had been built in 1799 and remodeled to a comfortable standard in the 1920s. The property came with 135 acres of land (at a price of twenty-five dollars an acre). Its handsome structures and rolling lawns and surrounding woods provided a haven. "With typical generosity my parents gave it to me on my thirtieth birthday." Although the senior Grays traveled much of the time, when they needed headquarters they stayed there as well. Cleve, meanwhile, was painting in a more directly figurative style than previously. "My work at this time reverted to greater realism, perhaps because, living in nature as I did, I was more than ever divorced from current New York fashion." He managed to earn a bit of money painting portraits on commission and selling landscapes.

His 1949 exhibition at Seligmann's was devoted to paintings of France and Italy, the subject matter ranging from the Eiffel Tower to Mont St. Michel to the island of San Giorgio Maggiore in Venice. We look at Cleve's 1948 *Gardens of the Villa d'Este* and his 1946–48 *Portrait of Jacques Villon* as well as other canvases from that period. "I was thrilled by the Villon concept of light, which is surprisingly Rembrandtesque but in intense colors," Cleve explains to me. "The color is the reverse of Rembrandt's palette, but the light falls on certain defined areas the way that Rembrandt's does."

Cleve's 1950 exhibition with Jacques Seligmann bore the title "Youth and Age." His new-found champion, Jacques Barzun, wrote the catalogue text. Barzun identified the young artist

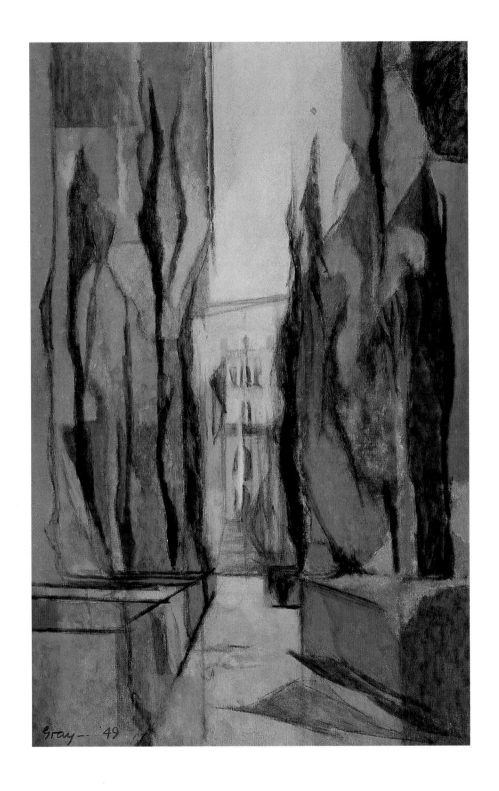

Gardens of The Villa d'Este.
1949. 47 × 30″. Oil on canvas.
Columbus Museum of Art. Museum
Purchase: Howald Fund

as belonging "to the lineage of the Cubists. . . . Whatever his subject matter, his work proceeds from an analysis of the solids which compose the subject to a reconstruction that proves them solid indeed—real, working, not disintegrating. . . . The colors, too, that Cleve Gray uses are evidently chosen in the belief that the world is young, bright, immediately beautiful. . . . His delicacy resides in unobtrusive details, such as the torsion of the hand of Hipparchus, or the faint frown on the boy's face bent over the sword. Yet even here we have the delicacy of strength rather than of fashionable sensibility. . . . Cleve Gray . . . may feel confident that his wonderfully animated work, already abundant and always deliberate, will win and retain a majority of enthusiasts."[6]

The work that Cleve produced for this exhibition, and the vein in which he continued into the early 1950s, has a spiritual intensity and a visual lightness. A lot of it is now in museum collections, and many paintings were sold at these shows at Seligmann's; but when we look at these earlier canvases, I am struck by the degree to which he had imbibed the technique of Cézanne-Villon-Lhote and applied it in a way reflective of both his own emotional interests and his consistent passion for oppositions.

A 1952 portrait of Gustav Mahler combines the intensity that is reached in the composer's symphonies with the ease and dexterity of a painter who wields his brush much as a conductor moves his baton. The confluence of climates is similar to those London Ruins painted six years earlier; Cleve has a remarkable ability to abut light and darkness, just as he sees life and death as part of a continuum, not as forces antithetical to one another.

"I loved Mahler's music," the artist tells me. "I still love it, although now I much prefer chamber music. I started with the late Beethoven string quartets, which led me to Bartók, which led me to Shostakovich." Much later, in 1987, Cleve made four heads of Anton Bruckner; in 1995, eight years later, he painted a series of Bartók heads, in which the power and sense of tragedy in the music become visible (pages 126–27).

In Connecticut, Cleve opted for a way of life unusual for a young American painter of that decade. "Succumbing to bucolic intoxication, I took a short course in agriculture at Cornell. In 1950 I bought a modest herd of Aberdeen-Angus cattle. From my childhood on I had yearned to work with and watch animals, to learn how they behaved, how food grew, what the earth did in the cycle of a year." And although he had a helper on the scene, he still made the key decisions—whether rain prospects would affect the haying schedule, whether it was a good

time to breed a cow in heat, and other such issues quite atypical of a painter's life. He sold the herd eight years later, but initially, between farming, working, and reading, he thought he was in want of little.

He also seemed to have a native gift for working with animals. "I had friends who had a large working farm nearby with a fancy British manager and a considerable amount of helpers. I'd sold them an Aberdeen-Angus cow, and one evening I had a telephone call from them that their staff was not able to load the cow, who was indeed rather wild, into a cattle truck; could I help them? I went over immediately and asked for a halter. The manager said, 'You can't put a halter on her, she's too wild.' I reached out my hand for the halter and went up to the cow and spoke to her and slipped the halter on her head. My friends and their manager were bewildered; the cow offered no opposition. I led her up the ramp to the waiting truck."

Although those "bucolic" interests are now pursued on a very different scale by the Cleve Gray I have come to know, his and Francine's emotional involvement with their dogs, their extensive vegetable gardening, their imaginative cooking with homegrown produce, still speaks to their continuing interest in the process of nature. That understanding of how components yield end results, the careful combining of elements and attention to detail, had many parallels, of course, to the act of painting.

On the other hand, in some of our conversations Cleve points to his chosen way of life as a reason for what he perceives to be his outsider status in the art world. Just as he sensed that he should not have let Alfred Barr see his parents' posh digs on Fifth Avenue, he still has a certain self-consciousness about being someone who lives with a degree of luxury, with a taste for certain comforts, in a milieu where struggle, or the appearance of struggle, have often been identified, generally erroneously, with being "the real thing."

As usual, the person on whom Cleve is hardest in his commentary is Cleve himself. "I've often been mistaken for a rich boy who could buy his way in," he says to me one afternoon in his studio, his face almost mournful. "A lot of people thought I was very arrogant. I also get told I'm too modest—I get both reactions. I'm not modest; I try not to be arrogant; if I seem that way, it's because I believe in what I'm doing. People tend to size you up too quickly. Well, I've been painting longer than most anyone. I'm very self-critical. I'm certainly the biggest critic of my work; I spend more time with it than the others do."

Yet Cleve sees the choices he has made for his way of life as vital to the serenity that allows

OPPOSITE TOP:
Gustav Mahler. 1952.
42 × 28". Oil on canvas.
Berry-Hill Gallery

OPPOSITE BOTTOM:
Head of Béla Bartók #6. 1995.
66 × 46". Acrylic on canvas.
Berry-Hill Gallery

him to focus on his work. "I undergo extensive material and psychological struggles, but I have to admit I'm not a suffering artist. I make plenty of mistakes, and they make me temporarily unhappy, but I know I can defeat them. My life is so blessed in every way that to talk of my suffering would be absurd, unholy."

Yet in reality, the Grays, who, "until arthritis and advancing years caught up," did every bit of work on the upkeep of their property themselves—the mowing, the woodchopping, and house painting—have been struggling with serious financial problems for decades. This was in part caused by their need to support Cleve's mother for many years, until her death in 1992 at the age of ninety-five—and in part by their desire to remain in the house in which they began their life together and raised their sons and on which they look, in Francine's words, as "a matrix of our selfhood."

"I always ask myself, 'Why am I painting? What's the use of this activity? It does nothing for the world.' Maybe every painter has that problem. But if I reconcile myself to those questions, then the great difficulty has really been in knowing *what* to paint.

"I destroy an entire painting if there's a mistake; I'd say I've destroyed a quarter to a third of all my work, and I will get rid of many others that are not worth keeping. You have to judge a painting by what a painting wants to be.

"There are always so many questions. This color or that? What kind of line? Or none? What if I used wide brushes, sponges, or blotting paper on the surface? Blah. Blah. This is what I always tell art students: 'You've got to keep questioning, or challenging yourself. Don't be satisfied.' "

Cleve's ruminations often touch on the difficulty of blending daily life with his wish to focus entirely on painting. On another occasion, he points out to me that even though his daily garb is paint-splattered corduroys, in public he always dressed "like a gentleman" and didn't feel the need "to approach the world in costume."

"Ironically, this is the mode of artists of the '80s and '90s," Francine points out. "Stay out of fashion, and you'll eventually come back into fashion. As Isaac Bashevis Singer put it, 'Today's news wraps tomorrow's fish.' "

Cleve has never had to mask himself as a bohemian. In fact he finds his sense of order and discipline a comfort and aid. Yet Cleve sees his stylistic choices as another reason why in the past he has not always been taken as seriously as he would like. "I think I was initially looked

on as a satellite from Europe. My work and my bourgeois lifestyle have always had a French aspect to them."

The pivotal meeting with Francine du Plessix occurred after Cleve had moved to Connecticut. Here, too, there was a paradox. What turned into a great romance and a lasting marriage was not love at first sight. Their first meeting gave little indication that Cleve and Francine would evolve into the couple my wife and I know them to be: each one the other's most loyal supporter, the two of them remarkably in accord on issues ranging from grandchildren to politics, films, and books. Their camaraderie and mutual devotion is palpable to friends and acquaintances, in spite of the willingness of each of these strong-minded individuals to challenge the other on any issue at hand.

Francine and Cleve Gray
at St. Tropez, c. 1960. Photograph by
Alexander Liberman

Starting in 1947, Cleve had been a close friend of Muriel Oxenburg Murphy, a young assistant to Robert Hale at the Metropolitan Museum, who had come to his first exhibition. In the early 1950s, Muriel began talking about "a lovely, wonderful French girl who had her hair cut strikingly short"—in a style that Francine in retrospect calls "a Joan of Arc bob."

Sitting at their dining room table with me forty years later, Cleve and Francine take turns recalling that seminal meeting at Muriel Murphy's New York apartment. They concur that they did not particularly take to one another. Francine, who was then majoring in philosophy at Barnard, thought he was "a silent icy guy, with a smug Cheshire cat grin, who had no desire to talk about Hegel." Cleve was put off by her boyish haircut. "I had traditional notions of femininity." Francine comments, "He was quite content with his solitary way of life: painting full-time and attending to cattle."

Then came an interlude of some five years in which Cleve began to feel the necessity of making a more complete life for himself. Louise Grace had left him her Tucson property, which he later had to sell; and in 1955 Cleve's father also died. Cleve subsequently encountered Francine again at the home of Barbara and Stanley Mortimer in Litchfield, not far from Warren. She had grown her hair, and at first he didn't recognize her. This time he was very intrigued. "She was beautiful, but seemed very sad; I wondered why. When I met her, what fascinated me was her unhappiness. Why is that beautiful girl with long hair and with those extraordinary eyes unhappy?" As he discusses their early connection with me, I have the

impression that Cleve initially was somewhat in the irresistible role of savior.

Francine describes herself at the time of that second meeting: "I was convalescing from an extremely serious case of mononucleosis and hepatitis which had required many months of bed rest. I had worked as an editor and journalist since graduating Barnard, but was under orders not to work for another whole year and was going through a vocational crisis—wondering whether painting, for which I'd always had a gift, might not be my real vocation, rather than literature.

"On our first date Cleve took me to a horse show, which I hated, and to which, as I've often teased him, he had free tickets. I asked him whether he would give me painting lessons, and he agreed." Cleve adds, "The lessons were also free."

In one of those slight variations of personal history endemic to human nature, Cleve explains that he "joined her in painting sessions in which I advised her on her work. Soon I got to love her, and I asked her to marry me. I was thirty-eight; she was twenty-six. We both had a lot of growing up to do; we helped each other." Within six months of that second meeting at the Mortimers', they were married—on April 23, 1957.

Portrait of Francine du Plessix Gray.
1957. 11 × 8". Oil on canvas.
Collection the artist

Francine was also a writer, torn between the two vocations. Cleve credits himself with helping her get back to writing in the early years of their marriage. In 1963, Francine wrote a memoir called "The Governess" that Cleve sent to his friend William Maxwell, who was then the fiction editor at the *New Yorker*—and to whom Cleve had been very close for over a decade. Maxwell was delighted with the story and had it immediately published. A decade later it became the first chapter of her novel *Lovers and Tyrants*.

Francine in those years was struggling "between being a wife, a mother, and a writer in a new situation." Her writing then tended to be extremely "retrospective and self-critical," Cleve says. "Trying to write personally, she was always crying." Cleve had for a few years served as the book reviewer for *Art in America*, and "got her to take the job" from him. Book criticism enabled her to break free from her introspection.

The marriage had as significant an effect on the direction of Cleve's work as on Francine's. Here, too, the personal life and artistic development are inseparable. "If the first half of my life was colored by my mother and Louise Grace, the second has been polychromed by my wife. Her parents, Tatiana and Alexander Liberman, became close friends." Alex—actually Francine's stepfather, although for many years she has referred to him as her father—was the chief artistic director at Condé Nast; Tatiana was a renowned milliner. They provided intellec-

tual conversation that increasingly opened a world to Cleve that he had missed in his own childhood. "These were people who could talk about most every aspect of culture. Their world was all new to me, and it intrigued me." So although Cleve and Francine kept a distance from the fashion-world side of Alexander and Tatiana Liberman's lives, they benefited from their support and friendship.

"I had acquired a family most of whose passions were parallel to mine. Conversing with Alex Liberman surely helped direct my work to become increasingly abstract. This was a period when I had absorbed color structure and Villon's color theories as fully as I could. I painted, in fact, like a disciple. I was not risking myself at all in my work; some of this restraint may have been due to financial pressures which were then at their height. In the late 1950s I sold the Angus herd and the art objects I had collected in Paris in the 1940s to help pay bills."

In my view Cleve is unjustly hard on himself in this evaluation. While he gleaned a lot from Villon—about whom he wrote a major essay for *Perspectives USA* in 1953, in which he declared that "the painting being done by Jacques Villon ranks with the very finest creative art of modern time"[7]—he took Villon's method in his own distinct direction. Villon would hardly have delved into the unsettling subject matter of the London Ruins or Holocaust paintings. As for Cleve's notion that he was not risking himself: surely to choose the painting life, to attempt to assimilate the lessons of Marin and Cubism, to transform his concepts of color value and light intensity, to merge the wonders of ancient Chinese art with the liberating possibilities of abstraction, were all steps that would qualify as risks. From his Apocalypse series, the 1953 *Which Was, and Is, and Is to Come* (page 58)—in the collection of the Metropolitan Museum of Art—shows the ability to take many of those chances and achieve with resolution the goals that others might find disparate. "The eyes within and without," and the four evangelists, are part of the subject matter that comes directly from the Revelations of St. John. In *The Harvest of the World Is Ripe* (page 59)—the reference is also to St. John—and in *Ghandi* [sic] *Praying* (page 60) the artist similarly invests traditional subject matter, a portrait, with intense emotionalism expressed through the loaded brush.

One June morning, we look at Cleve's 1958 *Maternity* (page 61), a painting inspired by Francine, which he painted the year after they were married. The canvas remains a quintessential exemplar of what he achieved in the Villonesque mode. In the painting, a woman resembling Francine is holding a baby—wishful imagery, since Francine, to her considerable

RIGHT:
The Harvest of the World Is Ripe.
1954. 80 × 50″. Oil on canvas.
Sheldon Memorial Art Gallery,
University of Nebraska,
Lincoln. F. M. Hall Collection

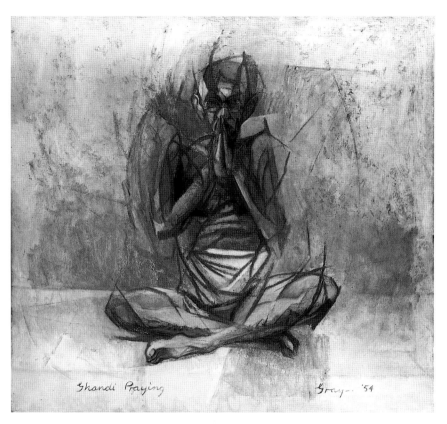

Ghandi [*sic*] *Praying.*
1954. 50 × 50″. Oil on canvas.
Present whereabouts unknown

despair, had recently been told by an inept doctor that she would probably be unable to bear children. (This prediction proved wrong when she became pregnant the following year.) The portrait combines structure with exuberance. This was a period in which Cleve made drawings preparatory to everything he painted, and when he was consciously affected by various sources. In this case a part of his inspiration was Matisse's *Woman on a High Stool*, which he had seen at that early show at the Museum of Modern Art. Yet if he turned to Matisse for ideas on posture and structure, he transformed the mood of his source through his own intense, sunny, Villonesque palette.

What is clear in *Maternity* applied to all of Cleve's work of the period: his preference for structure and rationalism, the pervading sense of culture in his work, the European sensibility. Consistent with that, Cleve had developed his own strong views about the current trends of American art. He kept a deliberate distance from the art scene, to which he certainly could have had easy access through his father-in-law and other connections. "I didn't like the talk talk talk about art in New York. And I'm not a very sociable person, so I didn't go out of my way to join the art world."

Cleve was someone of consummate knowledge and intellect, so he was completely alert to the world he shunned even if he stayed detached from it. In 1959, he published a remarkable essay, "Narcissus in Chaos," subtitled "Contemporary American Art," that appeared in the *American Scholar*. Brave, unabashed, and completely original, it articulated the belief system central to his modest role as a writer on art and to his own painting.

"Francine and Alex Liberman said, 'Don't publish it! You're going to regret it.' Well, I've never regretted it. I have changed my mind, but I would hate to feel I've never changed my mind." Both the courage and the openness are hallmarks of the speaker.

"Narcissus in Chaos" reflects the same evangelical streak and powerful credo that I find in Cleve Gray today. Then as now, he excoriated the poor taste of the art world, calling for discipline and advocating art as a means of celebration.

In this essay Cleve states that the situation in contemporary painting had reached a dan-

ger point. "The new and the shocking in all arts are still so eagerly received that they are scarcely questioned so long as they are not academic. Branded as conservative and reactionary are any suggestions that order is intrinsic to art, that an artist has an obligation of aesthetic responsibility, that individuality should be disciplined. But if these standards are no longer reputable, what has replaced them?" It was a rhetorical question.

After referring to Pollock, de Kooning, Motherwell, Still, Kline, and Francis, along with the teachers Hans Hofmann and Stuart Davis, Cleve pronounced that "these painters have declared over and over, both in words and in paint, that they were not painting the visual world but rather their inner responses." He asserted that

this is a presumptuous program for an artist. It is presumptuous because it deliberately states that the visual declaration the artist makes is not about his conception of the visual world, but is only about his own individuality. The artist assumes that his own ego and unconscious are worth contemplating, are more worthy of contemplation than the objective world. Yet he will admit to you in the very moment he sets his unique individuality before you that he is saying nothing more than, "Here I am!"

This egotism—as Cleve labels it—is, of course, antithetical to his own beliefs. He goes on to criticize the espousal of disorder, and the predominance of personal reactions over a wish to evoke external subject matter. "It is related of Wu Tao-tzu, the Giotto of China, that one day he disappeared into his own painting of a landscape and was never seen again. In the contemporary American abstract expressionist action painting, it is the landscape that disappears into the artist. The unhappy spectator stares at an unintelligible vacuum."

Even though in our conversations Cleve would recant some of this—assuring me that he has come to love the work of Jackson Pollock and other Abstract Expressionists, those observations stemming from the tale of Wu Tao-tzu capture both Cleve's passions (for nature and its virtually religious evocation) as well as his most profound loathings (for extreme disarray, both emotional and visual).

In "Narcissus in Chaos," he voiced these beliefs with unabashed conviction. "What I am saying is that although the best work of the contemporary non-objective painters, such as Pollock's, may be agreeably decorative, it is nothing more. . . . The object of all great art, Oriental or Occidental, is to elevate the human spirit. . . . In its honest effort to understand

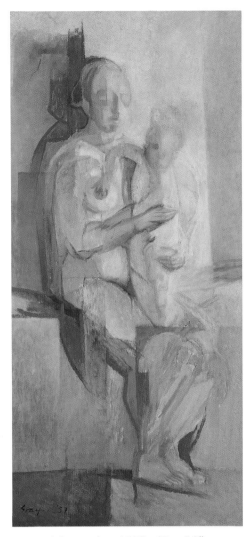

Maternity. 1959. 60 × 28".
Oil on canvas. Berry-Hill Gallery

Cleve Gray at forty. Photograph by
Alexander Liberman

OPPOSITE:
Cortez.
1959. 60 × 83". Oil on canvas.
Berry-Hill Gallery

modern art, let us hope that the American public will soon be shown more of the constructive and less of the capricious."[8]

Naturally, in his consideration of the art of others, Cleve saw their position in regard to his own. Just as in the world of his parents and the milieu of Andover he was a bit of a loner, that situation continued to pertain even when he was in his chosen arena of painting. Cleve has long held a stance counter to the trends of the time, and his position has always been fiercely independent. So reading "Narcissus in Chaos," we are not surprised that its author is the man who almost forty years later says to me, somewhat wistfully, "At least at the end of my life I'll get to have a book that is a record of my work. And when one thinks of the others today who get so much attention: Damien Hirst, my God!" Today we, and Cleve, may laugh at the courageous conservatism of "Narcissus in Chaos," but the convictions, and ardor, remain much the same.

"What I've done all my life is work against what I've done before. As soon as I realized I had gotten as Villonesque as I had become at that point—not that I was nearly as good as Villon—I started to move away. I immersed myself in something very different. It was getting too dry and too theoretical."

Cleve made the necessary breakthrough. "In *Cortez,* I began to make a break with Cubism and the Villon palette, and achieved a new sense of space." The painting has the dash of victory that its maker felt.

As was often the case, an outside influence inspired the change. Cleve has often steered the course of his art in direct response to something he has read, to music, to a political event, or a new landscape. This was one of those occasions when a trip launched a whole new development. "We went to Spain in 1958, for our postponed honeymoon, and I was thrilled. But my first Spanish painting dissatisfied me. Francine, in an effort to help, asked what had impressed me the most there. I answered, 'Black and white.'

" 'Then you must paint it that way,' she said." And so Cleve's work turned in a new direction; with less emphasis on color and more on structure. A new austerity replaced the School of Paris suaveness that had prevailed in his art of the preceding period. We look together at *Mosque in Córdoba* (page 65). "I was looking for structure in my more expressionist brushstroke," Cleve allows. "And I was also much under the influence of Japanese scroll painting. I was using lots of turpentine to make the paint more fluid—a practice I had to stop because oil paintings are easily damaged, and also because I was getting violent headaches from the turp."

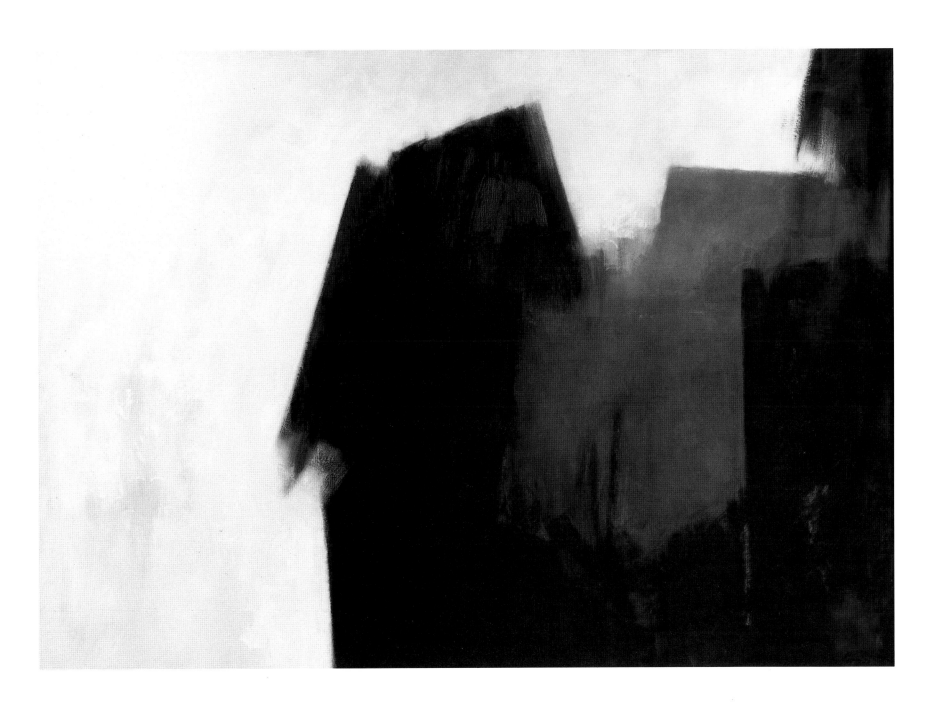

Mosque in Córdoba #2.
1959. 72 × 96″. Oil on canvas.
The Whitney Museum of American
Art, New York. Purchase
with funds of Friends of the Whitney
Museum of American Art

The paintings of the late 1950s represented a major move from the work that preceded them, but there was consistency in the variability. "All my life I've gone through this process of reversing direction. When I believe one direction is explored to its end, I like to reach out in another direction rather than continue repeating a solution. As I swing back and forth year by year, say from color to black and white, from line to pattern, from casual composition to tight structure, from the intuitive to the rational, I hope that, like a pendulum that eventually comes to rest, I will in the end find my own center of gravity."

The late 1950s was a time of productivity and success. In 1959, Francine gave birth to their first son, Thaddeus. The black paintings influenced by Spain were well received. An exhibition of them the next year at the Staempfli Gallery—then one of the most prestigious New York galleries in which an abstract artist could hope to show—nearly sold out. John Canaday reproduced *Mosque in Córdoba #2* in the *New York Times* to illustrate a review the critic labeled "Genuine Avant Garde," and the Whitney Museum of American Art bought the painting thus singled out by Canaday.

The Staempfli exhibition not only allowed Cleve for once to pay all his bills, but also, a few years later, gave him and Francine the means to go to their Connecticut neighbor Alexander Calder to acquire a sculpture. Calder was generous to his young friends, letting them take the piece of their choice for a very paltry sum, and joining them in Warren to help site the sculpture and then celebrate its installation with much merriment. (Years later, the sale of this piece would enable the Grays to pay their sons' college tuition.) Calder was one of the first artists since Villon with whom he made friends. "I had few artist friends as I don't particularly enjoy talking about art, and in any case, like many painters, I'm taciturn. But Francine is more gregarious, and she delighted in bringing me closer to the art world than I had ever been."

Later there were certain other artists who became seminal in Cleve's life. "A great exception to my dislike of art talk were my conversations with Barnett Newman. His insights were invariably inspiring and expressed with such imagination and wit that he opened up new areas of the human spirit to me." One evening in the mid-1960s the Grays and Annalee and Barney Newman went back to the Newmans' apartment after dinner. "He showed us his newly started series The Stations of the Cross. I was utterly overwhelmed and totally surprised, for until that evening I had not been entirely convinced by his painting." Newman suggested new possibilities to Cleve, perhaps in regard to spirituality and the potential religiosity of abstraction, and specifically with regard to the role of the vertical form, which began to predominate

in the younger artist's work.

But before the vertical assumed its strongest voice, Cleve took several other essential steps. His way of life in Warren was becoming increasingly fixed—in 1961, their second son, Luke, was born—and he and Francine set about to improve what would be their lifelong homestead, a place that would give them both the maximum ability to work as well as provide a felicitous atmosphere for family life. In 1962, Barnett Newman suggested that Tony Smith—who is now best known as a minimal sculptor, but was also a skilled architect—redesign the hay barn in Warren to serve as Cleve's new studio. This is the space in which most of Cleve's and my discussions take place thirty-five years later.

"The great space of the studio gave me a new and liberated sense of scale," Cleve explains. His freedom was also manifest in his choice of subject matter and the evolution of his technique—as is clear in one of the first major paintings he made there, *Reverend Quan Duc* of 1963, which was also his "first artistic response to the deepening political crisis in Vietnam." We look at this impressive canvas—both tranquil and disturbing—one summer morning. The world, of course, is historically so different, but many of the issues it raises are quite unchanged. Cleve explains, "Quan Duc was sitting in the middle of a square in a contemplative Buddhist position, cross-legged, and poured gasoline over himself. He lit it and turned to ashes."

I ask how literally the incineration was on Cleve's mind.

"Only that, and nothing but that," he replies matter-of-factly. "I think the blue is meant to be within his head or his spirit. I was very early in protesting the war; curiously, Francine was slower. I brought her into it. But from then on, she led me." As with everything else he tells me, I feel that Cleve is more accurate than most people in charting his own past; his mind permits neither illusion nor delusion.

"The self-sacrifice of Quan Duc became a focal point for me, and was something I could make a painting about. I was very much interested in the idea that you could give an overt meaning to abstract painting. I was very opposed to unstructured art—this is really very structured—but at the same time it exploded." The logic of those oppositions is essential to Cleve Gray.

In the early 1960s, Cleve had become a regular contributor to *Art in America*, at first writing book reviews, and then producing major articles on artists ranging from Picasso to Walter

Reverend Quan Duc.
1963. 60 × 50″. Oil on canvas.
Berry-Hill Gallery

Nureyev (Dancing "Le Corsaire"). 1963. 50 × 144". Oil on canvas. Addison Gallery of American Art, Phillips Academy, Andover, Massachusetts. Gift of Francine du Plessix Gray

Murch, on developments in printmaking, and on the latest gallery and museum exhibitions.

His own work, meanwhile, was showing the influence of further events and travels. "The great genius of ballet, Nureyev, made his New York debut at the Metropolitan Opera. The Libermans thoughtfully brought us to the opening night. Nureyev danced 'Le Corsaire,' a solo. By the end of the dance I was collapsed into my seat. The whole place went crazy; I have never seen such a manifestation of joy and excitement. I will never forget the energies, tensions, passions of that dance. When I got back to my studio, I had to try something on canvas that would celebrate the experience." Thus came the vibrant, ethereal, celebratory large canvas, *Nureyev*, of 1963.

In 1964, Cleve began to produce some stirring small paintings that came out of two trips he and Francine took to Greece on the yacht of shipping magnates Niko and Dolly Goulandris, close friends of the Libermans. The inspiration was both external and internal, as Cleve admitted in one of our studio conversations. The setting was exquisite, the conditions luxurious. But as is so often the case in life, the emotional circumstances were less felicitous than the surroundings. "It was, for me, a psychologically bad period—a strained time in our marriage." Getting up at 4 A.M., Cleve would sit on the bow of the fishing boat, watching the sun rise over the islands while his host diverted himself fishing with the crew; later in the day, he and the

Empyrean.
1963. 70 × 50″.
Oil on canvas.
Berry-Hill Gallery

rest of the guests would also explore islands and temples. But what one sees in these stirring, small canvases is the artist's personal turmoil more than any of those vistas. The art reflects a moment of brooding, of trying to sort things out.

One might think, of course, that in their intensely personal nature, and the relatively minimal reference to the role of the scenery of the Greek Islands, Cleve was violating the very standards he had espoused in "Narcissus in Chaos." This was not the case, however; these paintings are too orderly and restrained, too dependent on nature and the values of Asian art that had become constants in Cleve's life. However much chaos their maker may have been feeling inside, art was the antidote to inner struggle, not its road map.

We stand before these 1963–64 canvases inspired by the Greek trips (pages 71, 72, and 73). "I was coming out of the black-and-white period of Spain. When I got what I had previously done down on canvas, it didn't suit me. I would get very angry; the results could be very beneficial. Some of the brushwork you see here is a result of anger and disappointment. The anger helped me find the way. This was a conscious unconsciousness. It's the anger that shows."

Yet, I allow, I do not think of these as angry paintings.

"No, no. They simply have some emotion in them." But Cleve remains eager to distinguish himself from the Abstract Expressionists. "Having written 'Narcissus in Chaos,' I suppose I had purged myself of my dislikes. I could now get closer to gestural painting. I liked Motherwell. But I came to the gestural through the Chinese and Japanese connection. Motherwell came to the gestural out of Surrealism and the Abstract Expressionists."

Looking at these 1964 paintings with Cleve, I fall into a trap I generally am assiduous to avoid—the usual art historian's gambit of finding influences. But I cannot help wondering how he feels about certain European abstractionists who seem quite close to him in spirit, with their orderly freedom and the structure they always lend to their visual musings. I ask, first, about Wols. Cleve's face indicates that the question is not the offense I feared it might be. "I liked him very much. But I don't know how much I was thinking about him. I was certainly thinking admiringly about Fautrier. I wanted to free my brushwork, to be more spontaneous, and to incorporate Chinese ideas. I was very interested in the brush, but certainly not the kind of brush the Abstract Expressionists were using." On the other hand, if my gambit of mentioning Wols—as well as Nicolas de Staël, Vieira da Silva, and some of the other post-School of Paris abstract painters—is a success, I get a very different response when I ask about Soulages and Schumacher. "Too facile, no depth to their work," Cleve declares with certainty.

Cleve next found himself doing further paintings evocative of classical origins, most significantly his Augury series. "I began to probe further into the psychological and spiritual possibilities of abstract art. Evolving from the female form, an image developed for me that was part goddess, part column, part tree." This vertical image would be the basis of much that followed.

It was in these 1964 Auguries that this laden vertical began to assume its dominance. "It all came out of Greece. The auguries were the prophesies. I was reading Aeschylus, Euripides, the tragedies. I could find images in them that were very visual. An awful lot of my imagery comes out of my readings directly or indirectly in this way."

The paintings fit into that category of art that has been labeled as sonic design, audible art. We hear the voice, the resonant bellowing, of the great heroines of mythology. We feel the superhuman force, the energies and history and emotions that can be contained within a single being.

Throughout the period of making these images rooted in ancient Greece, Cleve was reckoning with mundane issues as well. In 1965, following the second of two exhibitions that had not been as successful as his first at the gallery, he and the Staempfli Gallery decided to part ways. "I felt it was the duty of the dealer to follow the artist, not the artist to follow the dealer," Cleve tells me of his relationship with George Staempfli. In 1965 and 1967, the artist had two shows with the Saidenberg Gallery, neither of which was the success he or the gallery hoped for.

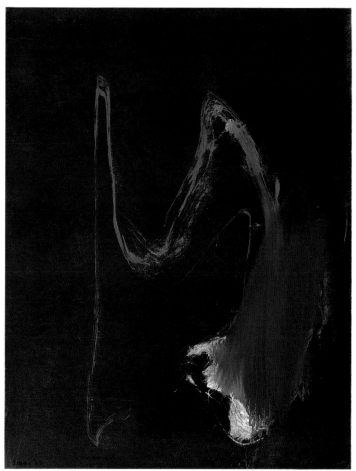

Ios.
1964. 24 × 18".
Oil on canvas.
Berry-Hill Gallery

Looking at the Auguries, I am eager to discuss the extent to which each painting has a subject: emotional, visual, political. And I wonder how Cleve reconciles this with his focus on the process of painting, and whether he ever uses abstraction as a deliberate means of purging himself of certain emotions.

His answer to my questions about his underlying ideas is a pleasant surprise. It takes me in a direction I have never before experienced, a route resultant of his intellectual originality. "I don't think I've ever made a painting without an idea in my head. Space is an idea. I read a book on the big bang theory, and the way the universe developed. In the back of my mind I may have had whirling galaxies. How can you conceive of space that is both nothing and

Omen.
1965. 34 × 23″.
Oil on canvas.
Berry-Hill Gallery

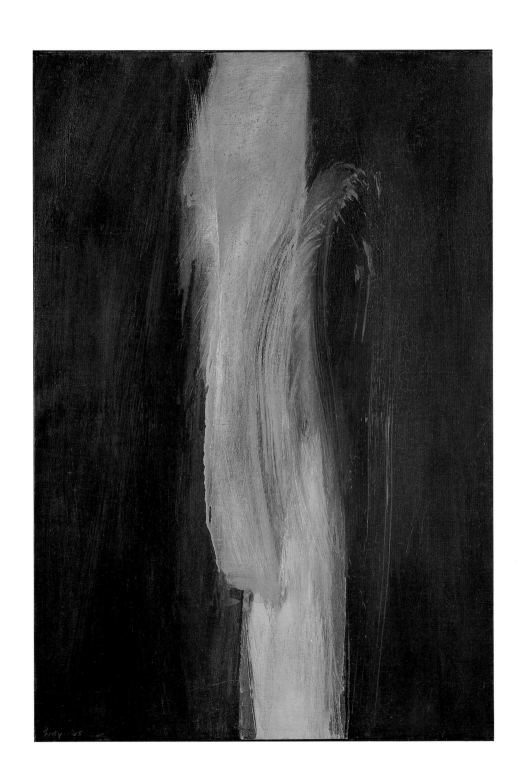

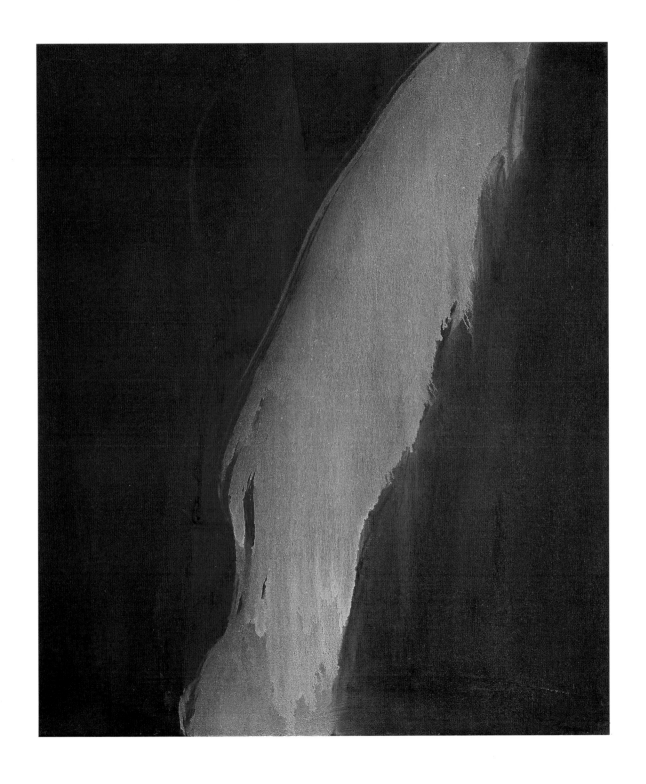

Premonition.
1965. 36 × 30″.
Oil on canvas.
Berry-Hill Gallery

everything? It's a rather abstract idea."

The black-and-white works soon added an element of color. Standing with me in front of *Empyrean* (page 69), Cleve says, "I knew I wanted to replace black with blues and other colors. The element of the void comes right out of China and Japan: the sense of the void moving into the image, and the image into the void. I've always wanted to make images that would help to move the spectator into a world of contemplation, so that they could relate themselves, almost physically, to the work."

In those small canvases following the trips to Greece, Cleve was trying to sort out personal dilemmas: his inner struggle was manifested in the paintings, a sense of anxiety and discontent that could apply to any of us for our own reasons. He was also, however, simultaneously trying to resolve certain technical issues of his craft. Toward the end of the 1950s, he had been "using very liquid paint, with lots of turpentine to keep it fluid. Yet, in 1960 and 1961 I was still very influenced by the structure of Villon and Cubism. I wanted to loosen up. I wanted to break away from Cubism to something that could bring me back to my love of Oriental art. There was brushwork, and line." Within myself, everything was in flux, and evolving. "I was going from one extreme to another: tightening, loosening, limiting my color, then coming out with a lot of color. The color for me was always totally emotional, although I knew it should be planned." He needed the means that would facilitate these changes.

Cleve would move toward freedom, and then come, in time, to feel he was too loose. But one goal was increasingly consistent: the impression of transparency, a quality that prevails in his work to the present day. And in the mid-1960s the vertical form was emerging with new strength. This was evident in the highly charged, gripping *Premonition* and *Omen* of 1965 and *Demeter* of 1966. These were to be among Cleve's last paintings using oils. A major move ensued: one of the few developments that did not reverse itself. Cleve has referred to the change in virtually every conversation we have ever had about his work. "I switched into acrylic. It took me ten years to get going with it."

Since the late 1940s, Cleve had periodically been trying to use acrylic paints, only to find the results unsatisfactory. One of his reasons for wanting to make the switch was that oil paints gave him intolerable headaches. These increasingly became a problem in the mid-1960s. But, beyond that, he wanted to use acrylics because of their durability, color intensity, permanence, and speed of drying. Initially, he could not get acrylics to perform as he needed to achieve his desired results. He found acrylics "like watercolor, too facile looking. There didn't

seem to be any depth to the paint.

"But at the same time, oil paint didn't stand up. The linen canvas required by it was too fragile. It always needed a ground of gesso, all of which took me so long. I wanted to be more spontaneous, and oil took so much time to dry. You couldn't put lean over fat—you couldn't put turpentine over oil—and the headaches were getting worse."

Yet he would not switch mediums until he could achieve certain results. "Oil has a translucency and mellowness which increase as it oxidizes; this imparts a subtlety and depth to the surface which acrylic cannot equal. For me the great problem was to avoid the rubbery, repulsive surface that acrylics acquire when used in the customary manner. At first everything I did with acrylic was objectionable, either too facile or dead, overworked."

He was able to resolve the problem, however. "I learned to use acrylic in a very liquid way on cotton duck instead of on the linen I had hitherto employed. The acrylic gave me a chance to put one wash on top of another. I began to be satisfied with these new paints in the Ceres series. Now I could paint very quickly; I could make my forms much larger; I could use one clear color over another one and, above all, a more resolute and expressive line." As Cleve tells me this, I can hear the rising excitement in his voice. He is describing some of his dearest objectives. "I was struggling to make a line that was strong and clear, but the oil medium made that difficult—it was too flaccid."

Cleve found that he could get rid of the facile impression of acrylics "not by staining the canvas, but by putting one color over another to get increasing transparencies and the resonance I sought. I didn't want the sleazy, waxy effect, which I didn't like. Most people, in fact, think I'm working in oil." This last statement is one I hear the artist utter with quiet pleasure on numerous occasions. It is as if his technical magic—the ability to have modern, more efficient paints acquire the looks of traditional pigments—creates some of that same multiplicity and ambivalence that he strives for.

The first acrylics were the Gaia series of 1967 (pages 77 and 78). As with the Demeter series in oil paint of the preceding year, Cleve had been inspired to deal with the ancient earth goddesses both by those trips to Greece and by his reading of Erich Neumann's book *The Great Mother*. I have noticed that this volume, faded and well worn, is still in his studio. Gaia, of course, was the Greek goddess of the earth.

"At this point Matisse became my prime inspiration, as he has been ever since," Cleve

explains as we look at *Gaia #1* together. The admission is a fascinating one; I am used to artists who refuse to acknowledge influence. So many painters insist that they have come from nowhere, that they have invented their vision entirely on their own. Cleve, on the other hand, is not only quick to cite his sources; he sometimes does so at his own expense, deprecating himself as being more in another artist's shadow than he actually is.

Again putting down all of his pre-acrylic work as too Villonesque or too much in the shadow of others, Cleve tells me, as we study this painting together, "Well, I was still learning how to paint. I always considered 1967 as the beginning of my own work, even though Matisse was dominating me." While I agree that 1967 occasioned a breakthrough in his art, and that he was becoming increasingly independent, I cannot sanction the implicit diminution of all of his earlier work, which is full of strengths as well as of searching, and where the signs of influence and visible groping are a big part of its substantial success.

I concur with Cleve, of course, about the Matisse influence in this work. Matisse's *Moroccans Praying*—and the more abstract side of the Frenchman's work—is certainly apparent in the Gaia paintings. But what Cleve has done with that influence is totally original and imaginative. And his ability to incorporate the authentic voice of ancient Greece in his distinctly contemporary style, to combine strong structure with vibrancy and imagination, is very much his own. Devoting himself to this imagery roughly based on the mythological personage he also calls "the goddess of plenty," he has, indeed, in the best Matissean sense, evoked plenitude.

Gaia #4 is, to me, profoundly celebratory and wonderfully light. It takes certain of the best qualities of the School of Paris, even of their Impressionist predecessors—the order, the luminosity, the ability to be vaporous and organized at the same time—and expresses them with a new vocabulary. *Gaia #4* is a jubilant work: artistically loaded, connected to nature in all its complexity, at once bold yet subtle. And in addition to being a significant achievement, it represented the major step forward launched by the new acrylic medium. Emboldened by his technical advance, Cleve had begun to develop a theme that would give his art a new power, a force that would only increase in the various series of canvases that followed.

On his property in Connecticut, Cleve now has, in addition to his studio, three simple barn-like white clapboard structures in which he stores paintings. His output has been prodigious, so much so that in spite of having sold many hundreds of works over the years, to museums

Gaia #1.
1967. 82 × 80".
Acrylic on canvas.
Berry-Hill Gallery

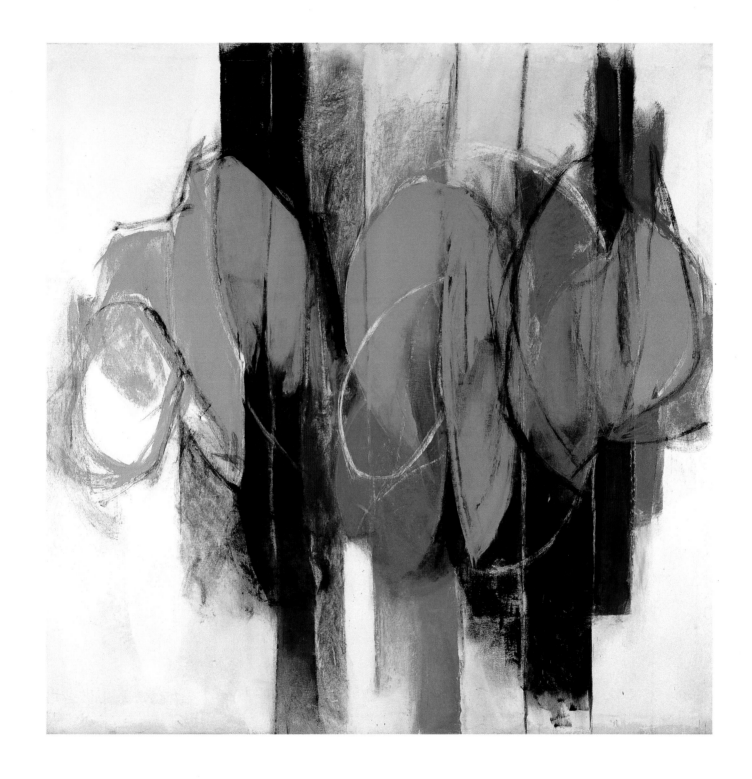

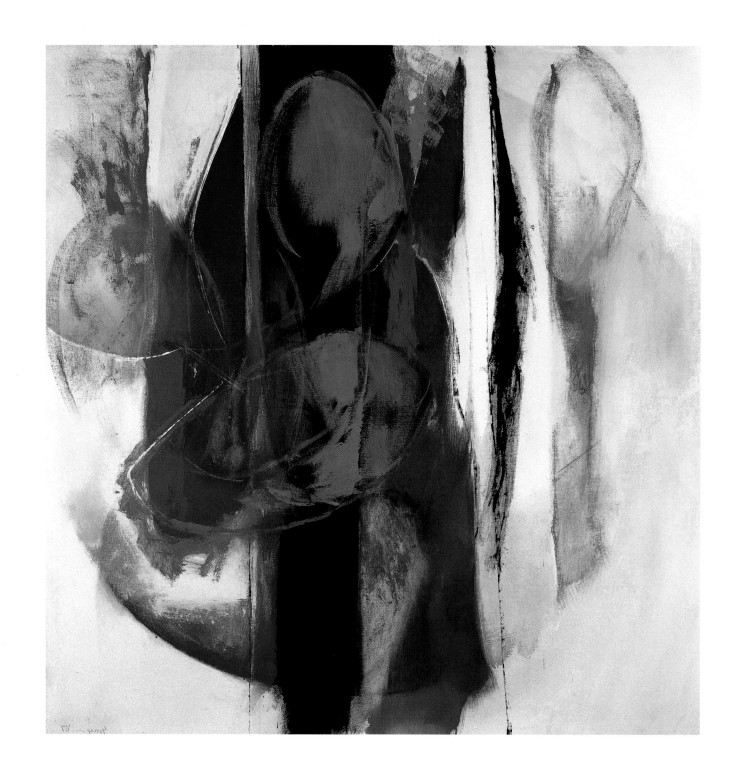

and private collectors alike, and having burned up, particularly in recent times, hundreds more that he deemed unsuccessful, the racks in these buildings are loaded with canvases. In the course of my average visit to the artist, we regularly walk from storage to storage as we work our way through his various series chronologically.

One day in late June we have been going back and forth among these various buildings so frequently that if you were to map out our footsteps the paths would make a complex spider's web. One of the reasons for all of this movement is that we are carrying, painting by painting, work that I want photographed for this book into one of these storages, where they are being assembled as a group. Fortunately, we are in complete agreement as to which works should be reproduced: either that, or Cleve is so determinedly affable, so eager not to be the egocentric and demanding artist, that he has decided to let my taste prevail. It is almost noon, and we are shouldering together an especially large canvas that I consider one of his major successes and am particularly eager to reproduce. As has been true all morning, Cleve wonders if the very humid air will turn to rain, "which we desperately need," he says with some urgency. The asparagus and raspberry gardens are near to our route, and Cleve is looking at them longingly.

As we huff and puff along, Cleve explains that he cannot water these particular gardens. "Only the vegetable garden, nearer the house, can be watered, because we pump water up from the pond near to it." He repeats how much he hopes the rain will come.

This is remarkably of a piece with what he tells me a moment later. We are looking at *Ceres #4* (page 81)—"the Ceres series," as Cleve delights in saying because of the pun. An extremely strong canvas, to the average onlooker it might seem to be pure abstraction, nothing else, but I suspect otherwise and ask the artist its significance to him.

"I had decided that I wanted the image of the vertical goddess—the goddess of plenty, of agriculture, of fertility—from which would emerge these circular forms like breasts."

The consistency of Cleve Gray's life seems remarkable to me. He is one of those rare people who, however worldly and sophisticated, has never lost track of the elemental. Focused on the need of plants for water, he both understands and marvels at every manner of growth. I do not believe I have ever spent a day with him on which he has not referred to the births of their sons, now over thirty-five years ago, as miraculous, and their subsequent development even more wondrous. His love for Francine—by all estimations a powerful, fascinating woman—is equally apparent. And in his art the idea of femininity, of woman as nurturer, of

Gaia #4.
1967. 82 × 78".
Acrylic on canvas.
Berry-Hill Gallery

79

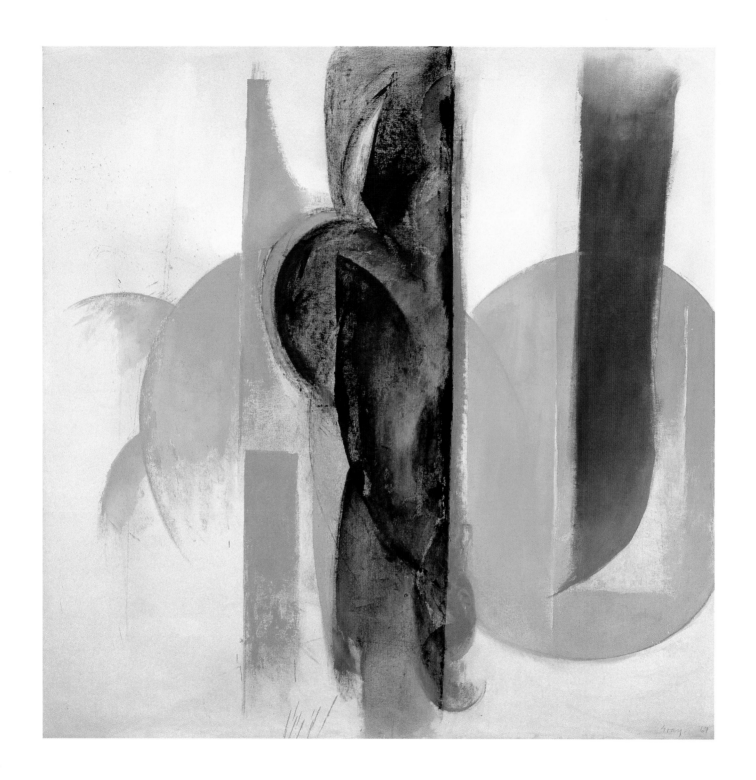

80

OPPOSITE:
Ceres #1.
1967. 82 × 80".
Acrylic on canvas.
The National Museum
of American Art,
Smithsonian Institution,
Washington, D.C.
Gift of the artist

RIGHT: *Ceres #4.*
1967. 82 × 80".
Acrylic on canvas.
Berry-Hill Gallery

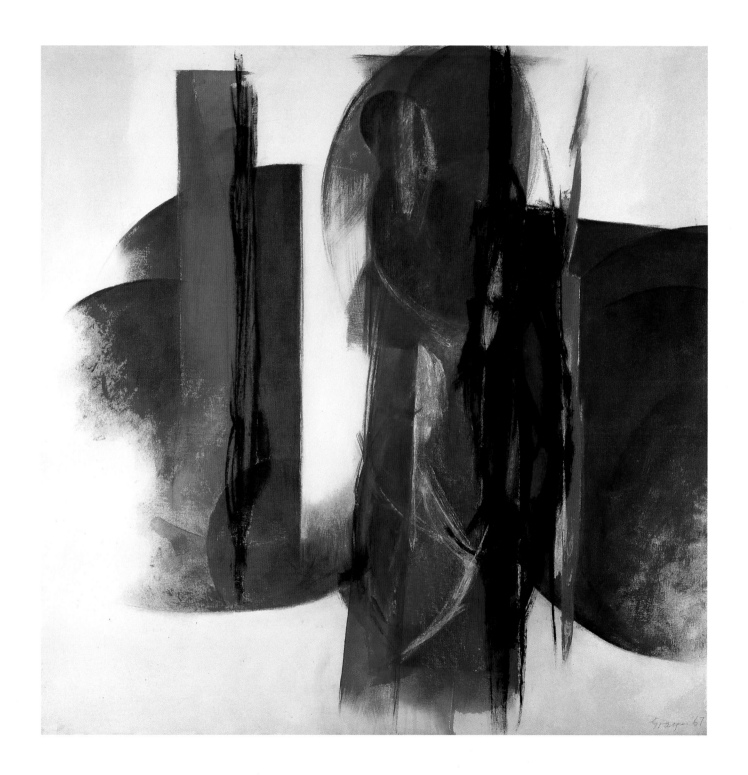

all that has been embodied not just in the goddesses of ancient Greece but, even earlier, in Paleolithic goddess figures, is equally vital.

All of the Ceres paintings, to me, reflect one of Cleve's periodic returns to the Villon/Delaunay side of his work. This is true both in their vibrant coloring and in the balance of their slightly cubistic, transparent forms. But the series also has a mythic significance, as well as a personalized abstraction, that are very much Cleve's own. Speaking specifically of the vertical form within them, Cleve observes, "It's a god or goddess; it's a column, it's a tree, it's architecture, and it's myth. In the beginning of Greek mythology, trees were worshiped. The columns supporting their temples were replacements of the trees that supported their earlier wooden temples."

"This is the ambivalence that I'm always looking for. It is both the myth and, at the same time, the origin of their mythology." That quality of ambivalence, the multiple readings invited by Cleve's art, has, in fact, become increasingly strong since the early 1960s. It had been there, of course, as early as those London Ruins of the 1940s—simultaneously abstract and based on actual appearances, combining the elegance and luxury of Georgian interiors with the chaos and destruction of wartime bombing. But in the more mature, and, seemingly, more purely abstract later work, the myriad interpretations offered by a single painting, the combination of our moods, the sense of vast potential and few prohibitions, are ever more apparent. In all of our discussions, Cleve never once objects to any reading I give a work, be it a psychological interpretation or a visual analogy. Rather, he always seems to delight in all the possibilities.

To me, the columnar form is also like a forward march. Cleve is, patently, moving on in these works. From the visible darkness of the earlier Greek works, he has emerged invigorated. As is so often the case with human progress, this recharging of his art and his self has been achieved in part through a process of simplification. The Ceres paintings reflect invigoration, a burst of energy that would carry the artist well into the future. The latitude available with acrylic paint has, of course, played a large part in making that move possible.

In general, Cleve's series go in one of two directions: they either become progressively looser and freer, revealing his prevailing desire to let go of the reins, or they grow simpler and minimal and more reduced. The developments within the *Ceres* paintings fit clearly into the former category. We are standing in one of the art storage buildings when Cleve explains, "I got tired of the vertical form always on its own. I was trying to dissolve the form more and

more. Making it more and more loose, more and more explosive."

That explosion is especially evident in *Silver Diver* (page 84). Cleve's sense of freedom, his deliberate release, his looseness resonate from this highly charged canvas. "I was mad at the painting. It was boring. I thought I should do something untoward and without the rational guidance of my paintbrush. I had nothing to lose, and I wondered what would happen; I picked up a bucket of aluminum paint and threw it at the canvas lying on the floor. I watched fascinated as the silver spread under its own momentum across the canvas. That wondering guides all my paintings; I am always curious to see what may happen when I paint."

Cleve recalls that he may have had the aluminum paint around for painting a tennis court fence. This sort of happenstance appeals to him, for, deliberate as his thinking is, he believes in the power of accidents, of chance occurrence, the *I-Ching*.

"I continued to use the aluminum paint in the Ceres series, but later I used a compressor to make the splashes, and those shifts in the silver fascinated me even more," he goes on to explain. "I was trying to express an ambiguity between the white and gray and silver." I find, looking at this painting, that it is one of those works that takes a while to absorb—we have to let it sink in—but in little time it acquires tremendous richness and poetry.

We look next at *Spider*, another of these late Ceres paintings done with his compressor blowing even more metallic paint (page 85). The large canvas conveys the feeling of outer space, of a cosmic incident somewhere in the distant universe. The medium is silver and gold paint on top of acrylic. Again Cleve talks about accident. "I was tremendously interested in what would happen. I was trying to get away from my goddamn brain. I had become too rigid."

The painting makes me ask him, naturally enough, about Jackson Pollock: in many ways, ironically, the bête noire of "Narcissus in Chaos." "Well, now I love his work. It took me a long time, a lot of looking, but I think it's very beautiful, and very organized." Cleve then talks about how contradictory this view is from his previous stance on the Abstract Expressionists, from the diatribe he issued in that 1958 essay. Back in the late 1950s, he had never dreamed that he would come to have this deep admiration for Pollock. But, he adds with a resounding laugh, "I got my hatred for the Abstract Expressionists out of my system—I grew."

That shift, that growth, is one of the traits I have come most to admire in the painter. Cleve Gray is one of those people strong enough to allow himself to shift course, more interested in change and development and progress than in an arbitrary definition of self. Just as within his

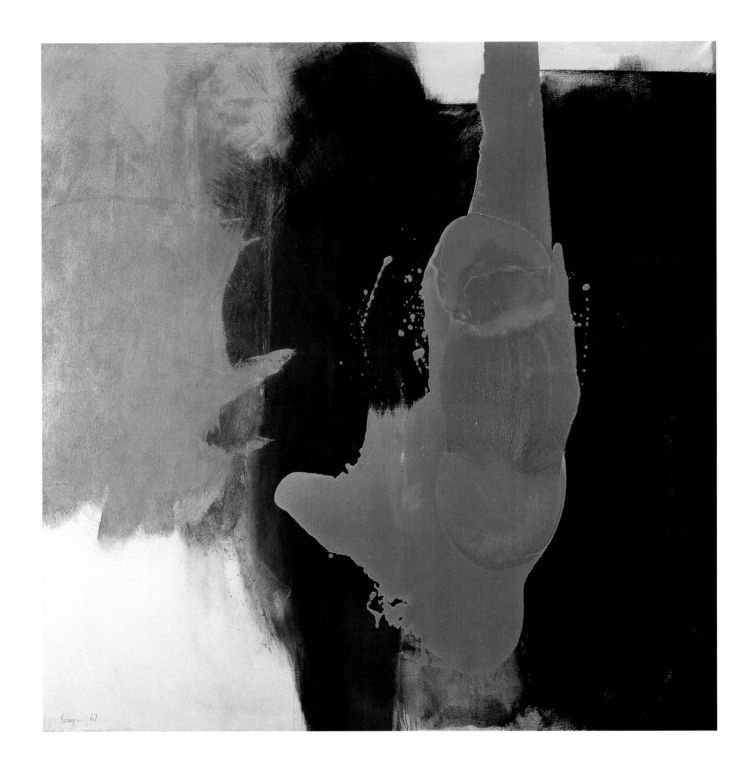

OPPOSITE:
Silver Diver.
1967. 82 × 81″.
Acrylic and aluminum
paint on canvas.
Berry-Hill Gallery

RIGHT:
Spider.
1967. 81 × 79″.
Acrylic and aluminum
paint on canvas.
Berry-Hill Gallery

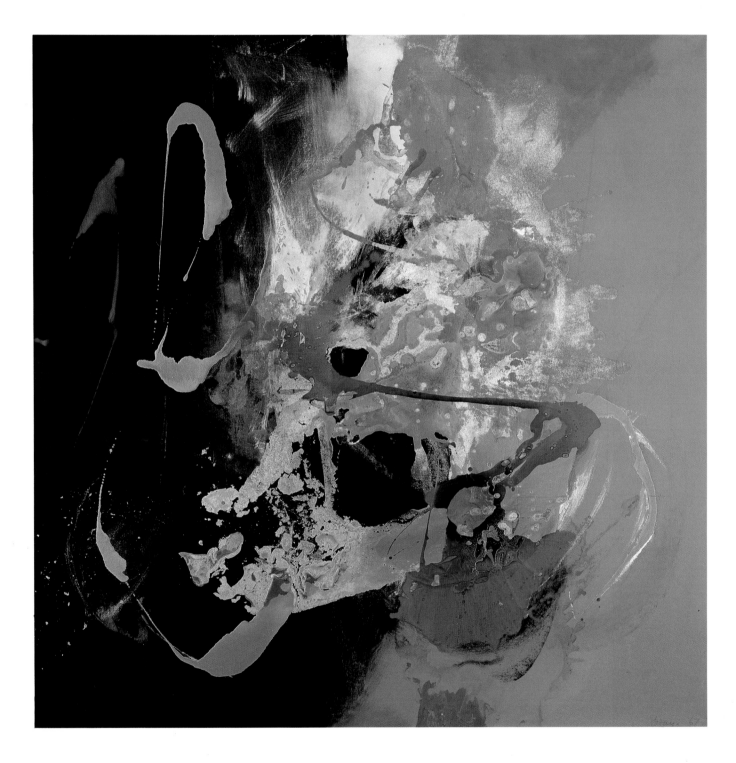

Silver Song.
1967. 101 × 80″
Acrylic and aluminum
paint on canvas.
Berry-Hill Gallery

painting series he always forges ahead, rather than repeating the same approach in his thinking. Over the years he has continuously been open to new understanding and to adventure.

A large part of the mood of these paintings on which he blew paint through a compressor may stem, in fact, from the darker side of Cleve's temperament, which is every bit as strong as his Matissean sense of celebration. From the time of his student days at Andover, he had ardently decried any form of human injustice. Ever since the early 1960s, when he painted *Reverend Quan Duc,* he had felt growing disgust at the horrors and tragedy of the Vietnam War, an attitude that he and Francine shared. Their rage on that subject may have had a lot to do with how Cleve was painting in this period.

"From 1966 onwards, opposition to the Vietnam War was occupying an increasing amount of time for Francine and me. With friends we founded a chapter in northwest Connecticut of Clergy and Laymen Concerned about Vietnam, which had its headquarters in New York. We marched, we organized meetings, we distributed literature, we sponsored speeches in our area of Connecticut. We felt a strong obligation to dissent. A few years later we were twice jailed in Washington for lying across the thresholds of the House of Representatives and the Senate. I loathed my brief jail experiences; Francine was not as disturbed. She likes small spaces and lots of people around her. I don't." Whatever their differences in attitude, for many years the Grays' political activism was an essential element of their lives.

Painter above all, conscientious and devoted parent of two lively boys, committed political activist, Cleve was also writing and publishing with protean energy. In 1965, shortly after the sculptor David Smith had died, Cleve, who had recently become a friend of Smith's, wrote a memorial tribute to him that appeared in *Art in America.* In 1966, he translated Marcel Duchamp's *A l'Infinitif,* although Duchamp was by no means an unequivocal hero for him, and in our conversations he would often focus on the negative impact of Duchamp's influence, respectful though he was of the artist's imagination. That same year, he had articles in *Art in America* about Lyonel Feininger's prints, Duchamp, and Naum Gabo; he would then write about John Marin, his old Princeton teacher Jim Davis, Hans Richter, and many other topics. The David Smith essay led to Cleve's editing, in 1968, his first book: *David Smith by David Smith,* which was published within the year in New York and London.

This was followed, two years later, by his editing *John Marin by John Marin.* In the book's foreword Cleve testifies both to Marin's wit and his literary eloquence. Marin had been one

of the first artists to move the young Cleve with the transcendental qualities of his art, his ability to render nature and transfigure it. Having discovered and come to admire Marin's work when he was at Andover, he had had his first direct encounter with the artist a couple of years later. "I was his ready victim when I met him. As an undergraduate at Princeton, I believed, as I do now, that Marin was America's greatest artist of the prewar years."[9] In his foreword to the book he emphasized that while Marin's watercolors had enjoyed a degree of popularity, his oils, which Cleve esteemed even more highly, had not been adequately acclaimed.

Cleve's concluding paragraph suggests that Marin was, indeed, a sort of role model, one whose resolve he may have somewhat envied:

> Marin's conceptions were clearly situated in the stream of 19th century thought. He believed in the beauty of the earth, in the value of his own intuitions, in the existence of the "Great Law," in "a balanced reality" as he put it, and in the importance of his own expressions of this faith. He was probably the last of the generation of artists who didn't question the significance of the work of art. He never doubted that he was involved in a matter of infinite importance to man.[10]

Hera #1. 1968.
82 × 79". Acrylic on canvas.
Berry-Hill Gallery

Above all, Cleve continued to paint. In 1968 he completed his Hera series. "Working in acrylic helped me to loosen up. Even so, when I began to feel that the Ceres paintings were beginning to tighten and tried using the air compressor instead of the brush to spread some of the paint, I felt this was too easily successful. Before long, the image had become too dissolved; I had to get back to more structured work, to more drawing, and move away from the use of the compressor." The Heras were the result.

We concur that #1 and #3 of the Heras are the best. "I generally feel that the first work in a series has elements I like best," he says as we look at this rather stately canvas. "It's still the female goddess," Cleve adds, to which I remark that these are actually very sexy paintings. "I hope so," says the artist.

Of *Hera #3*, Cleve tells me, "I was interested in seeing whether white could hold the intensity of the yellow orange." Even though he has less of the white than anything else, he achieves that objective. Meanwhile, the blue form, though restrained, has a voluptuousness that recalls Matisse's *Blue Nude*. Yet the work is extremely lean.

"I was pushing as far as I could go, away from complexity and toward more structured form. And then came the beginning of a simpler statement. We look at *Woman Tree #2*. It is, Cleve tells me, very similar to one Bunny (Mrs. Paul) Mellon bought from Betty Parsons for her house in France. "The image was first drawn with a blue pastel crayon; then I painted the white over it. I left in the pastel line because it helped to move the image into the space around it. This prevented it from being a hard-edged painting. I also left in a wash of blue because it, too, moved the image into the void. That is what I think of as Cézanne's *passage*. What could be an outline in Cézanne's imagery is broken in that way. The space is always moving into the image and the image into the space. There was never a simple outline, it was opened up so that space could move through or around it."

On the other hand, the Woman Tree paintings did not ultimately suit the artist. "I later destroyed many of these. It got to be too much and too little. Too much for me and too little for the spectator. It got too simple." Yet this was a period of great productivity for the painter, and the Woman Tree paintings soon led to *Black Limb* of 1968, very organized abstractions based on nature in which figure and void play against one another vibrantly ("my passion for oppositions"). A particularly fine example was acquired by Marjorie Phillips for the Phillips Collection in Washington, always the connoisseur's museum. In a setting rich in work by Courbet, Bonnard, and Braque, it was at home.

IV

For the artist 1970 was an exciting year. Betty Parsons, who ran one of the most important avant-garde galleries exhibiting contemporary art in New York, asked Gray to show with her. "I developed very well with Betty. Artists need encouragement. She said, 'Cleve, you're the best. You're following in the footsteps of my giants.' And I admired her very much. We were on the same wavelength, with her interest in poetry and religion. She was whimsical; she was unique." He had his first solo exhibition in Parsons's 57th Street headquarters, a space that was instrumental in the acceptance of abstract painting in our society. Shortly thereafter, he and Francine went to Morocco for the first time to celebrate the publication of her first book, *Divine Disobedience: Profiles in Catholic Radicalism*. The trip inspired a new direction.

"I play a painting image as long and hard as I can, until the moment comes when I'm sick of it. Sometimes that's when we can afford a trip. Occasionally, that resolves the quandry." The renewal inspired by the jaunt to North Africa is apparent in *Rabat #1*, with its "deliberate ambiguity" of form and true loveliness—one should not disparage the word. "The female form is a voluptuous curvilinear form all the way through. The male form is different—straight lines," Cleve says of this large canvas that nearly resembles pure abstraction. Indeed, the sensuous female presence is something of a Cleve Gray trademark. Female power, expressed in any number of ways, sometimes as a stolid goddess, sometimes in a softer mode, prevails throughout his varying series. *Rabat #1* (page 92) also evokes the sea in its pure, lush blue, as well as Moroccan tiles. I am astonished to learn that it has never been shown: too often the case with some very fine paintings by this prolific artist.

That same year, at his alma mater, the Princeton University Art Museum held a retrospective of Cleve's work that the artist dedicated "to the four students killed at Kent State University on May 4, 1970." To many of us the dedication may not seem a radical gesture, but in the setting of what was perhaps the most hidebound of the Ivy League universities, it was

Black Limb.
1968. 82 × 62".
Acrylic on canvas.
Berry-Hill Gallery

a bold statement.

Very few of Cleve's classmates were in tune with the exhibition, however. "At the opening of the exhibition, some of them wandered into the museum, quite drunk, often with children at their sides, and pointed to a painting, saying, 'What's it supposed to be? My kid could do as well as that.' Princeton was a lunar landscape, with these red-faced guys in outlandish class costumes. I remember one getup in particular where hundreds of dollars must have been spent to make them look like astronauts on a moon walk. I lost complete control and, for the first time in that decade, got very drunk myself, and by the time we had to go home a friend had to drive us to Connecticut."

The following winter of 1970–71, for six months under the auspices of the Ford Foundation, Cleve was artist-in-residence at the Honolulu Academy of Arts. The decision to go had not been easy. The way in which it was made, and the results, tell a lot about the dynamics of the Gray family. "I would be well paid, could bring my family, the boys could go to Honolulu's Punahou School. We had a family vote and Francine lost three to one. She was a good sport about going. She had written short stories and articles for the *New Yorker* and the *New York Review of Books* and published her first book. She believed she could occupy her time in Hawaii. A year after the Grays' return, Francine's profile of Hawaii would appear in the *New Yorker* and would become her second book, *The Sugar-Coated Fortress*. In January of 1972, Cleve's Hawaiian paintings—based on the volcano Kilauea, waterfalls, and mountains (page 93)—would be exhibited at Betty Parsons.

"We had rented a beach house in Lanikai on the edge of the Pacific about twenty minutes across the mountains from Honolulu. The landscape was lush and glorious, the weather gentle and glowing, the ocean enveloping. It was a time of flowers and

OPPOSITE:
Rabat #1. 1970.
81 × 49″. Acrylic on canvas.
Berry-Hill Gallery

LEFT:
Hawaii #1. 1970.
66 × 48″. Acrylic on canvas.
Berry-Hill Gallery

fruits. I painted about eighty canvases. Too many. I eventually burned almost half of them, a great fire," Cleve says with a boyish grin. "The tyranny of facility, the dangers of glibness and shallowness are always lurking."

Meanwhile, those dangers were certainly surmounted in the art that followed in Connecticut. Cleve's political activism and painting would soon begin to coalesce in the Threnody series. But first came a particularly busy period in which he was active on various fronts. In 1971 Cleve edited *Hans Richter by Hans Richter*. Having overcome his "barely controllable dislike of Germans," he had been befriended by both Richter and his wife, Gaby. Richter was a founder of the Dada movement and a filmmaker who had settled nearby in Connecticut. As Cleve became more acquainted with Richter's painting, he sensed "an affinity with Richter's later work, his painting and his thinking, an affinity so close that at times it would surprise us both."

In 1971 the Grays returned to Spain for a month of the summer to stay with "our closest friend in Europe, Ethel de Croisset." It was following that trip that the large, square Sheba paintings—each was nine feet by nine feet—first appeared. An important step forward, these were to be the seeds for *Threnody*. Cleve and I look together at the Shebas one July morning on which the summer light is strong enough to pour through the door of one of his storage buildings. The sunshine allows the subtle surface and fascinating paint handling on these canvases to emerge. With six of these paintings before us, I am aware of a strong resolution in the group; there are fewer changes within the series than is usually the case. Pointing to *Sheba #6*, Cleve explains, "Here I reverted to oil in the last coat to get the color I wanted." That care about tone and texture, the pervasive subtlety, is remarkable in these large canvases.

What also strikes me is the way that the "figure" reads both as figure and void, as a looming presence at one moment, and, alternately, as a window, opening. Yet whether it appears to be offering up a distant vista or to be a powerful being, it has the same complexity and forceful certitude. "I was still on my goddess kick," Cleve explains. "These Shebas show a mythical woman, or not mythical, doesn't matter." Again the artist refers to Eric Neumann's book and its fascinating premise. "I was reading the Eric Neumann at the time—*The Great Mother*—about the great female goddess worshiped at the beginning of civilization." This is, of course, a variation of the theme that is central to a large body of his work. Looking at the Shebas, he speaks again of fertility symbols, of the Willendorf *Venus*.

Unlike the Willendorf *Venus,* a stone statuette less than five inches tall, this rendering of

Sheba #6. 1971.
104 × 104″. Acrylic on canvas.
Berry-Hill Gallery

the potent female force is physically enormous. "The size was heroic. That's what would be so fortunate for me about the potential of *Threnody*. For when Bryan Robertson came to see my work, the Sheba paintings were in process, tacked to the wall. I paint on canvas stapled to the wall because I like the hard surface that offers resistance. That was when he offered me the pivotal commission. He must have instinctively seen the possiblities of my Shebas."

Cleve's relationship today to the Threnody paintings is like that of most creative people to their best-known work. He is thrilled to have done it, satisfied with the results, happy enough with the present acclaim and the obvious significance of the commission, but he hopes it will not be his sole source of recognition in the world.

He spent that period of more than two and a half years of intense work, from first planning to the completion in situ, on the vast installation in Purchase. It was his most important work

Gray '72

to date, a culmination of effort, a larger-scale version of the visual and psychological terrain in which he had been working for years. It was as physically big as anything he had ever made or would ever produce, perhaps the largest of any painting series of the twentieth century.

In 1973—the year *Threnody* was completed—Betty Parsons put on a show of Cleve's bronzes. Over the years, Cleve had periodically made sculpture. The inspiration for these bronzes had come from the stay in Hawaii. "We had been entranced with the volcanic activity of Kilauea. The lava flows, as they crossed the landscape covering villages and papaya groves to creep into the ocean, manifested an elemental force such as I had rarely seen. The sight gave me the sculptural clue I had been looking for. I made pieces combining wood, papier-mâché, and metal which I later cast in bronze. Not too far from home, in Poughkeepsie, Dick Pollich and Toni Leger had opened a foundry, and they taught me the lost wax process of casting bronze. I produced about forty small bronzes with them, all of which I finished and patinated myself."

The exhibition at the Betty Parsons Gallery comprised twenty-nine of these. "Their reception was indifferent. Perhaps for once I was ahead of my time!"

Cleve's preoccupation with sculpture in the early 1970s led him to begin putting together another book about a friend and Connecticut neighbor: *Naum Gabo by Naum Gabo*. "Gabo, piqued by my Hans Richter book, had begged me over and over to do a volume on his work. He continually hugged me, saying 'Cleve, you're my posterity.' I respected him as a truly important sculptor. His pieces moved me greatly, but I hesitated because I knew he would be exceedingly difficult to work with." That estimation would be more than warranted. "When the book was 90 percent finished, Gabo, who as usual had been hugging me tenderly an hour before, suddenly turned on me as I handed him my dummy manuscript, grabbed the transparencies we were to use, and said he no longer wanted me to do the book. I had wasted almost a year and decided to do no more books."

What is quintessentially Cleve, however, is that he sees the Gabo episode as part of his personal learning process, and does not lapse into vitriol as most people would. "Up to that time I sincerely believed that an artist who produced works of transcendent quality must have, even if deeply buried, a noble character. I was over fifty and still learning."

By this point in his life, Cleve had begun to assume a role in which he would continue for several decades: as a board member of some important arts organizations, generally in the south-

Sheba #4. 1971.
104 × 104". Acrylic on canvas.
Berry-Hill Gallery

ABOVE: *Bronze #5.*
1971. 20″ high.
Cast bronze.
Berry-Hill Gallery

ABOVE RIGHT:
Bronze #16.
1971. 18½″ high.
Cast bronze.
Berry-Hill Gallery

RIGHT:
Bronze #119.
1971. 16½″ high.
Cast bronze.
Berry-Hill Gallery

ern New England area. Museums and art schools need living artists as well as the traditional business people and local aristocrats on their boards of trustees, and with his insightful mind and genial manner Cleve fit the bill. In 1968, the Rhode Island School of Design asked him to become a trustee. He would remain on their board for almost a decade and recently was appointed an honorary trustee. In subsequent years he would serve also at the Wadsworth Atheneum in Hartford, the Connecticut Commission on the Arts, and the New York School for Drawing, Painting, and Sculpture.

He was achieving recognition in other ways as well. Beyond his regular solo shows at New York's leading galleries, Cleve's work, starting in the 1960s, was widely exhibited. Recent paintings were often in the Whitney "Annuals"; drawings and prints as well as large canvases were included in group shows at museums large and small.

Following *Threnody*, Cleve had the idea of doing polyptychs, inspired by the end wall of the installation at the Neuberger, which he considered the eastern apse of the chapel. "Mary was on the left, John the Baptist on the right, with a void in the middle where the viewer could imagine Jesus. A painted void, to be sure, but I slowly discovered that no figure I could paint in that panel was as strong as the energies developed in that void, and nothing I could add was as strong as the energies I hoped viewers would themselves supply if they responded to the rest of the painting."

This faith in the viewer, in the potentially marvelous engagement between an impassioned onlooker and the canvas, is central to Cleve Gray's approach.

The Polyptychs, however, did not last very long. A few years later, Cleve ended up destroying almost all of them. "The image itself got very tight, and I realized I was trapping myself in my dependence on this one rationalized vertical image. I started the scream performance."

The "screams" were a complete letting go, a break with all of his educated, rational, intellectually based work. Thomas B. Hess described the process in an essay he wrote in the catalogue for an exhibition of Cleve's work at the Albright-Knox Gallery. "He closes his eyes, stoops over, and commences the gestural drawing. And he screams. A wild, crazy howl, like a Zen swordsman or *Wu* initiate."[11] In the studio, Cleve demonstrates that scream for me, that letting out of energy, fear, rage, tension. And then he calmly adds, "That was another year: 1975. I did fifty or seventy-five of the screams." The painting series were entitled Conjugation

Conjugation #13. 1975.
40 × 40″. Acrylic on canvas.
Berry-Hill Gallery

RIGHT:
Conjunction #150. 1976.
74 × 56″. Acrylic on canvas.
Berry-Hill Gallery

Conjunction #151.
1976. 100 × 70″.
Acrylic on canvas.
Krannert Art Museum.
University of Illinois,
Champaign

or Conjunction.

By painting in the process of screaming, Cleve used his anguish, and his need for release, to artistic purpose.

"With those screams I was able to break out of my obsession with the vertical image," Cleve explains to me as we look at a group of these spontaneous, liberated paintings. "I felt I'd been dominated all through my life by my brain. Rationalization, structure. I couldn't let myself continue to be dominated by Western civilization. The Chinese and Japanese influence allowed me to stop my brain from working."

I could not help but admire Cleve's willingness—more than that, his compulsion—at a point of considerable critical success to move in an entirely new, liberating direction. Classical thinking and mythology, both Western and Eastern, Greek mythology, the Bible, Zen philosophy: all had served in ways both as a seed and a goal of his work.

Again Cleve demonstrates for me the bestial scream he would let out while painting. He explains that pots of paint stood alongside a fresh canvas on the floor. The moment he dipped his brush and began painting, he started screaming. "My brain was overly active, and I had to think of some way of crowding it out. After several months, I learned to work freely without screaming."

Concomitantly, I ask Cleve if he has ever been drawn to psychotherapy or psychoanalysis. Surely, I think, his deliberate probing of life would incline him in that direction. His answer, however, surprises me. He has never been attracted to either process. "I felt I knew who I was. Knew my problems. Knew what I had to overcome. Art gave me a way of doing it myself. I believe in pulling yourself out of your own problems."

With his strong capacity for self-discipline, Cleve remained able throughout that decade to remain active on many fronts. In 1975 he designed, at the request of the pastor, a liturgical vestment for St. John's Episcopal Church in Washington, Connecticut, not far from his home. On the Feast of Pentecost, he addressed the congregation: "I appreciate at least an occasional reassurance that my work is not entirely useless; and I enjoy the thought that the traditional relation of the artist to the Church can be reasserted today, even if modestly, by these usable garments." Cleve also made an important statement about their abstract design, and about his belief that we have recently witnessed "the breakup of a materialistic world view. In the new physics, in the increasing decomposition of form in painting and sculpture, in the dissolution of traditional syntax in literature, in the breach with long accepted tonal systems in music we

are presented with a new set of affirmations . . . [but] we are also faced with possible hope, the hope that the new art predicts. I call abstract art the art of Hope."[12]

Subsequently, Cleve made a complete set of vestments for the Episcopal church in Farmington, Connecticut, each a visual hallelujah of great celebratory power.

Meanwhile, travel would continue to affect Cleve and his work. At the invitation of Mayor Teddy Kollek, he spent December of 1975 and January of 1976 in Jerusalem in Mayor Kollek's guest house for foreign artists. In Jerusalem he painted and made several prints.

The work of this period has some of the same play and ordered movement as Matisse's *Bathers,* yet this is a more intellectual Matisse, a Matissean idea darkened by an aura of crisis. The colors of the Jerusalem paintings are tragic, the tone serious, the atmosphere one of battle. Cleve concurs when I make these observations, saying that he inevitably reacts to his environment. But the formal purpose, he states, was the "development of the movement and rhythm, as well as of the larger void. The sense of a horizontal equipoise was very important to me. Yet the fact is that Jerusalem had no real impact on my later work."

Cardinal, also of 1976, takes similar ideas further (page 104). "I wanted to get away from the dark monochrome. I let my brush run away intuitively." Yet for all of that naturalness and spontaneity, I reply, the work is noticeably organized. Cleve does not argue the point. "I was able to make the image freely, but I knew what I was doing. I was able to place it in the void. I wanted a certain sense of compression."

To achieve this, Cleve explains, he used very liquid paint, with which he made many layers of red. "Every time the paint dried, in order not to have hard edges, I went over the whole canvas with a wet sponge before I continued painting." To speed up the drying between stages, he used a fan.

"The only imagery I had in my mind was my memory of Oriental calligraphy. This had nothing to do with Abstract Expressionism or with literary imagery. It came from my years of admiration of Sung, Ming, and Ch'ing Dynasty painting and even from such a recent artist as Ch'i Pai Shih, as well as my passion for Japanese calligraphy, their scrolls and screens and their Zen painting. The source of my gesture arose from that, though I cannot deny that the work of the Abstract Expressionists may have helped to alert me to what the Orient offered, no matter how different. After all, my love of Oriental art does go back to 1937–38 at Princeton."

It was a time of recognition. Robert Buck, then the director of the Albright-Knox Art Gallery in Buffalo, New York, had admired Cleve's work when he saw it at Betty Parsons's gallery. Parsons suggested that Buck go see *Threnody*; it clinched his admiration for the artist, and in 1977 he arranged an exhibition of Cleve's work of the previous eleven years. The show subsequently traveled to the Rhode Island School of Design and to two other museums in the Midwest.

The knowledge of his upcoming presentation at the Albright-Knox was an inspiration for Cleve. "I painted *Phoebus* and *Erebus* (pages 106 and 107)—Day and Night—especially for the Albright-Knox exhibition. I was thrilled by the prospect of showing in those great galleries and was delighted by Bob Buck's enthusiasm. These paintings are certainly my response to the faith he was manifesting in my work."

The catalogue essays by Buck and Tom Hess cast Cleve's art in clear perspective. Buck declared the work "a kind of breakthrough in which an expressionist painter, originally inspired by cubism, combines the legacy of American painting of the 50s with a remarkable sense of color and space bearing no relationship to the other work of the much touted, so-called color painters."[13]

Hess situated Cleve's work within the art of the century and provided readers with a vivid description of the artist at work. He also wrote an evaluation that, among other things, spoke to the synchrony of the artist's name and his aesthetic, and related the work and the man with splendid accuracy:

All paintings are self-portraits. In Cleve Gray's work, his fondness for grayed hues and the non-color itself is too evident to require any extended comment. Furthermore, as a tone, gray is the mediating presence, a Spinozian "yes, but" in which black meets white, color dissonances get a chance for resolution. The

OPPOSITE:
Cardinal.
1976. 103 × 62″.
Acrylic on canvas.
Berry-Hill Gallery

LEFT:
Last of October.
1977. 70 × 70″.
Acrylic on canvas.
Berry-Hill Gallery

artist quite consciously and systematically deals with a dialectic of opposites and with their syntheses; he will count them off in front of a painting in cheery lists: he confronts colors that are transparent with those that are opaque, light with dark, bright with dim, brushstrokes that are highly visible and gestural with areas of paint from which all signs of fac-

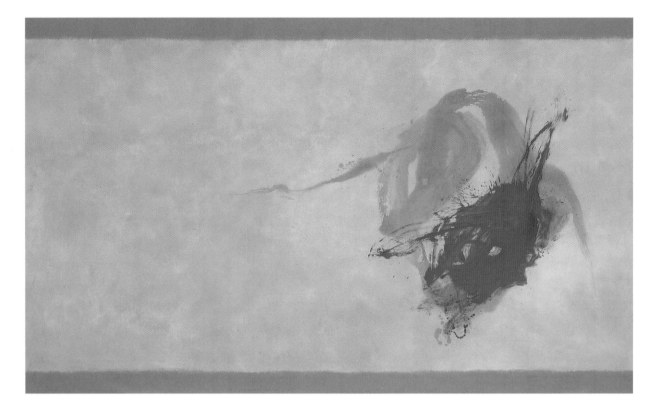

Phoebus. 1976.
116 × 186″. Acrylic on canvas.
Berry-Hill Gallery

ture have been eliminated, surfaces that are shiny with surfaces that are mat, shapes that are clearly structured with others that are amorphous and ambiguous, forms that are opened and closed, large and small, male and female. . . . He seeks a harmony between such countering elements. Just as even the brightest tones can find a unity in grays, Cleve Gray believes in an epiphany in reconciliation. He has the noble temperament of a peace-maker.[14]

The late 1970s were an especially rich and productive time for the artist. In *Last of October,* from 1977, Cleve effectively summoned the wonder of nature and the possibilities of paint in splendid conjunction (page 105). "It was the colors of fall that beckoned this," he allows as we look at the marvelously layered canvas, both complex and resolved.

His Egyptian series of 1978, which followed a trip up the Nile, is similarly impressive. "The colors were inspired by the Hatshepsut Palace, outside of Luxor. She was the great queen of the Eighteenth Dynasty." Again I am impressed with the way that history merges with

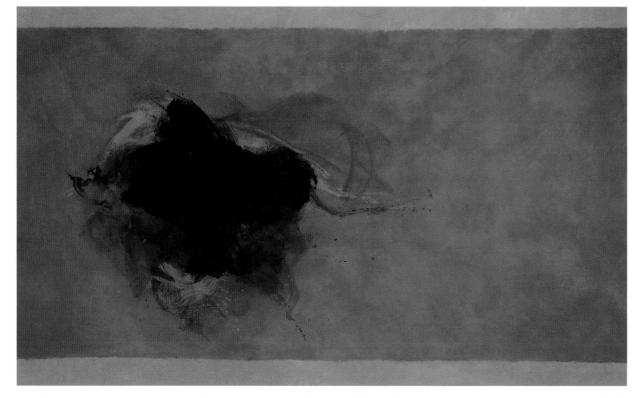

Erebus. 1976.
116 × 184". Acrylic on canvas.
Norton Museum of Art,
West Palm Beach, Florida.
The Gift of Joseph
and Caral Lebworth

modernism in Cleve's art. This is more evident still in the extensive Perne series, in which there were elements of William Butler Yeats's "Sailing to Byzantium," and an image of whirling, weaving motion. Cleve was in the process of painting these when he heard on the radio of the sudden death of Thomas B. Hess, with whom he was scheduled to play tennis the next day. It was a shattering loss. He dedicated the moving and elegiac *Perne #27* (page 110), later acquired by the Grey Art Gallery at New York University on Washington Square, to his friend and supporter. As Daniel Robbins wrote of this memorial to Tom Hess in an essay, "Cleve Gray's Recent Work," that appeared in *Art International* in November 1979, "It is a beautiful celebration of a lucid, vital man whose absence from the world continues to be a source of sorrow even while his writing—the communal memory—evokes energy and grace. . . . It reveals how Gray works, how different qualities of feeling are poured into a similar motif, how the motif develops for both the artist and the spectator."[15]

The 1979 *Earth's Echoes* and *Crash*, without having as historical or personal a basis, are also grounded but free. They reflect the sort of emotionalism that is effective when there is a

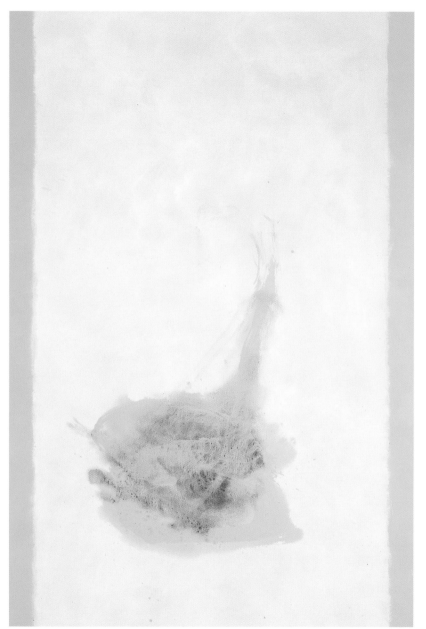

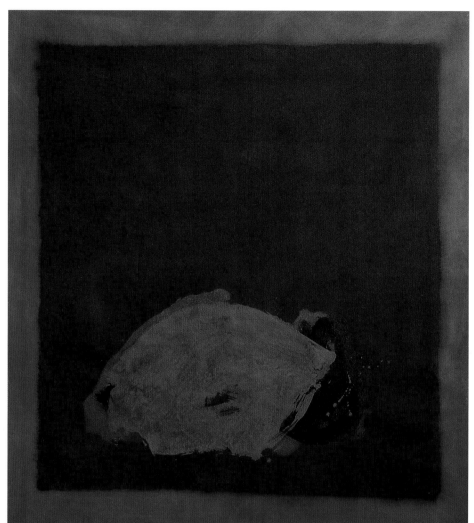

OPPOSITE LEFT:
Hansa.
1976. 120 × 80″.
Acrylic on canvas.
The Whitney Museum
of American Art.
Promised Gift of Cleve
and Francine du Plessix Gray

OPPOSITE RIGHT:
Sable-Vested Night.
1977. 76 × 69″.
Acrylic on canvas.
The Museum of Modern Art,
New York.
Gift of Agnes Gund and
Daniel Shapiro

LEFT:
Karnac Dawn #2.
1978. 72 × 60″.
Acrylic on canvas.
Museum of Art,
Rhode Island School of Design.
Gift of Lee Hall

firm foundation for exploration and exuberance. Also from 1979, *Each Other* (page 112) is "totally calligraphic, influenced by Chinese Zen painting, especially by paintings of the South Sung dynasty. Of course, a distinction from the Orient is that my calligraphy has no linguistic references. What concerns me is the quality of energy, the painterly meanings and formal action."

I ask Cleve if he has ever done a painting in which he does not see a shortcoming or flaw. He laughs when answering. "Probably not. But you learn best from your mistakes and shortcomings."

The results of his learning at that moment appear in *Steady Quick.* "I wanted to reduce. I had had this color splurge. Now I wanted to make a painting with as little as possible. I left out the margins. I had to have a stronger, more minimal image. I was working toward what happened later in the Thrust paintings."

His energy and the perpetual adventure of his work continued at this same remarkable clip in 1980. That winter, Francine and Cleve were offered simultaneous residencies at the American Academy in Rome, she as writer-in-residence, he as artist-in-residence. They would return for six consecutive winters as visiting scholars, an arrangement whereby former fellows and residents can lease rooms at the academy by the week or month—it

Perne #27
(In Memorium to T.H.).
1978. 57 × 65". Acrylic on canvas.
Grey Art Gallery & Study Center,
New York University Art Collection.
Gift of Mr. & Mrs. Alexander
Liberman

served them as their year's vacation.

In a sculptor's studio adjoining his room at the academy, Cleve saw Carrara marble dust on the floor. He asked to have it. "It worked out perfectly. I embedded it in my very liquid paint. It was just what I needed for the textural sense of a wall. When I got back to Connecticut, I had no more marble dust, but I found that I could use sawdust in the same way."

The Roman Walls are one of his most richly varied series, among the smallest scale works he has made, yet plentiful in form and texture, charged with suggestions of historical echo and lush in their colors and forms, however subtle and muted. "This experience in Rome distilled itself for me in abstract terms of light, color, and imagery. Even now, I see the city in those

Steady Quick.
1978. 72 × 84″. Acrylic on canvas.
Berry-Hill Gallery

same terms: gold on gold, red golds, green golds, ocher golds, blue golds, architectural images, doors, windows, columns, arches, pediments, that I could translate into calligraphic movements—textures that bring the centuries of Rome's contradictions into an equilibrium." As with those London ruins he had studied as a young GI, he responded both to architecture and its destruction, to stasis and motion, to the colors of the world and the unique character of human handwriting.

Back in Connecticut, Cleve immersed himself in his natural surroundings. *Underwood,* a

rich composite of three panels, all a variant of deep red, is redolent of earth and landscape, "the sensual sense of the woods," Cleve explains. As with so much of his work, what initially appears rather straightforward is complex on closer inspection. The panels are full of subtle variations and color surprises, just as woodlands themselves are. Using large brushes, Cleve has evoked an earthy, organic feeling: the moisture and fertility of compost, the wonderful territory that lurks underneath fallen tree trunks and dead leaves.

I am struck by what seems to me to be some rather distinctly sexual forms in this triptych, and while Cleve makes clear that they were not his intention, he agrees that they are there in the result, that the phallic black shape and vaginal green form belong among "the intuitive things that emerge." What was intentional is the visual resonance, the matte quality. "I don't like it when my work gets glossy, waxy, and disagreeable. That's when I have to destroy it." In fact, *Underwood* is anything but. "This is a very moody painting," Cleve comments, as if slightly putting it down. What seems to interest him in it is less the result itself than what it next led him to. "I considered this rich and rather luxuriant, with its complementary colors, so I started reducing again."

We turn to *Blue Circles* (page 114), a triptych that demonstrates some of that deliberate reductionism. It is closely related to *One, Two, Three,* owned by the Boston Museum of Fine Arts, so Cleve pulls out a transparency of that second triptych as well (page 115). "I wanted a thin line in *Blue Circles,* something very, very subtle. In *One, Two, Three* the line is broader, but both are much influenced by Japanese screens. The undercoat is the same color on all three panels of each. That underpainting helps unite the three separate panels."

I ask about the central image of *Blue Circles,* which strikes

OPPOSITE:
Each Other. 1979.
107 × 69″. Acrylic on canvas.
Berry-Hill Gallery

LEFT:
Underwood. 1980.
72 × 108″ (Triptych). Acrylic
on canvas.
Berry-Hill Gallery

me as representative of fruit. At first Cleve denies this, but then he contradicts himself by saying he was "again going back to Mu Chi's painting of pomegranates. Of course, I wasn't thinking of pomegranates. I was and I wasn't.

"I tried to give these circles a sense of weight. It wasn't a specific natural reference, but a specific feeling. The Chinese and the Japanese were always naturalistic; even when they seemed abstract, they never really left reality. I think this is what has made my work difficult for other people. I haven't been a naturalist or an abstractionist." It was at this time that he painted Boston's *One, Two, Three*.

"I carried on as far as I could the linear images I used in *One, Two, Three* into my Man and Nature series. Most of these were also triptychs, but they were almost entirely black-and-white, a void of white under which I had suggestions of very faint rose or ocher. The line was painted with Payne's gray, which I generally use instead of ivory black because it is quite transparent." After the series was shown by Betty Parsons, the earliest one (page 116) was

Blue Circles.
1980. 80 × 126″
(Triptych).
Acrylic on canvas.
Berry-Hill Gallery

acquired by Bob Buck for the Brooklyn Museum, and the acquisition was another example of the continuing support of Cleve's work by collectors Daniel and Joanna Rose.

While he showed the Roman Walls with Betty Parsons, in 1981, Cleve continued his Zen series with works on paper made with brush and bamboo pen. The following year he took the Zen idea further following a stay in Kyoto, where he and Francine, at the end of a lecture tour sponsored by the USIA, studied the city's famous Zen gardens. "I was particularly taken with the old monastic retreat of Rokuon-ji, its lotus pond set against the backdrop of Mt. Kinugasa; and, above all, the austere dry landscape of Ryoan-ji, consisting solely of raked gravel and fifteen rocks of various sizes. For me, Ryoan-ji was the most inducive to contemplation, at least the one that I could understand the best. It was a meditative experience, which was exactly what I wanted in my work."

One, Two, Three.
1980. 70 × 126″
(Triptych).
Acrylic on canvas.
Museum of Fine Arts,
Boston.
Daniel and
Joanna S. Rose Fund

On the plane home, Cleve began to plan his next group of paintings. These were to be "muted color depictions of rocks" in front of a white background. "Rocks and raked sand represented entire landscapes and had metaphysical meanings.

"In the earlier *Zen Gardens,* I was placing a lot of emphasis on the unifying rhythm of the black line, which was meant to be the space between the rocks. The basis of Japanese landscape, like the Chinese, is a moving focus, unlike the Euclidean basis of our own landscape. I tried to give some sense that you were not looking at rocks in a Euclidean geometric space, but as your eye—your soul, your focus—moved, you moved: the sensation you have as you meditate on these objects contains the sensation of the void between them, a kind of transparency."

I find these Zen Gardens (page 117) to be among the most moving of Cleve's work, the solidity and impassiveness of the rocks palpable against the fluctuation of air and sky and water surrounding them. These paintings seem to be about elementary materials. They truly evoke the substance of earthly life. Some have, in the right corner, the front porch of the monastery, and the juxtaposition of built structures within the natural universe is intriguing.

The Zen Gardens led to the marvelous Rocks and Water paintings of 1983 (pages 120 and 121).

Cleve is candid about their source of inspiration. "I got stuck. I was at one of those moments in my work when I had finished a group of paintings and didn't know what the hell to do. Francine and I took a walk. She said, 'I want to show you something I found.' She took me deep into the woods about a mile and a half from our house and showed me a good-sized stream. The water came rushing down over huge boulders, some of which were very flat. The whole thing was on a grand scale, intimate but very grand. Yin-yang: the water and the rocks. More yin-yang: the stillness and the movement. The transparent water and the opaque rocks. And the dark and the light. *Everything!*"

We look at the exquisite *Bonjour, Monsieur Courbet* (page 121), another in the Rocks and Water series. A couple of hours later, after lunch, I tell Cleve I would like to walk to that spot in the forest with him. He admits that he has not been there for several years, and he hopes he will find the paths. Walking stick in hand, he guides me through various bends and twists, past some tall pines that are his personal signpost, and toward the boulders. On the boulders overlooking the rushing water, we stand talking for quite a while. I am all too aware that in our world few people take this sort of time, engage in Cleve Gray's Thoreauvian noticing.

By 1984 he had started a new series, In Prague. These paintings came after a trip to the Czechoslovakian capital from Rome that Cleve and Francine took as guests of Ambassador William Luers and his wife Wendy. The experience of walking through the Old Jewish Cemetery near the Altneuschul Synagogue was a turning point.

"I was absolutely staggered," Cleve tells me as we face a group of the richly layered canvases that resonate with the forms and feelings of that visit. "The Jewish cemetery did something powerful to me. It freed me of my deepest fears, like a self-psy-

116

OPPOSITE:
Man and Nature #1.
1980. 100 × 65″.
Acrylic on canvas.
The Brooklyn Museum.
Purchased with funds given
by the Daniel
and Joanna S. Rose Fund

LEFT:
Zen Gardens #1.
1982. 70 × 60″.
Acrylic on canvas.
Neuberger Museum of Art,
State University of
New York at Purchase.
Promised Gift of Cleve and
Francine du Plessix Gray

118

choanalysis. It represented terrors I had fought against for a long time: the suffering of the Jews, the sense that I, too, might be dragged out in the night, the terrible submerged fear that I would reexperience what had happened to the Jews over the centuries." I picture the teenage Cleve Ginsberg with his ham radio set at Andover, listening to broadcasts about Hitler, feeling himself the outsider and potential victim.

"Seeing that cemetery was a frightening and moving experience. The graves are piled up, layers upon layers of tombstones: four centuries of Jewish tombstones, accumulating there because the Jews were not allowed to expand even in death outside the ghetto. Those stones spoke of the desire to dignify the human spirit in death. They became for me a metaphor for the indomitability of dream and prayer in life, at a time when hope seems impossible."

At this point Cleve locates a volume of the conversations of Franz Kafka. "You know, I have a favorite quotation from Kafka that I've often used when talking with students. 'Prayer and art are passionate acts of will. One wants to transcend and enhance the will's normal possibilities. Art, like prayer, is a hand outstretched in the darkness, seeking for some touch of grace that will transform it into a hand that bestows gifts. Prayer means casting oneself into the miraculous rainbow that stretches between becoming and dying, to be utterly consumed in it, in order to bring its infinite radiance to bed in the frail little cradle of one's existence."[16] The In Prague paintings before us are one such act of will, a means of suggesting a partial victory over loss (page 122).

This is true as well of some of the very last Zen Garden paintings Cleve was painting concurrently, the culmination of that large series. Here the rock has particular mass, while the water is penetrable. Yet everything is part of the same universe, both palpable and spiritual, imbued with an Oriental sense of grace.

Cleve's last show with Betty Parsons had been in 1983, when she devoted an exhibition to his Zen Gardens. Parsons died later that same year. It was a severe loss to her many friends and admirers and to the contemporary art world. Some In Prague paintings were shown in 1984 at New York's Armstrong Gallery, and the Fairweather Hardin Gallery in Chicago devoted a show to some of the Zen Gardens. As Cleve's work continued to be represented in various museum and gallery shows, these two galleries were both to give him solo exhibitions in the coming years.

The tragedy implicit in the In Prague paintings led to Cleve's Holocaust works of 1985,

Zen Gardens #116.
1983. 68 × 70".
Acrylic on canvas.
The Wadsworth Atheneum,
Hartford, Connecticut.
Promised Gift of Cleve
and Francine du Plessix Gray

twenty-one acrylics on paper, painted at the American Academy in Rome. He looked upon these works on paper as "a catharsis—as a human being, not just because I was born Jewish. This was a problem for all of humanity, not just for Jews. When I painted those papers, I believed that I had to make the forms of the human bodies quite apparent. Without a certain clarity in the subject matter, I felt there was no way of properly approaching the issue." Later, part of the Holocaust group was on canvas. He entitled this group Sleepers Awake. Unlike the earlier paperworks, these were in life-size scale and dark colors. For the works on paper, he had interjected one of his characteristic twists: he used bright hues. He believed that color might be a way of enticing spectators to look at a horrible subject—an ironic use of color.

121

In Prague #28, #29, #30. 1984.
Triptych: each panel 59 × 40″. Acrylic
on canvas. Neuberger Museum
of Art, State University of New York
at Purchase. Promised Gift of Cleve
and Francine du Plessix Gray

OPPOSITE:
Sleepers Awake! #27. 1985.
55 × 65″. Acrylic on Canvas.
Berry-Hill Gallery

"There followed in 1986 some much larger Holocaust paintings, the final one of which was *Conclusion* (page 124)." But the title was a bit of a misnomer; Cleve took up the theme again in 1989. "In the years between, however, I found I needed a more redemptive outlook. The need gave rise to a transformation of the dead souls into resurrected beings. As the Resurrection has to be an epic event, I had to increase still further the size of my paintings. *Red and Blue Resurrection*, for example, is over twelve feet across (page 125).

At an impasse after his struggle with the large Resurrection paintings, Cleve turned to an idea he had harbored for many years. He had collected a remarkable photograph of Anton Bruckner from a concert program in Rome. To him, the musician's head looked powerful yet almost half-witted. "How could such a head make this kind of music? I thought it might be interesting to try painting this head starting from the photo image. What would I find? How would it translate into music? It resulted in *Four Heads of Anton Bruckner* at midyear, after

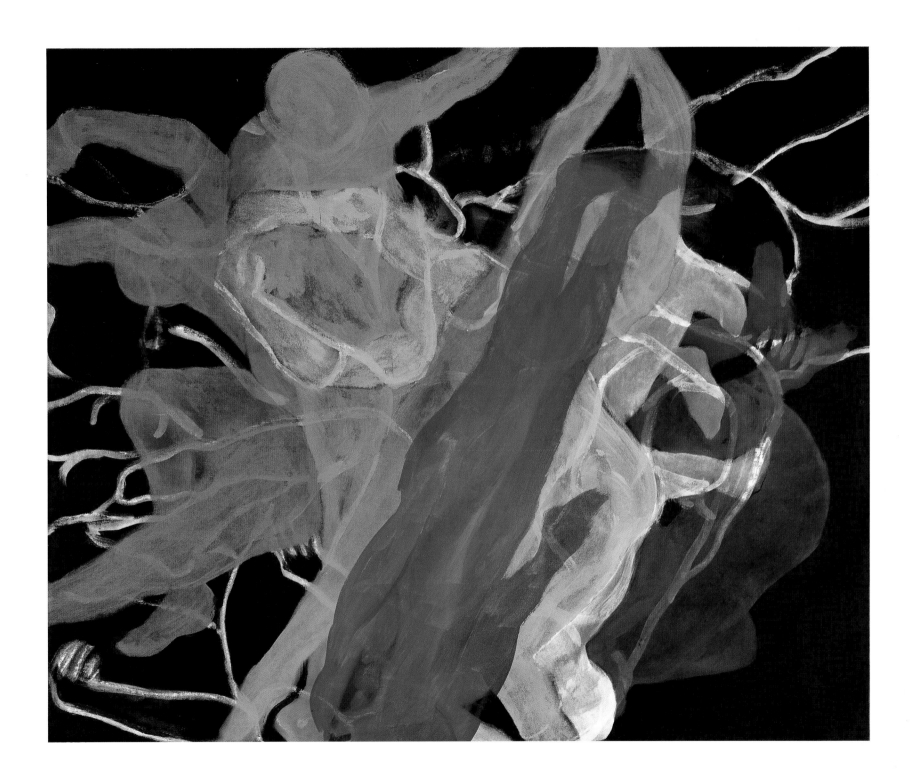

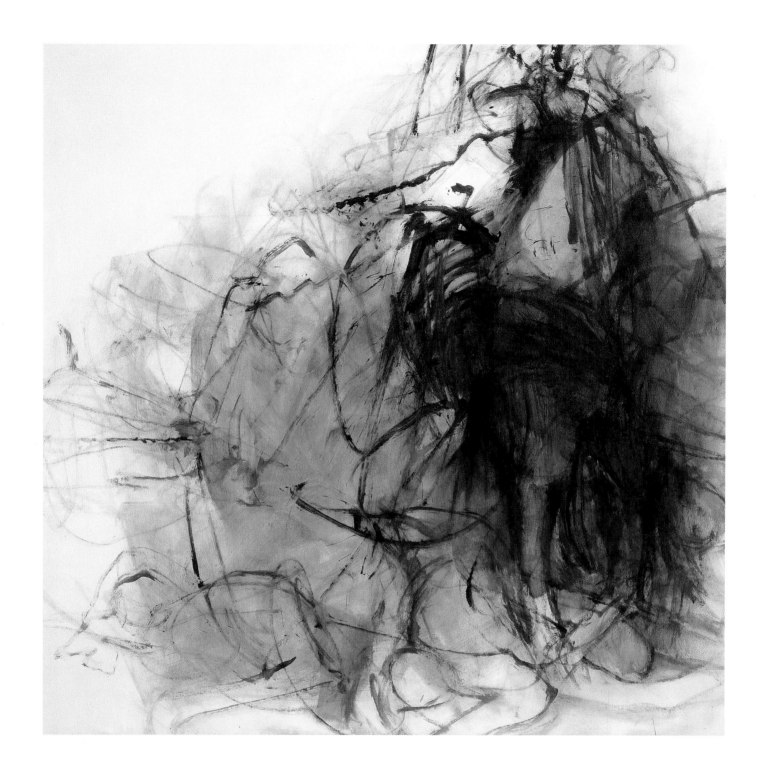

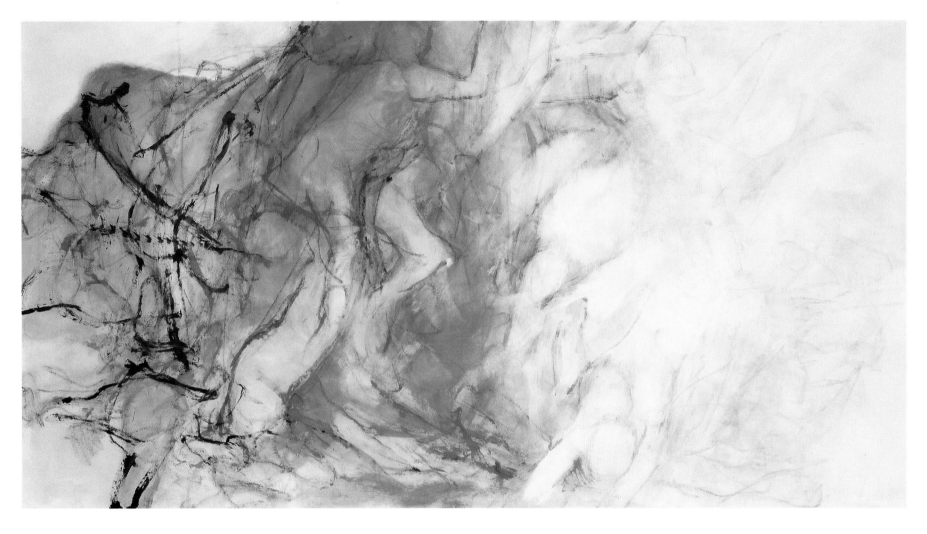

which I set myself back on track and did some good abstract canvases."

The four heads of Anton Bruckner of 1987 (pages 126–127), exhibited at the Wadsworth Atheneum in 1996, are now in the museum's permanent collection.

Red and Blue Resurrection.
1986. 81 × 146″. Acrylic on canvas.
Berry-Hill Gallery

OPPOSITE:
Conclusion. 1986.
90 × 89″. Acrylic on canvas.
Berry-Hill Gallery

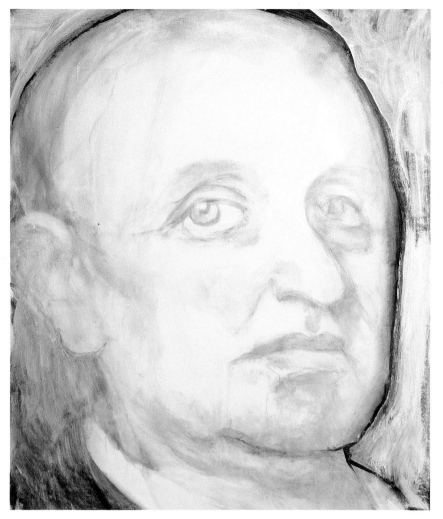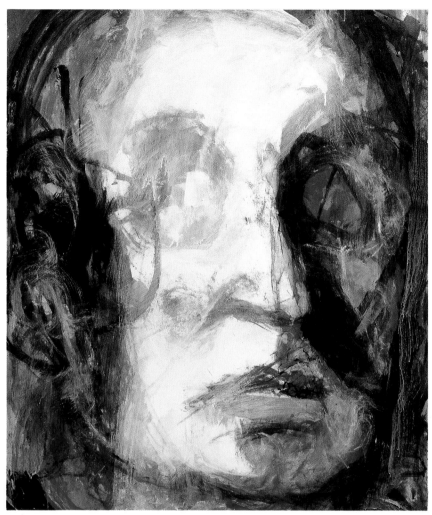

Four Heads of Anton Bruckner.
1987. #1, #2, #3: 60 × 50"; #4: 62 × 52".
Acrylic on canvas.
The Wadsworth Atheneum,
Hartford, Connecticut.
Promised gift of
Cleve and Francine du Plessix Gray

V

Francine and Cleve Gray
with their sons, Thaddeus and Luke,
at the Governor's Award Ceremony,
Hartford, Connecticut, 1987

OPPOSITE:
Station. 1988.
60 × 9 × 8'. Acrylic and paper collage
on walls, ceiling, and floor, and on
plywood constructions.
Paris–New York–Kent Gallery,
Kent, Connecticut

In each of the large storage buildings in Warren, there are so many paintings that little room is left to move them around. They are like gigantic picture libraries in which more space for further stacks are desperately needed. Sometimes there have been entire series comprising as many as seventy-five paintings on paper or canvas that we have had to skip over entirely. For Cleve's achievements of the late 1980s were prodigious.

In 1987 *Threnody* was reinstalled at the Neuberger Museum. That same year, the Brooklyn Museum mounted a small retrospective exhibition, "Cleve Gray: Works on Paper 1940–86." The artist received the Governor's Connecticut Art Award from the Connecticut Commission on the Arts. Early in 1986 he had been asked to compete for a commission to make a work that would be placed on the rear facade of Union Station at the Hartford Transportation Center. He underwent quadruple-heart-bypass surgery the following year, and not long after he returned from the hospital, he was awarded the commission. His proposal entailed a 683-foot-long porcelain-enamel-on-steel-tile work entitled *Movement in Space.* As with *Threnody,* he handled the monumental scale with gusto and bravery. "After my surgery, I didn't suffer from the postoperative depression that seems to affect many heart patients. Perhaps it was because I had just won the commission of the Hartford Transportation Center and saw the first stages being completed; I was buoyed up."

In the late spring of 1988, Cleve also completed *Station,* an onsite environment composed of painted paper and wood and installed by collage and staples in "the caboose," an empty railroad car that had been transformed by the collector Jacques Kaplan into the Paris–New York–Kent Gallery in Kent, Connecticut. Because the work was taken down as planned a few months after its installation, it exists today only in photographs. But it remains among Cleve's favorites within the body of his work. One can see why; it placed the viewer within a veritable Cleve Gray world, his own version of Kurt Schwitters's *Merzbau,* a universe in which abstraction surrounds and stimulates the viewer in every direction. Cleve included a large

128

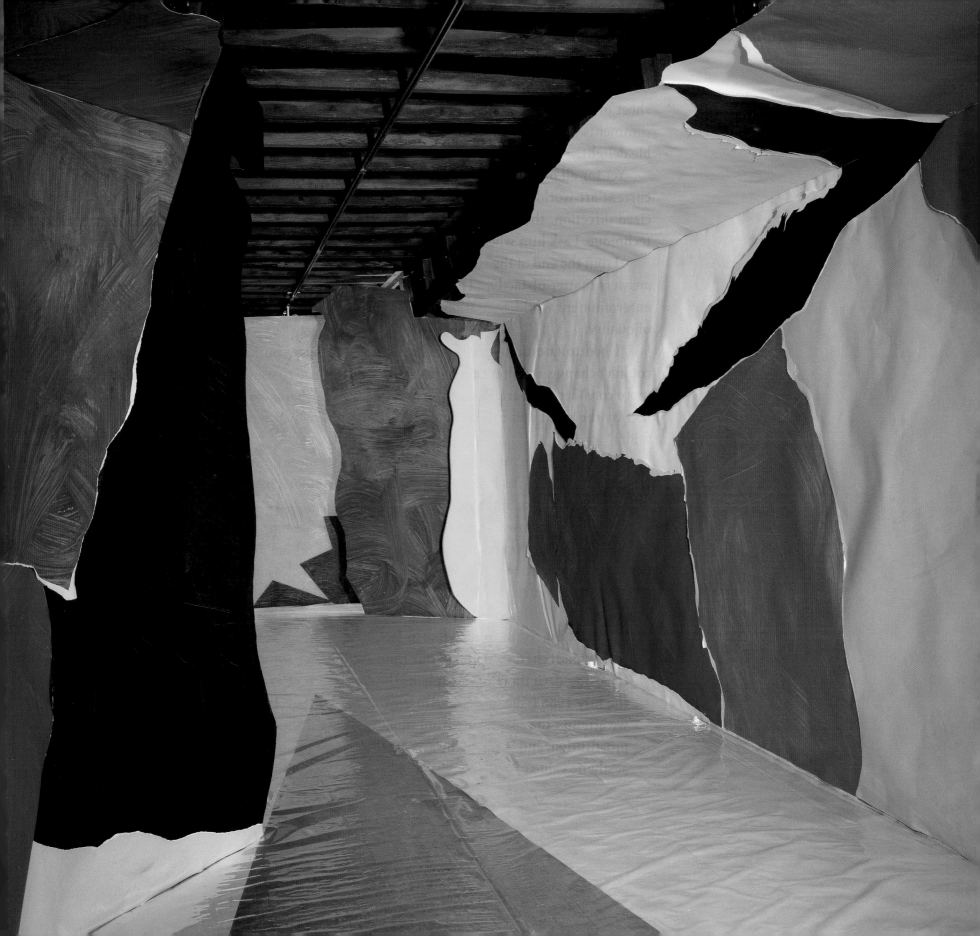

sheet of white paper at one end of the caboose on which spectators were asked to write their comments. "One woman wrote she felt 'like a bee inside a flower,'" Cleve tells me with visible delight.

Yet for all of his successes, I am aware of how often Cleve has bemoaned the state of the current art world: its commercialism and trendiness, the obsession with celebrity, its politicized direction, the precedence of extraneous theory and intellectualization over painterly technique. I ask him when, in his eyes, the art world reached its present state of catastrophe.

"From the end of the sixties, when Andy Warhol and others of his ilk came around," Cleve answers matter-of-factly. "The real catastrophe occurred when the art world turned into the entertainment world. Sensationalism. The idea that a work of art no longer has to be a work of quality.

"I had to question what I was doing. Make up my mind if I was right or wrong. But I couldn't change. I couldn't betray my own beliefs. I had to wait and see if the world would once more consider good art. Part of the problem was Duchamp's saying a work of art was painted half by the artist and half by the public. Unfortunately, there is a demonic truth to what he said.

"For me the goal of a work of art is to attain a more contemplative relationship with the rest of the world. If it's just there to titillate or stimulate, it's not enough. So much of today's art is a one-line joke. If it's told once, it's over."

Just as he had thrown caution to the wind in publishing "Narcissus in Chaos," Cleve wrote a similarly forthright article, "Seduction and Betrayal in Contemporary Art," that was published in *Partisan Review* in 1989. He did not pull punches about what he perceived as the prevailing corruption:

> Some art critics, quite a few in fact, readily accept venal motivations as being no more than typical characteristics of our time. Acceptance without discrimination is indeed a key to postmodern thought. It explains the comments of a critic like Carter Ratcliff, writing in the July 1988 issue of *Art in America*. . . . Ratcliff declared that we are misguided if today we attempt to separate art from money. . . . He does not praise or deplore this seduction, prostitution, and betrayal; he accepts it, declaring that money has now become part of the aesthetic value of art.[17]

Cleve goes on to examine the history of this syndrome and to deplore its many manifestations in the current art scene. Nothing could be more counter to his own beliefs than this corruption of the faith that had swayed him from early childhood and that he found to be so gloriously manifest in the art he believed in.

As for that relationship between art and financial success, Cleve's words in *Partisan Review* fit in with a discussion we have late one afternoon in Connecticut. "It's one of the great blessings I've had, that I didn't have that much worldly success. It too often makes people's work deteriorate. Especially when millions of dollars go to living artists. It diminishes their capacity for self-criticism. How can they resist this? Success goes to the head."

This prompts me to ask Cleve whom he most respects among his fellow painters at work today. "I admire very few living artists," he says, "though just as I say that I think with admiration of Balthus, Ellsworth Kelly, Sigmar Polke. But I'm totally consumed with where I want to go, and no one but myself can get me there."

These ruminations inspire me to lead Cleve toward some further self-assessment, some form of summing up from his current vantage point. "It sounds arrogant to say, but I have no regrets about anything. I know I've made mistake after mistake, but at the time I thought everything out carefully and did the best I could. I don't see any use in saying, 'I'm sorry, I shouldn't have done that.' Perhaps I should have known better, but I didn't.

"I find myself as lucky as anyone who's ever lived. To have met Francine, to have produced these two wonderful young men, to have done the work I loved. I mean: how lucky can you be? To have lived in physical comfort: all this is fortunate beyond hope. To work to the end of my life without great physical pain, I hope."

Sometimes it is hard to determine what Cleve's single greatest priority is—work or family—although he seems like someone who would have consciously thought the issue out. Indeed, he has an answer when I query him on the subject of his priorities. "If I had to stop painting for the sake of my wife or sons, I would. I only say this now, never before did I believe I would feel like that."

But happily he was never put to the choice. "I fell from one lucky thing to another, a series of incredibly fortunate events. To be an American: how lucky can you be? The adversities one has, I learned from them too: the army, and before that Andover anti-Semitism and the early death of my sister.

"You can look at Fra Angelico and at Oriental hanging scrolls, and you've got a lot to live

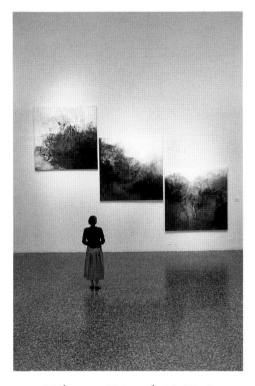

Holocaust Triptych #1 (Fire)
as seen at the Museum of Fine Arts,
Houston

up to. It takes an awful lot of cheek, of nerve, to try to produce any art worth making. And generally I don't know where I'm going to go. I just want to keep moving. We're talking about continuity. I don't want to betray myself, but I don't know where I'm going to go." In these somewhat rambling words, I feel both his exuberance and his perpetual questing, his pride and his modesty, his skepticism and, above all, the strength of his beliefs.

Those beliefs made an unexpected demand on him at the beginning of 1989. "I returned to the Holocaust theme, which I thought I had abandoned in 1986. Apparently I wasn't satisfied with much of that work; I began to destroy a large part of it.

"I hadn't made the kind of statement I wanted; I had been enticed away by my Resurrection series. By chance, I was offered a possible commission to paint a large Holocaust work for a New York City synagogue. The rabbi was enthusiastic about the idea, and I was, too, when I learned there was an excellent wall for a large work that led from the lobby to the sanctuary. I painted two big triptychs; the first I subtitled *Fire*. The lines were intense blues, reds, and oranges. The second I subtitled *Ashes,* for the hues had the pallor of bones and ashes. When I finished the two works, I heard that the rabbi had suddenly died and that the synagogue was no longer interested. The first triptych is now in the Museum of Fine Arts in Houston. The second is in my warehouse. But the return to realism was an interruption, and that chapter was closed."

Cleve's 1989 *Three* (page 134), leaning against a stack of canvases in front of us, led the way back to a return to abstraction in a group of paintings that Cleve considers among his very best. It strikes me as a splendid exaltation of the values he cherishes, and whose violation he deplored in *Partisan Review* and in our conversation. And in front of *Three* something extraordinary occurs. Cleve, for once, agrees when I say it's a wonderful painting. This self-approval is rare. "I know it's exactly right. I don't think anyone in my time has done anything much better."

The painting offers a rare voice of serenity. It embraces both Cleve's American transcendentalism and his Asian feeling for nature and for abstraction. "I feel good because I keep renewing myself. I can't worry about the state of the art world." While this is not entirely true—like all committed artists, Cleve cannot help noticing what is happening around him, but persists on his own way.

"In my abstractions of late 1989 I was striving for profound serenity in a way that was

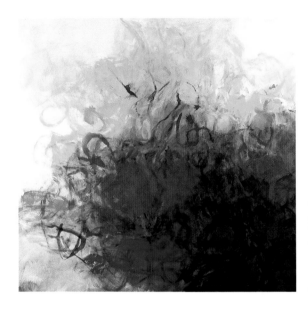

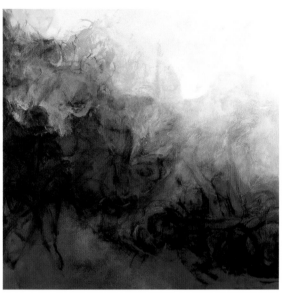

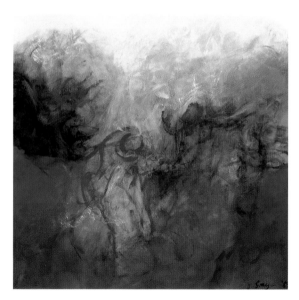

Holocaust Triptych #1 (Fire).
1989. Each panel 72 × 72″.
Acrylic on canvas.
The Museum of Fine Arts,
Houston. Gift of the artist in
honor of Joanna and
Daniel Rose

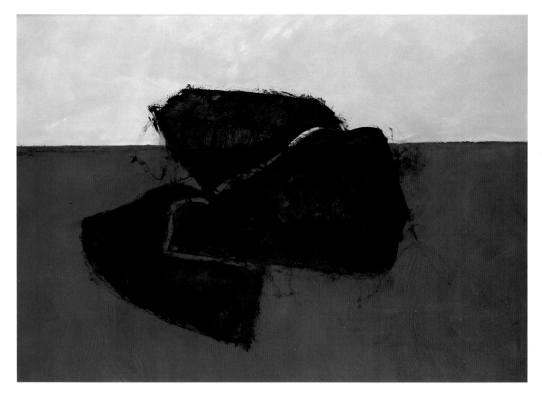

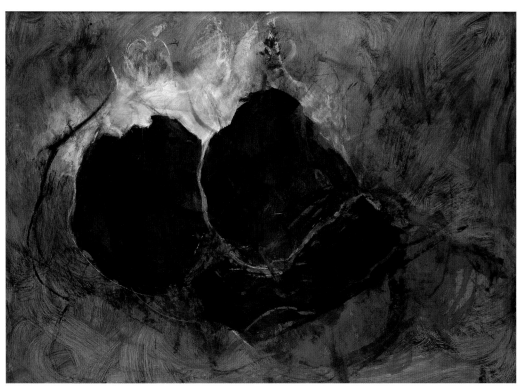

technically interesting. In my efforts to simplify my modes of expression, I turned once again to the emphasis on line that was manifested so clearly in 1981 in *Blue Circles* and *One, Two, Three*. But the subject matter was quite different in its suggestions of outer space. Very restrained, in color as well as emotional subtlety, some of the works revolve around the idea of the Big Bang, (*Tycho's Fruit*, page 136) and early concepts of cosmological events. It was to return to this interest in the cosmos five years later.

In a catalogue for his Berry-Hill exhibition in the spring of 1990, Cleve wrote an introductory essay entitled "The Painted Line." It explains his concept of "the dominance of Idea" in contemporary painting. "Line," he wrote, "is the most abstract element in a painter's arsenal. It is an invaluable illusion, which has no actuality in nature but springs entirely from emotion and contemplation; and as a result, it evokes a struggle with the medium."

The subject matter gradually became more earthbound in 1990, the same year that the Berry-Hill Gallery began to represent his most recent work in New York, initiating a sequence of regular solo exhibitions. Cleve continued his phases of simplification and reduction that generally follow the periods of lushness and complexity. We pull out a group of his Broken Horizons. "For so many years I was trying to do the simplest painting I could do. I wanted to make an artwork with one line. One brush line going across in space. Extremely minimal. Those were the beginnings of the Broken Horizons as well as the Lovers series and the Edge series, a very simple line." In the fluctuations

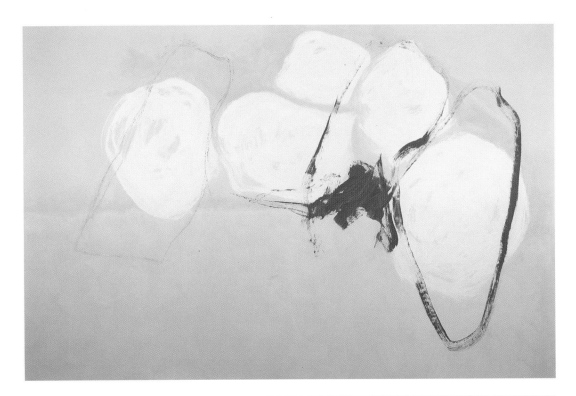

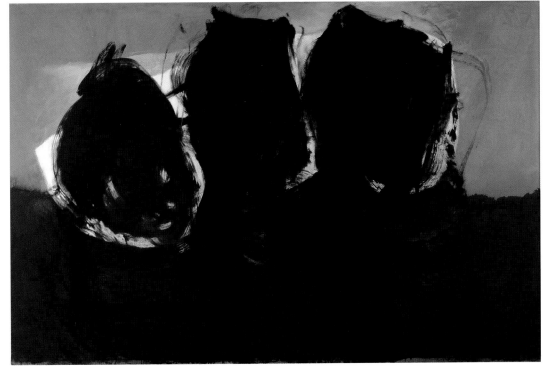

OPPOSITE TOP:
Three.
1989. 60 × 80″.
Acrylic on canvas.
Berry-Hill Gallery

OPPOSITE BOTTOM:
Breaker #2.
1987. 55 x 77″.
Acrylic on canvas.
Berry-Hill Gallery

RIGHT TOP:
Correspondence.
1988. 76 × 112″.
Acrylic on canvas.
The Art Museum,
Princeton University.
Museum purchase,
gift of Mr. and Mrs.
Daniel Rose

RIGHT BOTTOM:
The Troubled Sea.
1989. 75 × 112″.
Acrylic on canvas.
Berry-Hill Gallery

Tycho's Fruit.
1989. 50 × 70″. Acrylic on canvas.
Berry-Hill Gallery

Night Lovers.
1989. 53 × 71″. Acrylic on canvas.
Berry-Hill Gallery

of his work, these paintings represent the beginnings of his most severe distillation of line, color, and image, which was to reach its apogee two years later.

A large group of paintings followed: Considering All Possible Worlds and What is the Question? series. Cleve describes these as, "A meandering line made with one movement across a void, a line that, like the titles, was quite ambivalent in its imagery."

The Considering series culminated in the Thrusts of 1993 (page 140). As we look at a group of these and talk about them, Cleve, in a Zenlike pose, is seated on the floor of one of his art storage barns. It is a clear, dry, summer day, and he is diverted from his work by the open door. "That maple tree is so beautiful," he says quietly.

Looking at the Thrusts, he tells me, "The background of these paintings vibrates with energies set up by the brushwork and the underpainting. My void always has to be an active void, so that you have a background of space, not of flatness." That contradiction—a void, which is to say an absence of action but at the same time is active—a charge of energy within the void is what I want. That is essential."

On top of the underpainting, he would create his single-gesture Thrusts. "I would twist and turn, lift and lower, my loaded brush as I continued my voyage straight across the canvas. Later I began to apply one color on one side of the brush and another on the reverse, using both as I moved only once from one end to the other."

The Thrusts, of course, took an abstract image and an idea to their ultimate extreme. What came next in 1993 was the Collage series. "I felt I had gone as far as I could go as an artist, philosophically and in the execution of the paintings. Those Thrusts were a climax of my work. I have always felt that painting should be visual philosophy; I felt I had achieved a good moment in my work with them. So I had to move on, do something totally different."

Hence the Collages. "I had done a few collages that Betty Parsons had liked in the 1960s, when she showed them; they were obviously related to Oriental art. The works of 1993 were entirely Western in spirit."

At this point I became worried about the sheer number of series Cleve made, the volume of works within each series, the difficulty in evoking his many creative facets and doing justice to each, the magnitude of this book. At times we have decided not to give even cursory reference to entire bodies of work. But after Cleve has invited me to leaf, as it were, through his picture racks to see a dozen or so of these Collages (many of which are my height or larger), I was so excited by them that I had to include at least one (page 141); the only diffi-

Considering All Possible Worlds
(Blue on Yellow).
1990. 60 × 90″. Acrylic on canvas.
Berry-Hill Gallery

Blue-Green Thrust on Red.
1993. 43 × 81″. Acrylic on canvas.
Berry-Hill Gallery

Green Thrust on Yellow.
1993. 40 × 70″. Acrylic on canvas.
Berry-Hill Gallery

Big Yellow.
1993. 60 × 96″.
Collage: acrylic on canvas.
Berry-Hill Gallery

culty was in having to eliminate some of the best. As I spread them around the art storage space, Cleve explained that he had saved many discarded paintings on canvas, and had cut them up, hopefully for future assemblages.

My initial reaction is that the collages represent in part a return to certain ideas prevalent in Matisse's cutouts. Again, because of years of experience with artists who ardently eschewed any reference to their sources or influence, I hesitate to say anything. But then Cleve remarks, as he points to the last works in the series, "You see, I had to get away from Matisse. The first ones surely show his influence, but before long I moved ahead alone."

If anything, unlike more egoistic artists, Cleve is reluctant to acknowledge his own originality. He often makes references to Villon or Cubism or Chinese art or Matisse without crediting himself adequately for the inventiveness with which he has transformed those sources.

The Collages float. They have a unique esprit. They relate to Cleve's earlier Rocks and Water paintings in the sense that they are static and fluid at the same time. They are obviously about torn and cut canvas, but they also have an Eastern quality. Graceful, weightless, vibrant.

"Following the Collages, I had reached one of my impasses. Meanwhile, there was a painting that I had had in my studio for several years but had not been able to figure out how to finish; it was too crowded. Finally realizing it needed more space, I added a third panel to the left and made some small adjustments to the rest of the painting. The image just sprang into its place." The work, *Reach*, is appropriately named for its impression of springiness and energy as well as for the artist's perpetual endeavor.

"Once more I had to do something very different," he says, looking at his Imaginary Landscapes of 1994. "These are much more consciously based on Chinese painting. I continued with the broken horizon line and the landscape above it." This is, of course, a renewal of familiar themes: the personal mix of landscape and abstraction, the influence of Oriental art, the wish for simplification. Cleve has long been consistent in his concerns and passions. Yet at the same time these paintings represented a new direction for the seventy-five-year-old artist.

If we accept the ambivalence in Cleve's work, the invitation to multiple readings, and if we know what he has painted before, these Imaginary Landscapes offer vast possibilities. They read as mountain scenes and as rocks, as close-ups of female breasts and thighs, even as uteri. They present another planet—light years away from Earth—and the rocks we find outside the studio door.

These paintings are quintessentially modern and liberated, very much of the late twentieth century. Yet in their color and form and texture they echo the cave paintings of Lascaux: virtually the start of graphic imagery. This is in part because we feel in full immediacy the artist's craving to evoke and capture, to record his theme and at the same time to imbue his subject matter with its inherent magic. When I suggest this relationship to cave painting, Cleve tells me I am not the first person to have seen it, and that the comparison pleases him. "I would be happy to get that emotion, and the intensity."

These Landscapes are also form and void, monumental weight and complete ethereality. They are simultaneously veil and sculpture, painted canvases in which foreground and background interweave.

It is hard, in a way, to accept these seemingly simple, yet optically and intellectually complex, works as creations done in Connecticut in 1994. They have too much history, too many visual and philosophical layers. The line is so pure, simple, and Zenlike.

The paint may be acrylic, but who can believe that? It looks like chalkdust, like cave walls, like those faded bricks that caught the young Cleve Gray's eye as he walked through London after the blitz, like the muted rocks worn by centuries of flowing water in the streambed to which Francine led him that day in the woods when he was momentarily wanting in inspiration.

They are, indeed, as the artist so aptly named them, imaginary landscapes. As such, they lead us to new appearances and previously unknown spiritual realms.

We look next at the Golgotha series of 1994 that followed the Imaginary Landscapes. In the last of these—*Apparition* and *Orange Apparition* (page 144)—the skull on the hill of the Crucifixion has turned into a celestial image against a linear spatial division of a type Cleve has often done before. These works, in turn, led to the Firmament series: the third major group

Reach.
1994. 76 × 114″
(Triptych). Acrylic on canvas.
Berry-Hill Gallery

Orange Apparition.
1994. 40 × 60″. Acrylic on canvas.
Berry-Hill Gallery

of paintings from 1994 and a subject he was to return to in 1997.

"While I was up in the sky with my Firmament series, I started reading Aeschylus's *Oresteia* trilogy in Robert Fagle's translation. That's how the idea came to me for the Eumenides series. All of these Furies swoop down out of the heavens.

"I wanted a feeling of imminence. You felt the Furies, my images, were descending on you, attacking you. I cannot make a painting with no idea, no subject matter; but the inspiration can vary from a Greek tragedy to a still life to Zen thought."

The Eumenides (pages 146 and 147) were, in fact, one of the starting points in Cleve's and my discussions. A fine one hangs in Cleve and Francine's living room. Some of the Eumenides are often leaning about in the studio. They were exhibited at Berry-Hill Gallery in 1996, and a suite of five have just been acquired by the Colby College Museum of Art.

Again, it was the artist's wife who prompted him to look in a new direction that made a great difference. "Francine's been marvelous. She introduced me to the *Eumenides.* I was overwhelmed when Aeschylus describes those Furies as they come screaming out of the sky to punish the guilty people.

"I painted the images first without a black outline, but that didn't contain the power of the Furies. So I put in the black line, it was not a real outline of the form, I broke it up, Cézanne-style, a Cézannesque *passage,* to have the form come into the void, and the void into the form, to have it spread into the three-dimensional, or I might say four-dimensional. My black lines were broken so that they both contained and released the Furies." As receptive as Cleve is to nature, to history, and to the realities of human behavior, he is uniquely attuned to the craft of painting.

"Then came the Processions," Cleve informs me, as we pull out the much smaller works that followed the Eumenides (page 148). "With these I use a thin line rather than a thick. There's a counterpoint between the black line and the flat, colored canvas. The yellow's a coun-

144

Blue Firmament.
1994. 70 × 60″. Acrylic on canvas.
Berry-Hill Gallery

Imminence #26.
1995. 70 × 55″. Acrylic on canvas.
Berry-Hill Gallery

OPPOSITE:
Imminence #19.
1995. 80 × 75″. Acrylic on canvas.
Berry-Hill Gallery

147

Procession #14.
1996. 36 × 50″. Acrylic on canvas.
Berry-Hill Gallery

terpoint to the black, and the black to the yellow, the rhythm, the interplay between the two."

Cleve keeps a statement from Hokusai, set in large type, inside his studio door:

> I have been in love with painting ever since I became conscious of it at the age of six. I drew some pictures I thought fairly good when I was fifty, but really nothing I did before the age of seventy was of any value at all. At seventy-three I have at last caught every aspect of nature—birds, fish, animals, insects, trees, grasses, all. When I am eighty I shall have developed still further, and I will really master the secrets of art at ninety. When I reach a hundred my work will be truly sublime, and my final work will be attained around the age of one hundred and ten, when every line and dot I draw will be imbued with life.

Health problems, the pulls of a complex life: nothing could keep this tenacious, impassioned painter from moving on. And from offering further surprises. Although others might consider them an anomaly in his work, I am particularly excited by Cleve's 1995 Imaginary Still Lifes.

Francine recounts the circumstances of their making. "These paintings were initially a response to the exigencies of his health. He was suffering from intolerable pain caused by three degenerated disks, and while awaiting surgery, he couldn't stand on his feet for more than a minute at a time. Since he's incapable of doing any abstract work without standing on his feet and moving around, I suggested that he do a series of still lifes, and we made small round pillows to put on high stools. Cleve would endure three consecutive surgeries in the following five months, the first to cure his back; the second to implant a shunt in his cranial cavity, the third to remove a resulting hematoma. All three were brilliant successes." It was between the second and the third of these surgeries that he created the four large panels of *Elements IV* for Dallas.

The Etruscan Pitcher.
1995. 50 × 60″. Acrylic on canvas.
Berry-Hill Gallery

The Still Lifes are enchanting not only because they are a further adventure for this adventurous artist, but also because of their ambient warmth and plenitude. Although Cleve suggests that we need to stop somewhere, that perhaps it is not necessary for me to place each and every one of these canvases around the room, I don't agree, in part because I am enjoying myself so much. The nourishment and refreshment provided by these lovely Still Lifes is irresistible. "When I was in too much pain to work, I used to go to the market, with or without Francine, and I would look at these different fruits and vegetables—the tomatoes and peppers and whatever else was there—for a long time. I painted them from memory or imagination.

"I scrubbed on a green background color, and then scrubbed white over it. Often, with the second step, I used a sponge; of course the underpainting has to be dry. Translucency, air, the

149

Leeks.
1995. 50 × 60″. Acrylic on canvas.
Berry-Hill Gallery

juxtaposition of translucencies fascinates me. Then I did my vegetables.

"At first I had no idea where to place each vegetable or piece of fruit. I just started with one and moved to the next. After I did the produce, I did the jug. Then I tried to break up the jug so that it would be in keeping with the less realistic peppers. To achieve all that, I used newspaper to take away the excess of paint. Then I would rub in some of the paint that was left on the paper, and reapply the red, green, and yellow. It's not a unique practice; de Kooning did that. The use of accident is very important; if it's a good accident, it leads you in a direction you didn't expect. Thank goodness acrylics dry so quickly; they make so much possible."

I ask Cleve if he paints in silence or with music. "I either turn on the radio or use CDs when my fingers are not too full of paint, mostly chamber music. But if I didn't have the back-

ground music, my mind would wander from work: to household problems, children's problems, financial problems. Music fills up the problem-full space."

Cleve tells me in his calm, steady voice, "It's very revivifying to go back to nature." Yet he emphasizes that the transformation of nature is essential, that memory and imagination matter as much to him as the recording of reality. "Of course, my portraits are imaginary too," he remarks, with reference to the Bruckner and Mahler and Bartók paintings, as well as to his other representations of the human face.

On the other hand, he does not see the Still Lifes as representing a lasting change. "This was something to fill in an emptiness," he says wistfully. "I would never go back to that realism again. When I paint again"—a combination of health problems, the work on this book, and preparation for his major exhibition have clearly forced a hiatus in his work—"I have in mind to paint Heisenberg's ideas of indeterminacy.

"I was reading a compilation of writing about science from the beginning of time to the future. It is based on the most beautifully written texts. Einstein believed that all life is predetermined, that nature was not an accident, that everything from the smallest neutron to the greatest astronomical bodies was made with a unified scheme.

"Along came Heisenberg with his theory of indeterminacy. Totally different from Einstein's theory of relativity, or so my kindergarten version of physics goes. It interested me because of the accidental aspects, yet it was not destructive, it was constructive and positive.

"I can almost but not quite visualize these future paintings. Everything has to come out of feeling. Years ago I would see something beautiful, and I would make a drawing of it. Then I would bring it to the studio and tack it to the wall and make a larger painting from it. Now I am dealing more with abstract thoughts and abstract emotions. It's more challenging."

By the time I went to see him again, in September of 1997, after a hiatus of six weeks, Cleve had made one of his most successful abstractions ever, in many ways like an underwater universe, full of shimmering depths, yet quite unlike anything we have ever seen before (pages 152 and 153).

Those paintings of the future were once more being made.

The Separation of Continents #1.
1997. 60 × 84″. Acrylic on canvas.
 Berry-Hill Gallery

The Separation of Continents #6.
1997. 50 × 70″. Acrylic on canvas.
Berry-Hill Gallery

NOTES

1. Italo Calvino, *Difficult Loves,* trans. William Weaver (San Diego, New York, and London: Harcourt Brace Jovanovich, 1984), pp. 55–56.

2. Thomas B. Hess, "Calculated Risks," *New York Magazine,* November 17, 1975.

3. Jacques Barzun, letter to Philip Johnson, April 10, 1975.

4. Jacques Barzun, letter to Jeffrey Hoffeld, May 27, 1975.

5. Cleve Gray and George Rowley, "Chinese and Western Composition," *College Art Journal* 15, no. 1 (fall 1955), pp. 6–17.

6. Jacques Barzun, "Purpose in Paint," exh. cat. (New York: Jacques Seligmann Galleries, October 1, 1950).

7. Cleve Gray, "Jacques Villon," *Perspectives USA* (spring 1953), pp. 68–78.

8. Cleve Gray, "Narcissus in Chaos," *The American Scholar* 28, no. 4 (autumn 1959), pp. 433–43.

9. Cleve Gray, foreword to *John Marin by John Marin* (New York: Holt, Rinehart & Winston, 1970), p. 8.

10. Ibid., p. 14.

11. Thomas B. Hess, *Cleve Gray,* exh. cat. (Buffalo, New York: Albright-Knox Art Gallery, 1977).

12. Cleve Gray, statement of February 2, 1975, at Saint John's Parish, Washington, Connecticut.

13. Robert T. Buck, Jr., foreword to *Cleve Gray,* exh. cat. (Buffalo, New York: Albright-Knox Art Gallery, 1977).

14. Hess, *Cleve Gray.*

15. Daniel Robbins, "Cleve Gray's Recent Work," *Art International* (November 1979), pp. 118–19.

16. Gustav Janouch, *Conversations with Kafka* (New York: New Directions, 1971), pp. 47–48.

17. Cleve Gray, "Seduction and Betrayal in Contemporary Art," *Partisan Review,* vol. 56 (November 3, 1989), pp. 357–68.

CHRONOLOGY
by George Lechner
Adjunct professor of Art History, University of Hartford, and Archivist, Cleve Gray Collection

1918 Born September 22, in New York City.

1924–32 Attends Ethical Culture School in New York City.

1929–33 Begins formal art training in New York with Antonia Nell, a pupil of George Bellows.

1933–36 Attends Phillips Academy, Andover, Massachusetts; studies painting with Bartlett Hayes. Wins the Samuel F. B. Morse Prize for most promising art student.

1936–40 Attends Princeton University and graduates summa cum laude, with a degree in Art and Archaeology. Studies painting with James C. Davis and Far Eastern Art with George Rowley, for whom he writes his thesis on Yuan dynasty landscape painting.

1940–41 Lives for several months after graduation in Mendham, New Jersey; then moves to Tucson, Arizona.

1942 Exhibits landscapes and still lifes at Alfred Messer Studio Gallery in Tucson before returning to New York to join the United States Army.

1943–46 During World War II, serves in England, France, and Germany, where he makes color drawings of wartime destruction. After the liberation of Paris in August 1944, studies informally with André Lhote and Jacques Villon. After the war, continues studies with Lhote and Villon under the GI Bill. Exhibits Paris work at Galerie Durand-Ruel, *American Painters in Paris*.

1946–47 Returning to New York, paints London Ruins series, working on it through 1948. *New York Times* critic Edward Alden Jewell picks Gray's painting *London Ruins #1* for *Critic's Choice* exhibition at Grand Central Art Gallery, New York City. Joins Jacques Seligmann Gallery and has first solo New York exhibition. Exhibits at Whitney Museum of American Art, New York, *Annual Exhibition*; Metropolitan Museum of Art, New York, *Paintings of the Year*; Toledo Museum of Art, Ohio, *Abstract and Surrealist American Art—34th Annual*; Research Studio, Maitland, Florida, *Eighteen Young American Painters*. Returns to Arizona.

1948 Travels and draws throughout France and Italy. Exhibits at Jacques Seligmann Gallery, New York, *London Ruins*; Art Institute of Chicago, *58th Annual Exhibition*; Worcester Art Museum, Massachusetts, *Biennial Exhibition*.

1949 Moves to Warren, Connecticut. Exhibits at Jacques Seligmann Gallery, New York; Corcoran Gallery of Art, Washington, D.C., *21st Biennial Exhibition*; Art Institute of Chicago, *58th Annual Exhibition*.

1950 Exhibits at Metropolitan Museum of Art, New York, *Young American Painters*; Duke University, Durham, North Carolina, *Works by Cleve Gray, American Artist*.

1951 Exhibits at Brooklyn Museum, New York, *International Watercolor Exhibition*; Herbert F. Johnson Museum of Art, Cornell University, Ithaca, New York, *Young Painters U.S.A.*; Dayton Art Institute, Ohio, *The City by the River and the Sea*; Krannert Art Museum, University of Illinois, Champaign, *Contemporary American Painting*; wins University of Illinois Purchase Award; Pennsylvania Academy of the Fine Arts, Philadelphia, *146th Annual Exhibition* (subsequent exhibitions: 1958, 1960, 1962, 1964).

1952 Sheldon Memorial Art Gallery, University of Nebraska, Lincoln, *62nd Annual Exhibition*.

1953 Completes Apocalypse Series, allegorical and figurative works. Exhibits at Sheldon Memorial Art Gallery, University of Nebraska, Lincoln, *63rd Annual*

Exhibition.

1954 Completes *Ghandi [sic] Praying*. Exhibits at Birmingham Museum of Art, Alabama, *Steel, Iron, Men*; Virginia Museum of Fine Arts, Richmond, *American Paintings, 1954*; Des Moines Art Center, Iowa, *American Paintings 1954*; Jacques Seligmann Gallery, New York; Sheldon Memorial Art Gallery, University of Nebraska, Lincoln, *64th Annual Exhibition*.

1955 Continues landscapes of Arizona and still lifes, working on them through early 1958. Still strongly influenced by Jacques Villon. Exhibits at Corcoran Gallery of Art, Washington, D.C., *24th Biennial Exhibition*; Munson-Williams-Proctor Institute, Utica, New York, *Italy Rediscovered*.

1957 Marries writer Francine du Plessix. Exhibits at Jacques Seligmann Gallery, New York; Krannert Art Museum, University of Illinois, Champaign, *20th-Century Works of Art*; Philadelphia Art Alliance, Philadelphia, solo exhibition.

1958 Travels through France and Spain; begins using largely black-and-white palette. Exhibits at Solo Gallery, Richmond, Virginia, *Cleve Gray*; Detroit Institute of Arts, Michigan, *1st Biennial Exhibition*.

1959 First son, Thaddeus, born in November. Completes first sculpture in plaster. Last exhibition at Jacques Seligmann Gallery, New York. Exhibits at Krannert Art Museum, University of Illinois, Champaign, *Contemporary American Painting and Sculpture*.

1960 Summer months spent in France and Italy. Begins Maratea series, which continues through 1961. Becomes contributing editor of *Art in America*. Joins Staempfli Gallery, solo exhibition. Exhibits at Wadsworth Atheneum, Hartford, Connecticut, *Eight from Connecticut*; Detroit Institute of Arts, Michigan, *2nd Biennial Exhibition*.

1961 Second son, Luke, born in April. Begins lithography at the Pratt Graphic Art Institute, New York. Starts work on the Etruscan series. Wins the Ford Foundation Purchase. Exhibits at Galerie Internationale, Washington, D.C.; Solomon R. Guggenheim Museum, New York, *Abstract Expressionists and Imagists*; Tokyo, Japan, *6th International Art Exhibition*; John Herron Art Institute, Indianapolis, *Contemporary Drawings*; The Art Center in Hargate, St. Paul's School, Concord, New Hampshire, *Drawings USA/61*; Corcoran Gallery of Art, Washington, D.C., *27th Biennial Exhibition*.

1962 Completes *Altamira*, first significant manifestation of the vertical element in his painting. Exhibits at Staempfli Gallery, New York; Trabia Morris Gallery, New York, *Art of the Americas*; Pennsylvania Academy of Fine Arts, Philadelphia, *157th Annual Exhibition*.

1963 Completes *Reverend Quan Duc*, first artistic response to the crisis in Vietnam. As artist-in-residence at Oklahoma Art Center, Oklahoma City, under auspices of Ford Foundation Program, exhibits paintings. Completes *Oklahoma*, acquired by The New School of Social Research, New York, where it is later accidentally destroyed. Exhibits at Corcoran Gallery of Art, Washington, D.C., *28th Annual Exhibition*; The Art Museum, Princeton University, *Response*; Instituto de Cultura Hispanica, Madrid, *Arte de America y España*; Whitney Museum of American Art, New York, *Annual Exhibition*. Solo exhibitions at Jerrold Morris International Gallery, Toronto; Galeria Grattacielo, Milan, Italy; and Solo Gallery, Richmond, Virginia.

1964 During the summer, drives across the Peloponnesus and sails through Greek Islands. Develops a vertical form, initially based on studies of the female figure. (Vertical form later culminates as the dominating image in *Threnody*, 1973.) Paintings evoke classical origins: *Delphi, Crete, Ios*, the Augury series, and the Mycenae series. Exhibits at Pennsylvania Academy of Fine Arts, Philadelphia, *159th Annual Exhibition*;

Whitney Museum of American Art, New York, *Friends Collect*. Solo exhibitions at Staempfli Gallery, New York, *Recent Paintings;* and The Art Center in Hargate, St. Paul's School, Concord, New Hampshire, *Drawings USA/64.*

1965 Returns to Greece and the Aegean in the summer. Completes series of small canvases evocative of the two trips to Greece. Exhibits at Whitney Museum of American Art, New York, *Annual Exhibition;* Norfolk Museum of Arts and Sciences, Virginia, *American Drawing Biennial;* De Cordova and Dana Museum, Lincoln, Massachusetts, *New England Art: Prints;* Smith College Museum of Art, Northampton, Massachusetts, *New England Regional Drawing Exhibition.* First exhibition at Saidenberg Gallery, New York.

1966 Translates Marcel Duchamp's *A l'Infinitif.* Begins, with Francine, a period of several years of intense involvement with the anti–Vietnam War movement. Emphasizes the vertical form again in *Demeter* and the Demeter Landscape Series, the first of a number of series dealing with ancient earth goddesses. Begins to work almost exclusively in acrylics. Exhibits at Museum of Art, Rhode Island School of Design, Providence, *Recent Still Lifes;* The Art Center in Hargate, St. Paul's School, Concord, New Hampshire, *Drawings USA/66.*

1967 Completes a series on Gaia, Greek goddess of the earth and of death, followed by the Ceres series. Exhibits at Florida State University Art Gallery, Tallahassee, *National Lithography Exhibition;* University Art Museum, Berkeley, California, *Selections 1967.* Last solo show at Saidenberg Gallery, New York, the Ceres series.

1968 Upon sculptor's death, edits *David Smith by David Smith,* published by Holt, Rinehart & Winston, 1968, reprinted by Thames & Hudson. At the New York City branch of the Parisian printer Mourlot, produces color lithographs inspired by the Ceres paintings. Completes the Hera series. Becomes a trustee of the Rhode Island School of Design, serving until 1979. Exhibits at The Art Center in Hargate, St. Paul's School, Concord, New Hampshire.

1969 Exhibits at Phillips Collection, Washington D.C., *Loan Exhibition of Contemporary American Painting;* Betty Parsons Gallery, New York, *Reductive Vision;* Krannert Art Museum, University of Illinois, Champaign, *American Painting and Sculpture, 1948–1969;* Addison Gallery of American Art, Andover, Massachusetts, *Seven Decades—Seven Alumni of Phillips Academy.*

1970 Joins Betty Parsons Gallery. Appointed to the Board of Trustees, New York School of Drawing, Painting, and Sculpture (until 1975). Edits *John Marin by John Marin,* Holt, Rinehart & Winston, 1970. First solo exhibition at Betty Parsons Gallery, New York, *Paintings and Painted Forms.* Sneed Hillman Gallery, Rockford, Illinois, solo exhibition; The Graphics Gallery, San Francisco, *Cleve Gray: Prints and Drawings.* After trips through Morocco, begins Morocco series and Tamengrout series. For thirtieth reunion of the class of 1940, The Art Museum, Princeton University, holds a retrospective dedicated by Gray to the students killed at Kent State University. Under the auspices of the Ford Foundation, lives in Hawaii for six months with family as artist-in-residence at the Honolulu Academy of Art. The retrospective held at Princeton travels to Hawaii. Exhibition at the Honolulu Academy is followed, several months later, by work completed in Hawaii during his residency. Hawaii series continues well into 1971.

1971 Second exhibition, at Honolulu Academy of Arts, of work painted during term as artist-in-residence. Returning to Connecticut from Hawaii, works on many small bronze sculptures using the lost wax process. Visits Spain with family in August and begins the Sheba series upon returning home. Edits *Hans*

Richter by Hans Richter, Holt, Rinehart & Winston, 1971. Exhibits at Museo Universidad de Puerto Rico, *Lithographias de la Colección Mourlot*; Minnesota Museum of Art, St. Paul, *Drawings USA/71*; Minnesota Museum of Art, St. Paul, *Drawings in St. Paul* (through 1972).

1972 Commissioned by Bryan Robertson, director of the Neuberger Museum, State University of New York at Purchase, to create paintings for a gallery designed by Philip Johnson measuring 90 feet by 60 feet by 22 feet. Begins work on this project, entitled *Threnody*, which culminates in a suite of fourteen contiguous panels, each approximately 20 feet square. Exhibits Hawaiian paintings at Betty Parsons Gallery, New York; The Art Museum, Princeton University, New Jersey, *European and American Art from the Princeton Collections*.

1973 Completes *Threnody* as a memorial to the dead of both sides in the Vietnam War. Travels to East Africa with family. Exhibits at Betty Parsons Gallery, New York, *29 Bronzes*; Sneed Hillman Gallery, Rockford, Illinois.

1974 Neuberger Museum, State University of New York at Purchase, opening of *Threnody*. Exhibited through 1976. *Threnody* reinstalled in 1979, 1983, 1984, 1987, 1992–93, 1996. Exhibits at Wadsworth Atheneum, Hartford, Connecticut, *Nine Connecticut Artists*; Betty Parsons Gallery, New York, *Triptychs*. About fifteen years later, destroys most of Triptychs series. First trip to Nantucket with his family.

1975 Begins the Supplement series, followed by the Conjugation and Conjunction series, and the Lateral series. A liturgical vestment based upon his designs is completed for St. John's Episcopal Church, Washington, Connecticut. Spends six weeks in Jerusalem with family, as guest of Mayor Teddy Kollek. Exhibits at Neuberger Museum, State University of New York at Purchase, exhibition of working drawings, studies, photographs, and a scale model documenting the making of *Threnody*. In March travels to England.

1976 Joins Board of Trustees of the Wadsworth Atheneum, Hartford, Connecticut, a position held until 1978. Exhibition at Betty Parsons Gallery, New York, the Conjugation and Conjunction series. Exhibits at American Embassy, Bucharest, Rumania, *Arte Americana Contemporana*. Completes Milk Street series in Nantucket, small paintings with shaped canvas. Begins Nantucket series.

1977 Completes Warren series, which soon evolve into large vertical paintings. Exhibits at Albright-Knox Art Gallery, Buffalo, New York, *Cleve Gray: Paintings, 1966–1977*. Exhibition travels to the Museum of Art, Rhode Island School of Design, Providence; Columbus Museum of Art, Ohio; Krannert Art Museum, Champaign, Illinois. Late in the year, Gray family travels in Egypt, inspiring later work. Appointed Commissioner on the Connecticut Commission for the Arts (until 1982). Exhibits at the Solomon R. Guggenheim Museum, New York, *New Acquisitions*.

1978 Completes Hatshepsut series and Rameses series. Produces Perne series, inspired by William Butler Yeats's poem "Sailing to Byzantium." Exhibits at Betty Parsons Gallery, New York; Cathedral Museum of Art, Cathedral of St. John the Divine, New York, *Sacred Images—East and West*.

1979 Exhibition of Perne and Hatshepsut series at Betty Parsons Gallery, New York; Mattatuck Museum, Waterbury, Connecticut, exhibition of Perne and Warren series. *Threnody* reinstalled at the Neuberger Museum from June to August. Exhibits at Otis Art Institute of Parsons School of Design, Los Angeles, California, and Parsons School of Design, New York, *New York/A Selection from the Last Ten Years*; Sneed Gallery, Rockford, Illinois, *20th Anniversary Exhibition*; Rockland Center for the Arts, Maine, *Works on Paper, U.S.A.*

1980 Invited as artist-in-residence at the American Academy, Rome (where Francine is writer-in-residence). In Rome, using acrylic mixed with Carrara marble dust, begins work on the Roman Walls series. He later produces prints based on the same theme. Exhibits Roman Walls at the American Academy. In the summer, travels to Caracas, Venezuela, at the invitation of American Ambassador William Luers and the United States Information Agency. Exhibition at Museo de Bellas Artes, Caracas, *Roman Walls*. Returning from Caracas, enlarges exploration of calligraphic line with the Here series and the Man and Nature series. Late in year, begins an association of many years with Irving Galleries, Palm Beach, Florida. Exhibits at Commune di Udine, Civici Musei e Gallerie di Storia e Arte, *Arte Americana Contemporanea*; Yale Divinity School, New Haven, Connecticut, *Cleve Gray*; Indianapolis Museum of Art, Indiana, *Painting and Sculpture Today*.

1981 In January, returns as visiting scholar to the American Academy in Rome. Completes the Zen series, works on paper with a brush and bamboo pen, a continuation of Man and Nature series. Exhibits at Betty Parsons Gallery, New York, *New Paintings—Roman Walls*; Michael H. Lord Gallery 700, Milwaukee, Wisconsin; Stamford Museum and Nature Center, Connecticut, *Classic Americans: XX Century Painters and Sculptors*.

1982 Returns to the American Academy in Rome in January. Back in the United States, completes a set of vestments for St. James Episcopal Church in Farmington, Connecticut. Travels to India, Indonesia, and Japan under the auspices of the U.S.I.A. on a lecture tour with Francine. Before leaving Japan, Grays stay in Kyoto, Japan's religious capital, and he studies city's Zen gardens. Kyoto gardens inspire Zen Gardens series of 1982 and 1983. Exhibits at Betty Parsons Gallery, New York, *Group Exhibition*; Washington Art Association,

Washington Depot, Connecticut, works on paper.

1983 *Threnody* reinstalled at the Neuberger Museum for six months. Completes the Zen Gardens series and the Bridge series. Paints Rocks and Water series. Exhibits at Betty Parsons Gallery, New York, *Zen Gardens*; Betty Parsons Gallery, New York: *Painting—7+7+7*; Wadsworth Atheneum, Hartford, Connecticut; Benjamin Mangel Gallery, Philadelphia; G. Fox, Hartford, Connecticut, *Ten by Cleve Gray—Lithographs*; Silvermine Guild Center for the Arts, New Canaan, Connecticut, *Silvermine '83*.

1984 *Threnody* reinstalled at Neuberger Museum, January to June. From the American Academy in Rome, travels to Czechoslovakia and Austria. While at the American Academy in Rome, completes a series on paper inspired by the celebrated umbrella pines of Rome. These works are called Embassy series when exhibited at the Prague residence of Ambassador William Luers, where Roman Walls are also shown. In Prague, visits the Old Jewish Cemetery near the Altneuschul Synagogue, which inspires In Prague series. Back in the United States late in the year, designs a large altar cover for the Bicentennial Festival of the Episcopal Church, Diocese of Connecticut. In the fall, travels to China with Francine and other writers as guest of the People's Republic. Exhibits at Armstrong Gallery, New York, *In Prague, 1984*; Fairweather Hardin Gallery, Chicago, *From the East: Eastern Influence on Western Artists*; Griffin-Haller Gallery, Washington Depot, Connecticut, *Small Paintings*; Gallery Two Nine One, Atlanta, Georgia, *Cleve Gray*; Fairweather Hardin Gallery, Chicago, *Cleve Gray, Zen Gardens*; Robert L. Kidd Associates/Galleries, Birmingham, Michigan, *Cleve Gray— There Series*.

1985 At the American Academy early in the year, begins a series of works on paper, Holocaust, which signals the return of the human figure to his work. From Rome, travels to West and East Berlin and writes an article,

illustrated with his photographs, for *Art in America* about the paintings on the Berlin Wall. Begins a series of paintings entitled Sleepers Awake! based on the Holocaust works, quickly followed by the Resurrection series.

1986 Returns to Rome. Later exhibits at Armstrong Gallery, New York, *Cleve Gray: A Small Retrospective, 1934–1986*; Fairweather Hardin Gallery, Chicago, *Zen Gardens*; Armstrong Gallery, New York, *Resurrection Series*; Benjamin Mangel Gallery, Philadelphia, *Resurrection Series*; Paris–New York–Kent Gallery, Kent, Connecticut, *Roman Walls*; Mattatuck Museum, Waterbury, Connecticut, *Connecticut Masters*; The Jewish Museum, New York, *Jewish Themes/Contemporary American Artists*; Metropolitan Museum and Art Center, Coral Gables, Florida, *50 Works: Selections from the E. F. Hutton Collection (In Prague #22)*.

1987 Last year at American Academy in Rome; paints large works on paper, including Dancers and Flightsong series, most of which he later destroys. In April, receives the 1987 Governor's Connecticut Art Award. Paints *Four Heads of Anton Bruckner*, later acquired by the Wadsworth Atheneum, Hartford, Connecticut. *Threnody* reinstalled at the Neuberger Museum, February–June. Exhibits at Paul Mellon Arts Center, Choate Rosemary Hall School, Wallingford, Connecticut, *Cleve Gray*; Brooklyn Museum, New York, *Cleve Gray Works on Paper, 1940–1986*; Armstrong Gallery, New York, *Cleve Gray*; New Britain Museum of American Art, New Britain, Connecticut, *Cleve Gray Works on Paper, 1940–1986*; Duke University Museum of Art, Durham, North Carolina, *Cleve Gray: Recent Paintings*; Aldrich Museum of Contemporary Art, Ridgefield, Connecticut, *A Contemporary View of Nature*; Virginia Lynch Gallery, Tiverton, Rhode Island, *Roman Walls*; Westport Arts Center, Westport, Connecticut, *New York, New York*. In November,

undergoes heart bypass surgery.

1988 Awarded the Commission for the Outdoor Art at the Station Competition, Union Station, Hartford, Connecticut. The 636-foot-long mural in porcelain enamel tile, entitled *Movement in Space*, is installed on the terminal facade in September. *Cataract #2* (1984) purchased by United Technologies Corporation for installation at Bradley International Airport, Windsor Locks, Connecticut. Paints the Rope Dancer series and the Breaker series. Completes *Stations*, an on-site environment of painted paper and wood at the Paris–New York–Kent Gallery, Kent, Connecticut. Exhibits at The Art Guild, Farmington, Connecticut, *Cleve Gray: A Decade of Work, 1977–1987*; Bachelier-Cardonsky Gallery, Kent, Connecticut, *Cleve Gray*. Begins Late Zen series.

1989 Paints *Holocaust Triptych #1* and *Holocaust Triptych #2*. As part of the Aldrich Museum of Contemporary Art, Ridgefield, Connecticut, show, *Connecticut Artists*, creates an on-site installation entitled *Enter, Entrance, Exit*. Exhibits at Paris–New York–Kent Gallery, Kent, Connecticut; Salander-O'Reilly Galleries, New York, *Barnard Collects: The Educated Eye*; The Bruce Museum, Greenwich, Connecticut, *The Connecticut Biennial*.

1990 *Holocaust Triptychs* exhibited in the Cathedral of St. John the Divine as part of the *Concert of Holocaust Remembrance* in November, sponsored by the Interfaith Committee of Remembrance. Paints the Lovers series, Broken Horizon series, and the Edge series. First exhibition at Berry-Hill Gallery, New York, *Cleve Gray: The Painted Line*; Mattatuck Museum, Waterbury, Connecticut; *Cleve Gray: The Painted Line*; Central Connecticut State University, Samuel S. T. Chen Art Center, New Britain, Connecticut, *Cleve Gray Paintings, 1980–1990*.

1991 Completes *Inside Out*, an on-site installation on the exterior of the Paris–New York–Kent Gallery, Kent,

Connecticut, with a selection of small paintings in the interior. Begins Considering All Possible Worlds series. Exhibits at Berry-Hill Gallery, New York, *Cleve Gray: New Work*; Eva Cohon Gallery, Chicago and Highland Park, Illinois, *Cleve Gray*.

1992 *Threnody* reinstalled at the Neuberger Museum, March to August. Awarded an Honorary Doctor of Fine Arts Degree from the University of Hartford, West Hartford, Connecticut.

1993 Begins The Thrust series and the What is the Question? series. Begins and completes an extensive group of painted canvas collages, the first since 1965.

1994 Paints the Imaginary Landscape series, the Golgotha series, and the Firmament series. Exhibits at Neuberger Museum, *Inspired by Nature*.

1995 Completes the Eumenides series based on Aeschylus's *Oresteia* trilogy. Paints a series of portraits of the composer Béla Bartók. Exhibits at Wadsworth Atheneum, Hartford, Connecticut, *Cleve Gray: Romantic/Modern*.

1996 *Threnody* reinstalled at the Neuberger Museum, January to June. Exhibits at Berry-Hill Gallery, New York, *The Eumenides Series*; Neuberger Museum of Art, State University of New York at Purchase, *Cleve Gray: The Art of Memory—Threnody; Zen Gardens Series; In Prague Series*.

1997 While recuperating from a series of surgeries on the back and on the cranium, he completes *Elements IV*, commissioned for a residential building in Dallas, Texas. Elected as Honorary Trustee, Rhode Island School of Design. In midyear, he begins Space series.

1998 Elected to the American Academy of Arts and Letters. A suite of five paintings, the last of the Eumenides series, is acquired by the Colby College Museum of Art, Waterville, Maine. Harry N. Abrams publishes *Cleve Gray*, with text by Nicholas Fox Weber. Volume

coincides with traveling exhibition of Gray's work held at Butler Institute, Youngstown, Ohio; The Colby College Museum of Art, Waterville, Maine; and the Neuberger Museum (with reinstallation of *Threnody*).

WORKS IN PUBLIC COLLECTIONS

Addison Gallery of American Art, Phillips Academy, Andover, Massachusetts

Albright-Knox Art Gallery, Buffalo, New York

The Brooklyn Museum, New York

Cathedral of Saint John the Divine Art Gallery, New York

Colby College Museum of Art, Waterville, Maine

Columbia University Art Gallery, New York

Columbus Museum of Art, Ohio

The Corcoran Gallery of Art, Washington, D.C.

Grey Art Gallery and Study Center, New York University, New York

Solomon R. Guggenheim Museum, New York

Heckscher Museum, Huntington, New York

Honolulu Academy of the Arts, Hawaii

The Jewish Museum, New York

Krannert Art Museum, University of Illinois, Champaign

Mattatuck Museum, Waterbury, Connecticut

The Metropolitan Museum of Art, New York

Minnesota Museum of Art, St. Paul

Museum of Art, Rhode Island School of Design, Providence

Museum of Fine Arts, Boston

Museum of Fine Arts, Houston

The Museum of Modern Art, New York

National Museum of American Art, Smithsonian Institution, Washington, D.C.

The Neuberger Museum, State University of New York at Purchase

New Britain Museum of American Art, Connecticut

The Newark Museum, New Jersey

Norton Gallery of Art, West Palm Beach, Florida

Oklahoma City Art Center, Oklahoma

The Phillips Collection, Washington, D.C.

The Art Museum, Princeton University, New Jersey

Rose Art Museum, Brandeis University, Waltham, Massachusetts

Shearson Lehman Hutton Collection, New York

Sheldon Memorial Art Gallery, University of Nebraska, Lincoln

Shite Museum of Art, University of Notre Dame, Indiana

Tennessee Botanical Gardens and Fine Arts Center, Nashville

Union Station, Hartford, Connecticut

Vanderbilt Art Gallery, Nashville, Tennessee

The Wadsworth Atheneum, Hartford, Connecticut

Whitney Museum of American Art, New York

Williams College Museum of Art, Williamstown, Massachusetts

Yale University Art Gallery, New Haven, Connecticut

J. Willard Gibbs Research Laboratory, Yale University, New Haven, Connecticut

SELECTED BIBLIOGRAPHY

By the Artist

Books

Gray, Cleve, ed. *Hans Richter by Hans Richter.* New York: Holt, Rinehart & Winston, 1971.

_____. *John Marin by John Marin.* New York: Holt, Rinehart & Winston, 1970.

_____. *David Smith by David Smith.* New York: Holt, Rinehart & Winston, 1968.

Selected Articles

"Artist's Statement." From *Cleve Gray: The Painted Line.* Exh. cat. New York: Berry-Hill Gallery, 1990.

"Seduction and Betrayal in Contemporary Art." *Partisan Review* 50, no. 3 (1989), pp. 357–68.

"Report From Berlin: Wall Painters." *Art in America* 73, no. 10 (October 1985), pp. 39–43.

"Looking at Art: A Secret Kingdom in Chandrigarh." *Art News* 82, no. 7 (September 1983), pp. 112–14.

"Art in Sacred Service: Vestments by Cleve Gray in a Chapel by Richard Meier." *House and Garden,* April 1983, pp. 61–64, 160.

"Meaning in the Visual Arts." *Reflection* (Yale Divinity School) 79, no. 1 (November 1981), pp. 17–22.

"Lee Hall." *The Season Splendid: Paintings by Lee Hall in Honor of Kathryn Gamble.* Exh. cat. New Jersey: Montclair Art Museum, October 28–December 9, 1979.

"The Painting of *Threnody.*" *Focus on the Collection.* Exh. cat. Neuberger Museum, State University of New York at Purchase, 1975.

"John Marin: Graphic and Calligraphic." *Art News,* September 1972, pp. 48–53.

"Marin and Music." *Art in America,* July–August 1970, pp. 72–81.

"Marcel Duchamp: 1887–1968. The Great Spectator." *Art in America,* July–August 1969, pp. 20–27.

"Experiments in Three Dimensions—Michael Ponce de Leon," *Art in America,* May–June 1969, pp. 72–73.

"John Marin: The Etched Line." *Artists Proof,* no. 9 (1969), pp. 78–86.

"Portrait: Hans Richter." *Art in America,* January–February 1968, pp. 48–55.

"Rediscovery: Jim Davis." *Art in America,* November–December 1967, pp. 64–69.

"John Marin's Sketchbook: Summer 1951." *Art in America,* September–October 1967, pp. 44–46.

_____ and Francine du Plessix. "Who Was Jackson Pollock?" *Art in America,* May–June 1967, pp. 48–59.

"Naum Gabo Talks About Constructivism." *Art in America,* November–December 1966, pp. 48–55.

"Print Review: The Architecture of Lyonel Feininger," *Art in America,* March–April 1966, pp. 88–91.

"Speculations: Marcel Duchamp," *Art in America,* March–April 1966, pp. 72–75.

"David Smith: Last Visit." *Art in America,* January–February 1966, pp. 23–26.

"Print Review: Tatyana Grosman's Workshop," *Art in America,* December–January 1965–66, pp. 83–85.

"Retrospective for Marcel Duchamp." *Art in America,* no. 1 (1965), pp. 102–5.

_____ and Francine du Plessix. "Bruce Goff: Visionary Architect." *Art in America,* no. 1 (1965), pp. 82–87.

"Print Review: The Portfolio Collector," *Art in America,* June 1965, pp. 92–95.

"Robert Osborne: The Moment of Truth." *Art in America,* December 1964, pp. 100–105.

"Preview: Gleizes at the Guggenheim." *Art in America,* October 1964, pp. 68–71.

"Calder's Circus." *Art in America,* October 1964, pp. 22–48.

"Print Review: Jacques Villon," *Art in America,* October 1964, pp. 98–103.

_____ and Francine du Plessix. "Thomas Gilcrease and Tulsa." *Art in America,* June 1964, pp. 64–73.

"Print Review: New York Panorama," *Art in America,* April 1964, pp. 106–13.

"The Guggenheim International." *Art in America,* April 1964, pp. 48–55.

"New York: Remburgers and Hambrandts." *Art in America,* December 1963, pp. 118–20.

"Print Review: Looking for a Gift?" *Art in America,* December 1963, pp. 48–51.

"Walter Murch: Modern Alchemist." *Art in America,* June 1963, pp. 80–85.

"Print Review: American Prints Today," *Art in America,* January 1963, pp. 124–25.

"New York: International Headquarters." *Art in America,* winter 1962, pp. 88–90.

"Aspects of Anonymity." *Art in America,* fall 1962, pp. 92–97.

"The Gallery, the Museum, and the Critic." *Art in America,* summer 1962, pp. 90–95.

"Picasso and the Past." *Art in America,* no. 1 (1962), pp. 92–98.

"Galleries: The Art in America Show," *Art in America,* no. 4 (1961), pp. 94–100.

"Fall Reading." *Art in America,* no. 3 (1961), p. 114.

"Summer Reading." *Art in America*, no. 2 (1961), pp. 80–86.

"Spring Reading." *Art in America*, no. 1 (1961), pp. 90–97.

"Lyonel Feininger." *Art in America*, no. 4 (1960), pp. 76–79.

"Narcissus in Chaos: Contemporary Art." *The American Scholar*, autumn 1959, pp. 433–43.

"Ten Years." Artist's statement. Exh. cat. Jacques Seligmann Galleries, January 7–January 26, 1957.

———— and George Rowley. "Chinese and Western Composition." *College Art Journal*, fall 1955, pp. 6–17.

"Jacques Villon," *Perspectives USA*, no. 3, spring 1953, pp. 68–78.

"Albert Gleizes." *Magazine of Art*, October 1950, pp. 207–10.

"Orozco's Recent Frescoes." *Art in America*, July 1948, pp. 135–40.

Writings on the Artist

Alloway, Lawrence. *Cleve Gray*. Exh. cat. Honolulu Academy of Arts, September 10–October 11, 1970.

————. *Cleve Gray*. Exh. cat. The Art Museum, Princeton, New Jersey, June 5–28, 1970.

Anderson, Web. "An Encounter with Abstracts," *Sunday Star Bulletin & Advertiser* (Honolulu), September 1970, p. 36. [Review of the Honolulu Academy of Arts exhibition, 1970.]

Artner, Alan G. *Chicago Tribune*, December 7, 1984, sec. 7, p. 17. [Review of Fairweather Hardin exhibition, 1984.]

Barzun, Jacques. "Purpose in Paint," essay for Jacques Seligmann exhibition, October 30–November 18, 1950.

Bass, Ruth. *Art News*, February 1985, p. 148. [Review of Armstrong Gallery exhibition,

1984.]

Beck, James H. *Art News*, March 1964, p. 10. [Review of Staempfli Gallery exhibition, 1964.]

Benedikt, Michael. *Art International* 10, no.1 (January 1966): 98. [Review of Saidenberg exhibition, 1965.]

Berlin, Marjorie Elliot. *Design Through Discovery*, brief edition. Holt, Rinehart & Winston, 1980. [*Threnody* (1973), p. 184.]

Brenson, Michael. "Art: Two Looks at Cleve Gray's Works," *New York Times*, January 9. 1987, sec. 3, p. 1. [Review of Armstrong Gallery and Brooklyn Museum exhibitions, 1987.]

Brunelle, Al. "Cleve Gray at Betty Parsons," *Art in America*, March–April 1977, pp. 116–17.

Buck, Robert. "Cleve Gray," essay for Betty Parsons Gallery exhibition, November 6–24, 1979.

————. Foreword to *Cleve Gray: Works on Paper 1940–1986*, Brooklyn Museum exhibition, December 15, 1986–February 23, 1987.

Campbell, Lawrence. "Cleve Gray at Berry-Hill," *Art in America* 84 (June 1996), pp. 98–99.

Canaday, John. *New York Times*, February 16, 1960, p. 44. [Review of Staempfli Gallery exhibition, 1960.]

————. *New York Times*, November 18, 1967, p. 75. [Review of Saidenberg exhibition, 1967.]

————. *New York Times*, January 10, 1970, p. 27. [Review of Betty Parsons Gallery exhibition, 1970.]

Charles, Eleanor. "Works by Cleve Gray," *New York Times*, July 3, 1988, sec. CT, p. 1.

Cotter, Holland. "Cleve Gray at Berry-Hill," *Art in America*, October 1990, vol. 78, p. 206.

Damsker, Matt. "600-Foot Mural to Greet Travelers at Union Station," *Hartford Courant*, January 21, 1988, p. C5.

Danto, Arthur C. "Books and the Arts: Our Holi-

day Lists," *The Nation*, December 30, 1991, pp. 850–51. [Review of Berry-Hill exhibition, 1991.]

Dennison, George. *Arts Magazine*, February 1960, p. 64. [Review of Staempfli Gallery exhibition, 1960.]

Devree, Howard. *New York Times*, January 18, 1953, sec. 2, p. 10. [Review of Jacques Seligmann Gallery exhibition, 1953.]

————. *New York Times*, November 5, 1950, sec. 2, p. 10. [Review of Jacques Seligmann Gallery exhibition, 1950.]

————. *New York Times*, October 30, 1949, sec. 2, p. 9. [Review of Jacques Seligmann Gallery exhibition, 1949.]

Diamonstein, Barbaralee. "Song of Lamentation," *Art News*, September 1974, pp. 78–79.

Dillenberger, John D. "An Opportunity Not to Be Missed: Cleve Gray's *Threnody* Paintings," *Arts: The Arts in Religious and Theological Studies* 8, no. 2 (1966), p. 30.

Feldman, Anita. "Cleve Gray at Betty Parsons," *Arts* 44, no. 4 (February 1970), p. 59.

Fox, Catherine. "Paintings Suggest a Time Warp," *Atlanta Journal*, October 3, 1984, sec. C, p. 3. [Review of Gallery Two Nine One exhibition.]

Frackman, Noel. "Cleve Gray," *Arts Magazine* 51, no. 5 (January 1977), p 27. [Review of Betty Parsons exhibition.]

————. "Reductive Vision," *Arts Magazine* 43, no. 7 (May 1969), p. 64. [Review of Betty Parsons exhibition.]

Frank, Peter. "Alexander Liberman at Emmerich/Cleve Gray at Betty Parsons," *Art in America*, September 1973, p. 114.

Galbraith, Susan. "Cleve Gray at RISD," *Anyart Journal* 4, no. 1 (Spring 1977), pp. 7–11.

Genauer, Emily. "Art and the Artist," *New York Post*, May 18, 1974, p. 14. [Review of *Threnody*.]

————. "The Possessing and the Possessed," *International Herald Tribune*, May 18–19,

1974. [Review of *Threnody*.]

Goldman, Saundra. *Art News* 89 (September 1990), p. 164. [Review of Berry-Hill Gallery exhibition.]

Goodrich, Lloyd. *American Art of Our Century*, Whitney Museum of American Art, 1961. [*Mosque in Córdoba #2* (1959), p. 242.]

Hart, John. "Cleve Gray Strikes Flame at American Academy," *Daily American* (Rome), March 7, 1980, p. 5.

Hess, Thomas. "Cleve Gray," essay for *Cleve Gray Paintings 1966–1977*. Exh. cat. Buffalo, New York: Albright-Knox Art Gallery, 1977.

———. "Calculated Risks," *New York*, November 17, 1975, pp. 137–40.

———. "Recommended," *New York*, April 1974, p. 89. [Review of Betty Parsons exhibition.]

Hirsh, Linda. "Painting Unveiled at Airport," *Hartford Courant*, May 10, 1988, B4.

———. "Lucky Sevens," *Hartford Advocate*, March 2, 1983, p. 17. [Review of Wadsworth Atheneum exhibition, 1983.]

———. "Painting as the Dreamer Dreams," *Hartford Advocate*, September 26, 1979, p. 34. [Review of Mattatuck Museum exhibition, 1979.]

Hunter, Sam. *New York Times*, November 30, 1947, sec. 2, p. 12. [Review of Jacques Seligmann Gallery exhibition.]

———. *New York Times*, December 12, 1948, sec. 2, p. 10. [Review of Jacques Seligmann Gallery exhibition.]

Iovine, Julie V. "Connecticut Painters at the Wadsworth," *Connecticut Magazine*, February 1983, pp. 35–36.

Karafel, Lorraine. "Cleve Gray," *Arts Magazine* 57, no. 9 (May 1983), p. 19. [Review of Betty Parsons exhibition.]

Kotik, Charlotta. "The Painted Line," essay for *Cleve Gray: The Painted Line*. Exh. cat. New York: Berry-Hill Gallery, March 21–April 14, 1990.

Kramer, Hilton. *New York Times*, May 21, 1974, p. 50. [Review of *Threnody*.]

———. *New York Times*, January 22, 1972, p. 25. [Review of Betty Parsons Gallery exhibition, 1972.]

Kramer, Linda Konheim. Essay for *Cleve Gray: Works on Paper 1940–1986*, pp. 4–8. Exh. cat. New York: Brooklyn Museum, December 15, 1986–February 23, 1987.

Kuspit, Donald B. "Cleve Gray at Armstrong," *Art in America* 74, no. 10 (October 1986), p. 161.

La Farge, Henry. *Art News*, November 1950, p. 68. [Review of Jacques Seligmann Gallery exhibition, 1950.]

Landman, Hedy B., ed. *European and American Art from Princeton Alumni Collections*, The Art Museum, Princeton University, 1972. [*Santiago de Campostella* (1959), p. 150.]

Lester, Eleanore. "Abstract Artist's Works Evoke Struggle of Jews in Prague," *New York Jewish Week*, November 16, 1984, p. 35.

Levin, Kim. *Art News* 68, no. 10 (February 1970), p. 15. [Review of Betty Parsons Gallery exhibition, 1970.]

———. "Gray's Ceres Series," *Art News* 66, no. 7 (November 1967), pp. 52–53, 73–74. [Review of Saidenberg Gallery exhibition, 1967.]

Litt, Steven. "Drawing a Blank, But with a Burst of Excitement," *The News and Observer* (Raleigh, North Carolina), January 25, 1987, p. 3E. [Review of Duke University Museum of Art exhibition, 1987.]

MacBride, Henry. *New York Sun*, November 1947. [Review of Jacques Seligmann Gallery exhibition.]

McCaughey, Patrick. Essay for *Cleve Gray: Romantic/Modern*, Wadsworth Atheneum exhibition, 1995.

McGill, Douglas C. "Art People," *New York Times*, February 5, 1988, sec. 3, p. 27.

McNally, Owen. "Shades of Gray," *Hartford Courant*, July 2, 1995, pp. G1, G4. [Review of Wadsworth Atheneum exhibition.]

Mellow, J. R. *New York Times*, April 28, 1973, p. 27. [Review of Betty Parsons Gallery exhibition, 1973.]

Morris, Gitta. "Artists and Their Spaces," *Connecticut Magazine* 50, no. 10 (October 1987), pp. 112–17, 202.

Muchnic, Suzanne. "First Postmerger Show at Otis/Parsons," *Los Angeles Times*, July 3, 1979, sec. 5, p. 7.

Mulligan, Tim. *The Hudson River Valley, 1992–1993*. New York: Random House, 1993. [*Threnody* (1973), p. 217.]

O'Beil, Hedy. *Arts Magazine* 59 (March 1985), pp. 40–41. [Review of Armstrong Gallery exhibition, 1985.]

Porter, Fairfield. *Art News*, February 1957, p. 11. [Review of Jacques Seligmann Gallery exhibition, 1957.]

Preston, Stuart. "From Tradition to Innovation," *New York Times*, January 18, 1959, sec. 10, p. 12. [Review of Jacques Seligmann exhibition, 1959.]

———. *New York Times*, November 7, 1954, sec. 2, p. 10. [Review of Jacques Seligmann Gallery exhibition, 1954.]

Ratcliff, Carter. "Cleve Gray: In Prague 1984." Essay for Armstrong Gallery exhibition, November 15–December 8, 1984.

———. "Cleve Gray," *Arts Magazine* 59, no. 3 (November 1984), p. 3. [Review of Armstrong Gallery exhibition.]

———. "Cleve Gray at Betty Parsons," *Art in America*, January 1980, p. 110.

Raynor, Vivien. "The Sublime, the Modern, and the Literal in Views of the Land," *New York Times*, November 13, 1994, sec. WC, p. 20. [Review of Neuberger Museum exhibition, 1994.]

———. *New York Times*, November 16, 1979, sec. 3, p. 23. [Review of Betty Parsons Gallery exhibition.]

Reed, Judith Kaye. "London War Ruins," *Art Digest*, December 15, 1948, p. 21. [Review of Jacques Seligmann Gallery exhibition, 1948.]

Robb, Anne. "State Artist Cleve Gray Showcased in Two City Exhibits," *Hartford Courant*, January 30, 1983, p. E8.

Robbins, Daniel. "Cleve Gray's Recent Work," *Arts Magazine* 54, no. 3 (November 1979), pp. 118–19.

———. "Bronze Sculpture by Cleve Gray." Essay for *Cleve Gray: 29 Bronzes*. Exh. cat. New York: Betty Parsons Gallery, 1973.

———. "Cleve Gray: New Works," *Art in America* 53, no. 5 (October–November 1965), p. 74. [Review of Saidenberg Gallery exhibition, 1965.]

———. "Cleve Gray: The Burdens and Rewards of Tradition," *Art International* 8, no. 2 (March 1964), pp. 31–33.

Robertson, Bryan. "Triptychs by Cleve Gray," essay for Betty Parsons Gallery exhibition, May 14–May 31, 1974.

Rose, Barbara. "Cleve Gray: The Art of Memory," essay for Neuberger Museum of Art exhibition, 1996.

———. "Cleve Gray: The *Eumenides* Series," essay for Berry-Hill Gallery exhibition, 1996.

Rosoff, Patricia. "Zen and the Art of Cleve Gray," *The Hartford Advocate*, July 20, 1995, pp. 29–30. [Review of Wadsworth Atheneum exhibition.]

Russell, John, *New York Times*, April 25, 1986, sec. 3, p. 24. [Review of the Armstrong Gallery exhibition, 1986.]

———. *New York Times*, November 16, 1984, sec. 3, p. 15. [Review of the Armstrong Gallery exhibition, 1984.]

———. *New York Times*, February 11, 1983, sec. 3, p. 21. [Review of Betty Parsons Gallery exhibition, 1983.]

———. New York Times, January 9, 1981, sec. 3, p. 19. [Review of Betty Parsons Gallery exhi-

bition, 1981.]

———. *New York Times*, October 15, 1976, sec. C, p. 16. [Review of Betty Parsons Gallery exhibition, 1976.]

Santlofer, Jonathan. "Lions in Winter: American Artists in Their 70s and 80s," *Art News* 92 (March 1993), pp. 86–91.

Secunda, Arthur. *Arts Magazine*, March 1972, pp. 60–61. [Review of Betty Parsons Gallery exhibition, 1972.]

Shirey, David L. "Wall to Wall: Painting by Gray Nears Heroic Proportions," *New York Times*, August 12, 1979, sec. 12, p. 17.

Siegel, Mildred. "Abstract Art: Cleve Gray's 'Expression of Life,'" *Waterbury (Conn.) Republican*, September 26, 1979, p. 17. [Review of Mattatuck Museum exhibition.]

———. "Artist Cleve Gray 'Wanted to Continue Magic'," *Waterbury (Conn.) American*, 25 September 1979, p. 10. [Review of Mattatuck Museum exhibition.]

Southwell, William. "Gallery Encounters: Cleve Gray in Focus," *Art Matters (Philadelphia)*, April 1986, p. 7. [Review of Benjamin Mangel Gallery exhibition, 1983.]

Sozanski, Edward J. "From an Abstract, 'Cool' Painter, a Lively New Style," *Philadelphia Enquirer*, April 10, 1986, p. 5C. [Review of the Benjamin Mangel Gallery exhibition, 1986.]

———. "An Abstract Painter of Changing Styles," *Philadelphia Enquirer*, April 7, 1983, p. 5E. [Review of the Benjamin Mangel Gallery exhibition, 1983.]

Tallmer, Jerry. "Meet a Lucky Man," *New York Post*, November 17, 1979, p. 18. [Review of Betty Parsons Gallery exhibition, 1979.]

Tillim, Sidney. *Arts Magazine*, February 1959, p. 59. [Review of Jacques Seligmann Gallery exhibition, 1959.]

Tutko, Nancy. "Cleve Gray: An Artist's Itinerary," *Danbury (Conn.) News Times*, September 2, 1984, pp. E2–E5.

———. "Warren Artist to Discuss Works," *New York Times*, June 17, 1984, sec. CT, p. 21.

Walsh, Andrew. "Church's New Vestments Are Art for Religion's Sake," *Hartford Courant*, December 4, 1982, p. A17.

Weiss, Patricia. "Cleve Gray," *Hartford Courant*, December 20, 1987, pp. 30–33, 38–39.

Weissman, Julian. *Art News* 73, no. 7 (September 1974), pp. 114–16. [Review of Betty Parsons Gallery exhibition.]

Whitbeck, Doris. "Artists Judge Peers," *Hartford Courant*, January 14, 1983, pp. D7, D10. [Review of Wadsworth Atheneum exhibition, 1983.]

Willig, Nancy Tobin. "Gray's Canvases Explode, But Colors Temper His Work," *Buffalo Courier-Express*, June 11, 1977, p. 12. [Review of Albright-Knox Art Gallery exhibition.]

Winburn, Jan. "Art For All: A Public Collection for Connecticut," *Hartford Courant*, September 27, 1987, pp. 11–22, 38–40.

Wolff, Millie. "Irving Galleries Selection Provokes the Mind," *Palm Beach Daily News*, November 17, 1982, p. 3. [Review of Irving Galleries exhibition, 1982.]

———. "Gray's Philosophy in His Art," *Palm Beach Daily News*, December 20, 1982, p. A11. [Review of Irving Galleries exhibition.]

"Works of Art Given in Memory of Daniel J. Robbins," *Rhode Island School of Design: Museum Notes* 83, no. 4 (June 1996), p. 18. (*Broken Horizon*, 1990).

Yau, John. "Nature as Gesture." Essay for *Cleve Gray: A Small Retrospective 1934–1986*, Armstrong Galleries, 1986.

———. "Cleve Gray at Betty Parsons," *Art in America* 71, no. 4 (May 1983), pp. 168–69. [Review of Betty Parsons exhibition, 1983.]

Zimmer, William. "Connecticut Artists Are Given Rooms of Their Own," *New York Times*, March 26, 1989, sec. CT, p. 18.

INDEX

Page numbers in *italic* type refer to illustrations.

PHOTOGRAPH CREDITS

Pat Bazelon, p. 116; Berry-Hill Gallery, pp. 100 (right), 143; E. Irving Blomstrann, pp. 39, 44, 93, 98, 107, 108, 113, 114, 124, 126–27, 133; Randy Clark, pp. 2–3; Jeffrey Clements, p. 65; Columbus Museum of Art, p. 51; Jim Frank, pp. 117, 122; Greg Heins, pp. 31, 68; Evelyn Hofer, pp. 18–19; Robert Houser, pp. 8–9, 15, 33, 35 38, 45, 46, 49, 52, 56, 61, 63, 67, 69, 71, 72, 73, 77, 78, 81, 84, 85, 86, 89, 90, 92, 95, 96, 100 (left), 104, 105, 106, 111, 112, 120, 121, 123, 125, 134, 135 (bottom), 136, 137, 139, 140, 141, 144, 145, 146, 147, 148, 149, 150, 152, 153; Krannert Art Museum, p. 101, ; Alexander Liberman, pp. 55, 62; The Metropolitan Museum of Art, p. 58; Inge Morath, p. 7; Museum of Fine Arts, Boston, p. 115; National Museum of American Art, Smithsonian Institution, p. 80; Dwight Primiano, p. 109; Jacques Seligmann Gallery, p. 60; Sheldon Memorial Art Gallery, p. 59; Steven Sloman, pp. 128–29; Sarah Wells, p. 110; Bruce M. White, p. 135; Amber Woods, pp. 17, 48, 118